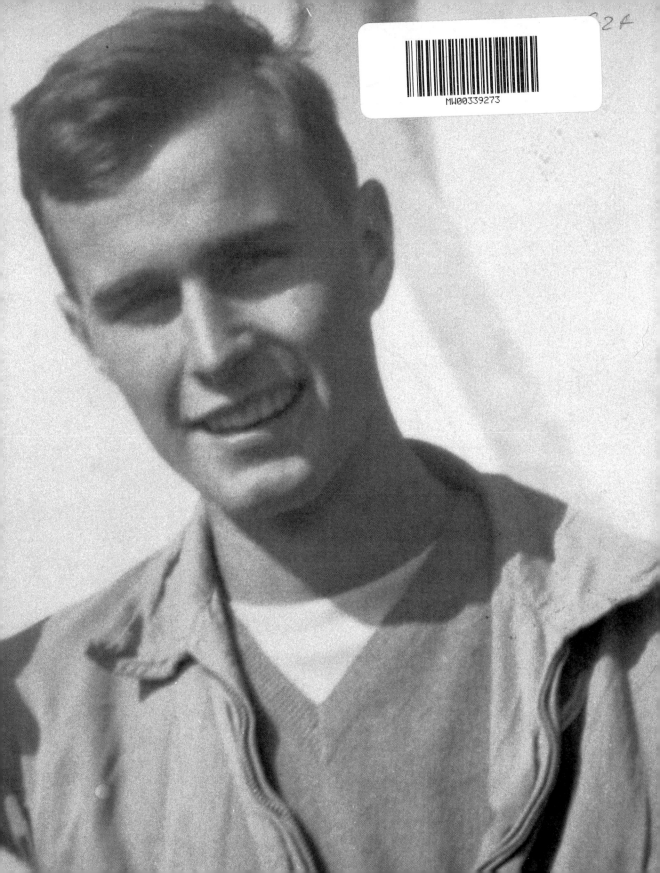

THE
CALL TO
SERVE

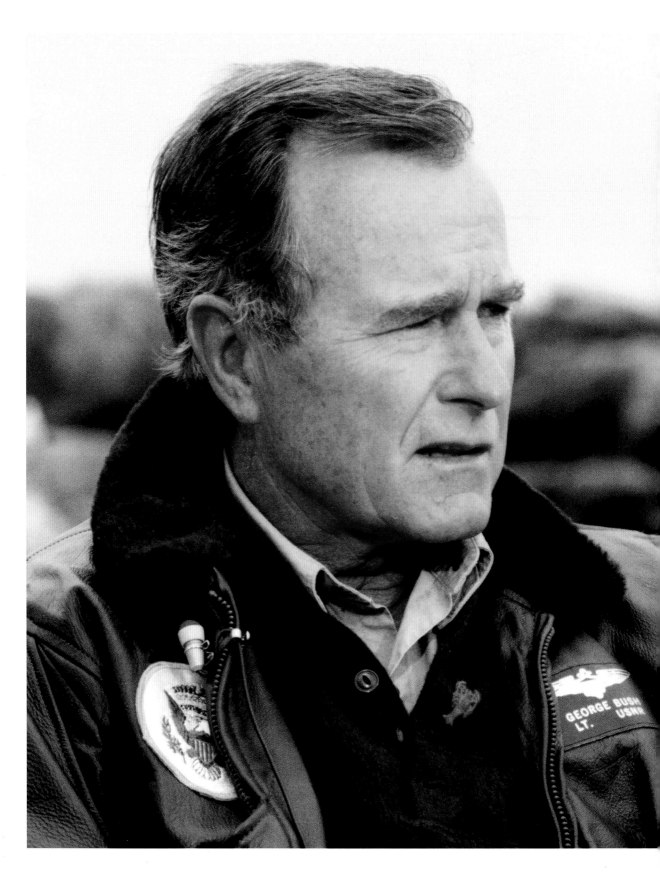

THE
CALL TO
SERVE

★

THE LIFE OF AN AMERICAN PRESIDENT,
GEORGE HERBERT
WALKER BUSH

★

JON MEACHAM

Random House | *New York*

Published in the United States by Random House, an imprint and division
of Penguin Random House LLC, New York.

RANDOM HOUSE and the HOUSE colophon are registered trademarks
of Penguin Random House LLC.

Portions of this work were originally published in different form in *Destiny and Power*
by Jon Meacham (New York: Random House, 2015). In addition, brief portions
of this work are taken from the author's eulogies given at the funerals of
President George H. W. Bush and Barbara Pierce Bush, both in 2018.

The author is grateful to the Estate of George Herbert Walker Bush for permission
to quote from the letters, diaries, and personal papers of George H. W. Bush
and of Barbara Pierce Bush.

LIBRARY OF CONGRESS CATALOGING-IN-PUBLICATION DATA
Names: Meacham, Jon, author.
Title: The call to serve : the life of an American president,
President George Herbert Walker Bush / Jon Meacham.
Other titles: The life of an American president, George Herbert Walker Bush
Description: First edition. | New York : Random House, [2024] |
Includes bibliographical references and index.
Identifiers: LCCN 2023038143 (print) | LCCN 2023038144 (ebook) |
ISBN 9780593729458 (hardback) | ISBN 9780593729472 (ebook)
Subjects: LCSH: Bush, George, 1924–2018. | Presidents—United States—Biography. |
United States—Politics and government—1945–1989. | United States—Politics and
government—1989–
Classification: LCC E882 .M42 2024 (print) | LCC E882 (ebook) |
DDC 973.928092 [B]—dc23/eng/20231025
LC record available at https://lccn.loc.gov/2023038143
LC ebook record available at https://lccn.loc.gov/2023038144

Printed in Italy on acid-free paper

randomhousebooks.com

2 4 6 8 9 7 5 3 1

FIRST EDITION

Book design by Simon M. Sullivan

To the memory of

BARBARA PIERCE BUSH
1925–2018

&

ARM2 JOHN LAWSON "DEL" DELANEY, USNR
1920–1944

LT (JG) WILLIAM GARDNER "TED" WHITE, USNR
1918–1944

To serve and to serve well is the
highest fulfillment we can know.

—George Herbert Walker Bush

CONTENTS

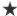

THE
CALL TO
SERVE

INTRODUCTION

FAREWELL TO
A STATESMAN

There is but one just use of power, and it is to serve people.

—GEORGE H. W. BUSH, Inaugural Address, January 20, 1989

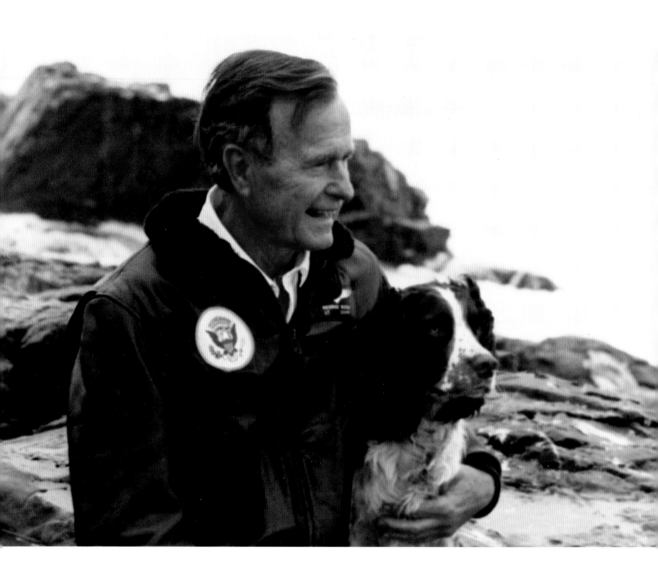

THERE HE WAS, one last time, silent and steadfast yet the center of everything. On a gray winter's day in Washington in 2018, in the Rotunda of the Capitol of the United States, the body of George Herbert Walker Bush lay in his flag-draped coffin on the catafalque that once bore the mortal remains of Abraham Lincoln. For days, hour by hour, mourners filed past to pay their respects to the forty-first president of the United States, a man who had served the nation since taking his oath as a naval recruit on his eighteenth birthday amid a global war pitting democracy against fascism. He had died in great old age, at ninety-four, at home in Houston on Friday, November 30, 2018, and was now in the midst of funeral rites that would conclude with his burial in a small grove of trees in Texas next to Barbara Pierce Bush, his wife of sixty-three years, and Robin, the daughter the Bushes had lost to leukemia in 1953.

There was a hum in the Rotunda—the shuffles of steps, the sounds of murmurs, the clicks of cameras from the press on risers. It was the hum of history, which was fitting, for George H. W. Bush had long been both a maker and a mirror of America's past and present. He had known more than a few of the figures commemorated in the vast and beautiful chamber where he had come to rest. Watching over the coffin were Dwight D. Eisenhower, a golfing partner of Bush's father, Senator Prescott Bush; Gerald R. Ford, who had been Bush's leader in the House of Representatives in the 1960s and had made Bush both America's envoy to the People's Republic of China and director of Central Intelligence; and Ronald Reagan, whom Bush had served for eight years as vice president, an experience the forty-first president always said had been instrumental in his own rise to the pinnacle of power.

Almost exactly three decades earlier, in the winter of 1989, Bush had stood not far from the Rotunda, on the West Front of the Capitol, to take the presidential oath. Before he began his inaugural ad-

Introduction opening page: The former president lay in state in the Capitol Rotunda in December 2018 after his death in Houston. The casket was set on the catafalque that had borne the mortal remains of Abraham Lincoln, James A. Garfield, William McKinley, Warren G. Harding, Herbert Hoover, John F. Kennedy, Dwight D. Eisenhower, Ronald Reagan, Gerald R. Ford, and other distinguished Americans.

dress, Bush withdrew a few note cards from his breast pocket. On them he had written a prayer, and it was with these words of humility and of supplication that he opened his administration of the most powerful single office on earth.

The wind whipping his auburn hair, the new president asked those in the audience to bow their heads. Then he prayed: "Heavenly Father, we . . . thank You for Your love. Accept our thanks for the peace that yields this day and the shared faith that makes its continuance likely. Make us strong to do Your work, willing to heed and hear Your will, and write on our hearts these words: 'Use power to help people.' For we are given power not to advance our own purposes, nor to make a great show in the world, nor a name. There is but one just use of power, and it is to serve people. Help us to remember it, Lord. Amen."

Use power to help people. There, in a phrase, was a fundamental conviction that guided George H. W. Bush. It is not a simple proposition—and Bush was not a simple man—for one has to amass power in order to wield it in the service of others. The amassing of power in a big, complicated, disputatious democracy is no easy thing. It requires a kind of ruthlessness, a willingness to make difficult calls, a capacity to caricature the opposition beyond the bounds of the gracious and the reasonable and even the fair. "Politics," Bush once privately mused, "isn't a pure undertaking—not if you're going to win, it's not."

And George H. W. Bush wanted to win. He always had, from an athletic childhood on Grove Lane in Greenwich to summers on Walker's Point in Maine to Andover, war, Yale, Texas, and politics and diplomacy at the highest levels. What is critical to understand about Bush is that winning was not the end of his endeavors, but the means—the way by which he could bring a sense of decency and dignity to a public arena often bereft of both. As he observed on the eve of his 1988 White House run: "If you want to be President—and I do—there are certain things that I have to do, certain speculation that I have to put up with, and certain ugliness that will crop into a campaign or into the pre-campaign." His impulses to do good and to

do in his opponent were intertwined. At the end of the 1988 campaign—a difficult one in which Bush portrayed his Democratic opponent, Massachusetts governor Michael Dukakis, as a left-wing ideologue out of step with the broad values of the country—he mused to himself, "The country gets over these things fast. I have no apologies, no regrets, and if I had let the press keep defining me as a wimp, a loser, I wouldn't be where I am today: threatening, close, and who knows, maybe winning."

He did win—and he redeemed his pursuit of power in office by seeking to be not corrosive but constructive, not divisive but unifying. Bush's life and presidency are not the stuff of hagiography—the story of a saint. He was not perfect—not even close. But then precious few human beings can make such a claim. What is important about George H. W. Bush is that he was an imperfect man who was ultimately devoted to the American journey toward a more perfect Union.

His victories, it is true, were provisional, hard-fought, and fleeting. But almost all victories in politics and in governance are provisional, hard-fought, and fleeting. That is the nature of the enterprise. The best we can reasonably expect is that those who are doing the fighting are in the arena not only for themselves but for We the People—that those who seek power at least believe in the American project of bringing liberty to the captive, hope to the despairing, and possibility to the many.

George H. W. Bush did believe in those things, and he spent his life seeking to make the ideal real.

THIS BOOK COMMEMORATES the centennial of George Herbert Walker Bush, who was born to Dorothy Walker Bush and Prescott Sheldon Bush in a Victorian house in Milton, Massachusetts, on Thursday, June 12, 1924. The text draws in part on *Destiny and Power,* the biography of President Bush I published in 2015, three years before his death. To create this volume, we sought revealing imagery and documents from the George H. W. Bush Presidential Library in College Station, Texas, and I believe the experience of

encountering the Bush story in context with the visual objects of a lifetime repays our time and contemplation.

Milestones are often occasions for retrospection, and what we see when we look back at given moments—and at given lives—is shaped by the perspectives, concerns, and experiences of our own time. History and memory are like that. And so as we look back at George H. W. Bush from the vantage point of the middle of the third decade of the twenty-first century, we can see that his steadiness, his aversion to slogan, and his belief in American democracy are virtues not only to be celebrated but to be honored, for these virtues are neither universal nor inevitable.

In his inaugural address, Bush spoke of big things, important things, *American* things. "We know what works: Freedom works," he said. "We know what's right: Freedom is right. We know how to secure a more just and prosperous life for man on Earth: through free markets, free speech, free elections, and the exercise of free will unhampered by the state." For freedom to work, though, Americans had to follow Bush's line of argument fully and see that freedom is *right*—and that the price of freedom is to lose graciously as well as to win humbly; to understand that the nation cannot long endure if one person or one party sees the give-and-take of democracy as an occasion only to take.

This is not a partisan point. George H. W. Bush was a Republican, yes, but a Republican who believed his office transcended party and who was able to govern with remarkable results with a Congress controlled by the opposite party. That he managed to do so well both at home and abroad without a favorable majority in either chamber is testament to his underappreciated but notable skills, and his example offers us lessons in how both leaders and the led can make advances despite differences of party, of background, and of ideology.

Sentimental? No, because it happened, and it happened here, in America, not too long ago. Among the reasons Bush succeeded in difficult circumstances was his allegiance to principles that are diffi-

cult to put into practice in the maelstrom of daily political life. Chief among those principles was his conviction that he was part of an unfolding story—a vital part, but still just a part—the significance of which outweighed his own ego, his own desires, his own ambitions, his own appetites.

One way to understand that story is to think of it this way: From 1933 to 2017, Americans inhabited a political universe largely defined by Franklin D. Roosevelt and Ronald Reagan. However different, however divided, each American president and each American era over eight and a half decades was a coherent and sequential chapter to the one that came before. We argued about the relative role of the state in the marketplace and about the relative projection of force against commonly agreed-upon foes and rivals—but all on a spectrum where the vast majority of Americans accepted the validity of election results. George H. W. Bush was a vital interlocutor in that conversation, a moderately conservative man who neither idolized nor disdained the capacity of government to do good.

Like Jefferson and Hamilton, two opposing forces who created a tension that enabled the country to flourish, FDR and Reagan represent enduring points of view that have together shaped the life of the nation. And even if we might wish the 1933–2017 period had been different in this way or that way, a nation that overcame the Great Depression, defeated the Axis, built a strong middle class, passed civil rights and voting rights acts, opened opportunities for women, welcomed immigrants, went to the Moon, enhanced public health, secured clean water and safe food, prevailed in the Cold War, and saved millions of lives from HIV/AIDS in Africa is a nation that got some big things right even as it failed on large questions of justice and equality before the law.

It was certainly not a perfect age. There were derelictions and debacles, dreams deferred and hopes dashed. Yet the lesson of the FDR–Reagan era—extending beyond Reagan to include the Bushes, Bill Clinton, and Barack Obama—is that we are at our best when we agree on the facts at hand, on the efficacy of compromise, and on the

legitimacy of our institutions. A unity of opinion is impossible. A unity of purpose, however, is achievable, even if the nation inevitably differs on how to fulfill that purpose.

In his inaugural address in 1989, Bush, a man of the broad American center, addressed himself to this point. "I take as my guide the hope of a saint: In crucial things, unity; in important things, diversity; in all things, generosity," the new president told the nation. "And so, there is much to do; and tomorrow the work begins. I do not mistrust the future; I do not fear what is ahead. For our problems are large, but our heart is larger. Our challenges are great, but our will is greater. And if our flaws are endless, God's love is truly boundless." Grand, perhaps predictable, rhetoric, but Bush's subsequent deeds as president matched the words he uttered as he began.

Character, as the Greeks understood, is destiny, and the character of George H. W. Bush repays our consideration, for that character oftentimes reflected the best impulses of the American project. Not always, to be sure—Bush was not a monument but a man, not a saint but a statesman—but just enough of the time, at critical junctures, the forty-first president chose right over wrong, the difficult over the easy, the arduous over the expedient. Bush's life code, as he once put it in a letter to his mother, was "Tell the truth. Don't blame people. Be strong. Do your Best. Try hard. Forgive. Stay the course. All that kind of thing."

As a president, Bush peacefully managed the end of the Communist threat, secured the heart of Europe, and struggled to bring order to the chaos of the Middle East. President and statesman, politician and father, he was part of the story of American power from World War II to the war on Islamic terror—a war that would rise in pitch and in intensity on the watch of Bush's eldest son, George W. Bush, the forty-third president of the United States. On the home front, the elder Bush's 1990 budget agreement created the conditions for the elimination of the federal budget deficit under Bill Clinton. He negotiated the North American Free Trade Agreement; signed the Americans with Disabilities Act; and passed historic clean-air legislation.

Bush did these things as the political world was shifting all around him. The right wing of his own party was growing in strength and scale. The mechanisms of media were changing, giving more influence to the most extreme voices. The country, always divided, was becoming ever more polarized. The America of 1988, the year of his presidential victory, was not the America of 1992, the year of his presidential defeat, and it was the America of 1992, with the emergence of protest candidates such as Patrick J. Buchanan and H. Ross Perot, that foreshadowed the chaos to come.

Bush was, in this sense, a countercultural figure. Reflexive partisanship was becoming fashionable; the politics of total war more common; the center ever smaller. Yet he embraced compromise as a necessary element of public life, engaged his political foes in the passage of important legislation, and was willing to break with the base of his own party in order to do what he thought was right, whatever the price.

And the price was high: defeat in 1992, which consigned Bush to a one-term presidency. He hated losing—*hated* it—and was, in the aftermath, something of an emotional wreck. Who wouldn't be? One day Bush was the most powerful man on earth. The next he was rejected by his own people, his reelection garnering only 39 percent of the vote.

And yet, and yet. The further the country moved from his time in the White House, the taller he loomed. Bush had been defeated and dispatched into an unwanted retirement, mocked for seeming out of touch and for calling for a nation that was "kinder and gentler"— a country where voluntary organizations and straightforward human kindness toward one another would create "a thousand points of light" in the night sky.

Asked in his ninetieth year what the conventional wisdom got wrong about him, Bush replied: "I'm not sure I know anymore. The common wisdom when Nixon was around and right after was that I wasn't tough enough, wasn't strong enough, maybe you want to say mean enough. I don't know how widespread that was . . . but publicly it may have been that, may still be for all I know. It's hard to tell

now, but I think there's been a certain revisionism. It seems to blend into 'Thank you for your public service,' not 'Hey, why'd you do this or that on taxes, or right wing or non-right wing.' I'm surprised people remember because I feel like I've gone away, out of the game. I haven't been particularly interested in the legacy thing, except hoping that historians get it right, which I think they will." Amid a conference at his presidential library in 2014, as public approval of his time in office was rising, a visitor asked him what he made of the encomiums. In a voice hoarse with age, Bush remarked: "Hard to believe. It's 'kinder and gentler' all over the place."

As it should have been, and should be.

S EVERAL DAYS AFTER he lay in state in the Rotunda, Bush was brought to College Station, Texas, aboard a special train commissioned for this final journey. He was carried to his presidential library and laid to rest in a small cemetery behind an iron gate emblazoned with the presidential seal. The prayers said, the martial music done, there was quiet.

The late president's Secret Service detail kept watch at the grave on that Texas night, standing guard one last time over the man codenamed Timberwolf. Finally, at dawn, the agents took their leave. Their mission was done.

Timberwolf's story, though, unfolds still in the life of the nation he led and the world he helped shape. To understand him, the country that trusted him, and the meaning of what he used to call, typically, "the legacy thing," we must engage again not with journey's end, but with its beginning.

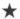

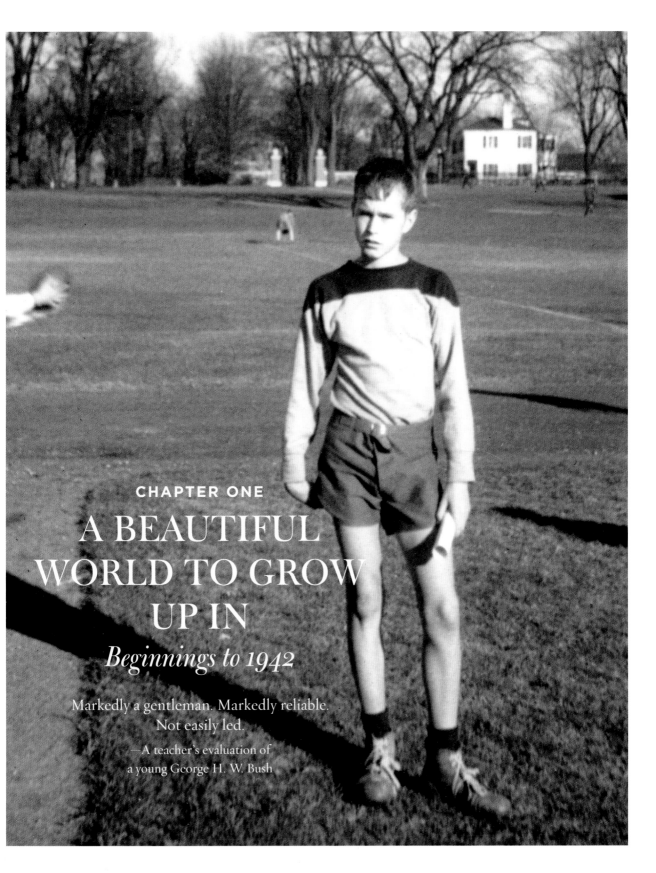

A BEAUTIFUL WORLD TO GROW UP IN

Beginnings to 1942

Markedly a gentleman. Markedly reliable.
Not easily led.

—A teacher's evaluation of
a young George H. W. Bush

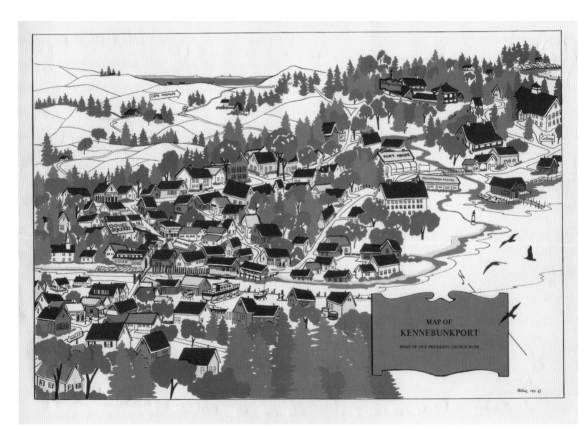

MAP OF
KENNEBUNKPORT
HOME OF VICE PRESIDENT GEORGE BUSH

H<small>IS FIRST MEMORY</small> was of the sea, and of his father—the tall, commanding figure of Prescott Bush. As best George H. W. Bush could recall, his consciousness began at Walker's Point, in Kennebunkport, Maine, where he remembered standing next to his father in the small entry hall near the front door of the oceanfront house on the peninsular estate his grandfather, George Herbert Walker, had bought in 1900 with his own father, David Davis Walker. Bush's childhood world was one of relentless competition, of opaque codes, and of an ambient sense that life was meant to be lived fully and graciously—but also fully and ferociously. You were gracious, but you were also expected to prevail. "It was a beautiful world to grow up in," recalled Bush's sister, Nancy Bush Ellis. "A grand, funny world, really. Unimaginable now."

That world was in fact not all that imaginable for most people even then. The Bushes were old Yankees with antecedents on the *Mayflower* and distinguished service during the American Revolution. (One Bush forebear, Dr. Samuel Prescott, was a Massachusetts patriot who rode with Paul Revere.) The forty-first president's great-great-grandfather, Obadiah Bush, served in the War of 1812 at the young age of fifteen, married a woman recalled as the "comely" Harriet Smith, and caught gold fever in the middle of the nineteenth century but died before he could move his family out to the promised land of San Francisco. Obadiah's eldest son, James Smith Bush, was an Episcopal clergyman who lost his traditionalist faith and became a Unitarian. And *his* son, Samuel Prescott Bush, known as "S.P.," born in 1863, became a successful industrialist in Columbus, Ohio. "Grandfather Bush was quite severe," recalled Nancy Bush Ellis. "He wasn't mean, but so correct." S.P. was, George H. W. Bush remembered, "respected"—a key attribute in the Bush ethos.

S.P. and Flora Sheldon Bush had a son, Prescott Sheldon Bush,

The young George H. W. Bush, known as "Poppy," grew up in great privilege. (Chapter opening: In his Greenwich Country Day School uniform.) He spent every summer of his childhood in Kennebunkport, Maine (left), a seaside town popular with prosperous eastern and midwestern Americans who retreated there for the cooler temperatures. Known as Walker's Point, the compound was Bush's maternal grandfather's domain. A competitive man, George Herbert Walker insisted on a bracing culture of contest, whether the sport was tennis, golf, boating, swimming—or tiddlywinks. As president, George H. W. Bush would invite world leaders to the Point and manage global crises from the stone porch and the family's cavernous living room.

Bush's paternal great-grandfather, James Smith Bush, was a Yale-educated Episcopal clergyman who left the Church and his traditional Christian faith to become a noted figure in Unitarian circles centered in Ralph Waldo Emerson's Concord, Massachusetts.

in 1895. A skilled golfer, Prescott attended St. George's School and was a successful Yale man, graduating in 1917. In 1918 he served in France as an army artillery captain before returning to go into business, first with Simmons Hardware Company in St. Louis. The move back to the Midwest after a childhood in Columbus was fortuitous, if not for his long-term professional prospects—Prescott would eventually make his mark in the East, in investment banking—then for his personal ones.

For it was in St. Louis that he met Dorothy Wear Walker—"Dotty" to her intimates—the daughter of a big, blustery investment banker named George Herbert Walker. "He was a flamboyant fellow, a boxer," George H. W. Bush recalled of his maternal grandfather. "A lot of people were scared of him, as we were." "He was a real son of a bitch. He would take his four sons down to the basement and box with them," recalled a grandson. "And he pulled no punches." Dotty, a skilled sportswoman, escaped the harsh treatment the old man meted out to his sons. But competition was a constant, and Dorothy inherited her father's toughness while eschewing his buccaneer style.

Known as "Bert," "Pop," and sometimes as "G.H.," Walker made and lost fortunes over the course of a tumultuous life that stretched from Hortense Place in St. Louis to Walker's Point in Kennebunkport to a quail-hunting plantation in South Carolina to a western estate in Santa Barbara. He came from a family as old as the Bushes. The Walkers had arrived in America in the seventeenth century and made their way to Maryland, where they settled along the Chesapeake on a river known as the Sassafras. There, in Cecil County, Maryland, Walker ancestors owned enslaved people and raised cotton.

His grandparents, George and Harriet Walker, lost the land in Maryland in the 1830s and went west, to Illinois, where their son David Davis Walker was born in 1840. The child was named for a kinsman, the future United States Supreme Court justice David

Davis, a political ally of Abraham Lincoln's. By 1857, "D.D." was in the dry-goods business in St. Louis, where he married a Roman Catholic, Martha Beaky. George Herbert Walker was one of their six children.

Born in 1875, "Bert" was sent to a Jesuit boarding school in England but abandoned Catholicism in order to marry Loulie Wear, a Presbyterian. After founding G. H. Walker & Company, an early investment banking business, in 1900, Walker came east to run the Harriman family of New York's investment arm in 1920. The next year, Dorothy married Prescott Bush at St. Ann's Church in Kennebunkport.

Prescott's business connections took them to Kingsport, Tennessee; St. Louis, Missouri; Columbus, Ohio; and then Milton, Massachusetts, where they moved into a Victorian house at 173 Adams Street. It was here that their second child was born on Thursday, June 12, 1924. Their first, born in 1922, had been named Prescott Jr.; this son would be named for Dorothy's father: George Herbert Walker Bush, called "Poppy," or "Little Pop," since his grandfather G.H. was "Pop."

The stay in Milton was brief; Prescott soon moved the family to Greenwich, Connecticut. From there he would commute to his offices at the investment firm of Brown Brothers Harriman. A director of the CBS television network and the insurance giant Prudential, Prescott Bush also served as moderator of the Greenwich town meeting. "Others would climb off the club car coming out from New York whining about how they wanted to get home for a drink and he'd go off to the town meeting and preside," recalled George H. W. Bush.

After Prescott Jr. and George, Dorothy and Prescott Bush had three other children: Nancy (born 1926),

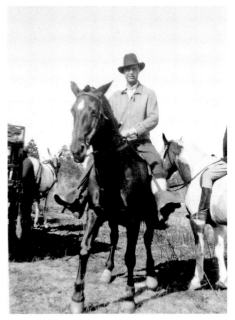

After Prescott Bush married Dorothy Walker in 1921 and the family began to grow, the Bushes occasionally spent Christmases at G. H. Walker's Duncannon property in South Carolina. There was quail hunting on horseback—and the men wore black tie at dinner.

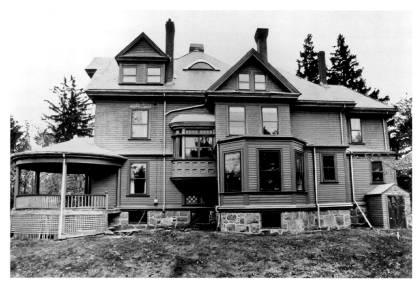

The Victorian house at 173 Adams Street in Milton, Massachusetts, where George Herbert Walker Bush was born on Thursday, June 12, 1924. He was the family's second child, after the birth of Prescott Sheldon Bush, Jr., in 1922.

Jonathan (born 1931), and William "Bucky" (born 1938). "Every mother has her own style," George H. W. Bush recalled. "My Mother's was a little like an Army drill sergeant's. Dad was the Commanding General, make no mistake about that, but Mother was the guy out there day in and day out shaping up the troops." She would play tennis until her blistered feet bled; a family story had a heavily pregnant Dorothy once hitting a home run in a softball game, rounding the bases, and leaving the field to deliver the baby.

Dorothy's orders often came in sporting terms. "She loved games and thought that competition taught courage, fair play, and—I think most importantly—teamwork," George H. W. Bush recalled. "She taught games to us endlessly. We learned from her everything we knew—solitaire, bridge, anagrams, Scrabble, charades, golf, swimming, baseball, tennis—you name it. She is still family champ in tiddlywinks." Moreover, Mrs. Bush "also tamed our arrogance," Bush recalled. "I'll never forget, years ago, saying rather innocently [that] I thought I was 'off my game.' Mother jumped all over me. 'You are just learning! You don't have a game!' The result: arrogance factor—down; determination to get a 'game'—up!"

GREENWICH COUNTRY DAY School was a new institution in the mid-1920s. "We are interested in the individual development of every member of the School," the school's first headmaster wrote, "and we cannot afford to develop in any boy a false sense of either superiority or inferiority." Students were graded on an unusual standard: "Claims More Than His Fair Share of Attention."

As their son prepared to graduate from GCDS in 1937, Bush's parents filled out a questionnaire from his next school, Phillips Academy in Andover, Massachusetts. Dorothy and Prescott referred to their second son not as "Poppy" or "George" but as "Walker" on the form—a detail that surprised the forty-first president when he was shown the document late in life. "Walker has always been a good healthy boy," the Bushes wrote. "At present he is having his teeth straightened. He has no other present physical weaknesses or disabilities although he is apparently growing rapidly and hasn't gotten quite the strength he should have for his size. . . . [He also has] a tendency to overdo and get tired, at times beyond a reasonable point."

The Bushes wrote: "He has plenty of initiative and determination. He may be a trifle too intense and has somewhat of a temper, which . . . we see much more of at home than has been seen at his school. . . . He has a good sense of humor. He is exceedingly sensitive and very considerate of the feelings of other people in all walks of life." The form continued:

SOCIAL CHARACTERISTICS

I believe Walker has been very popular at school and gets along easily with boys, and with older people as well.

PERSONAL HABITS

His record at GCD was very good for neatness and punctuality although we have noticed at home he is less neat than we consider desirable and hope that [Andover] will improve him in that respect. He is a good hard worker. He does not smoke.

SPECIAL INTERESTS

Walker likes all games and played both football and baseball at GCD, being on the first team in both sports. . . . [H]e has not shown the special interest in reading that we should like to see but he likes shop work and does things well with his hands. He has recently taken quite an interest in photography with a small camera.

SCHOLARSHIP

Apparently he learns easily and rapidly. His marks at GCD were always quite satisfactory and he was frequently on the honor roll. He seems to take pride in standing well in his class.

FUTURE PLANS

He hopes to go to Yale but beyond that has no definite profession or career picked out for himself.

SPECIAL NEEDS OR SUGGESTIONS

Plenty of sleep, as he gets so intense over everything he undertakes[,] lessons as well as sports.

HIS TEACHERS AT Andover, where Bush attended boarding school from 1937 to 1942, would see this intensity firsthand. "Markedly a gentleman," Bush's evaluating teacher wrote of him. "Markedly reliable. Not easily led. Decidedly a good investment. . . . Courteous, cooperative. Able to do better than he has done. Should do better in his studies. Has not made marked progress, but is a desirable boy."

Illness shaped him, too. In the spring of 1940 Bush suffered a staph infection and had to be pulled out of school and sent to Boston's Massachusetts General Hospital. "Not a strong boy," a teacher wrote of Bush that year. "Serious illness. Nice boy, popular, friendly, gets on well with adults, very polite. Slow but a hard worker. Illness put him at a great disadvantage this year. Can analyze well [but] is

slow in doing it. . . . Ambitious and self-confident but perhaps not self-assertive enough. Real interests are athletics. . . . Always a gentleman, responsible, courteous, generous. WATCH: should not attempt too much outside work this year. Not a neat boy."

But he was a popular boy—a *trusted* boy. One day a fellow student, Bruce Gelb, was being bullied.

"Leave the kid alone," came a voice—Bush's voice.

Spared, Gelb wondered who had saved him.

"That was Poppy Bush," a friend told him. "He's the greatest kid in the school."

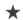

George Herbert Walker, known as "Pop" or "Bertie," was a larger-than-life character, a buccaneer financier, boxer, golfer, and domineering patriarch. Born a Roman Catholic, he fell in love with a St. Louis Presbyterian, Loulie Wear. Told by a priest that he would go straight to hell if he married her, he replied that he'd go to hell if he didn't. In that, as in many things, Walker had his way. An investment banker in St. Louis, he ultimately moved to New York. Walker's personal real estate holdings stretched from Sutton Place in New York City to Kennebunkport to South Carolina to Santa Barbara, California.

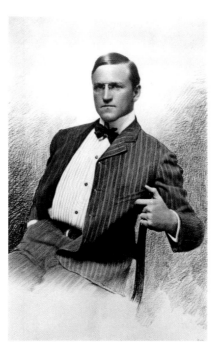

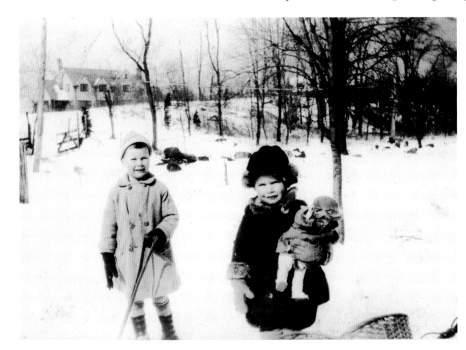

Poppy and Nancy Bush on a snowy day in Greenwich. Their childhood with Pres, Jon, and later, Bucky, was "beautiful," Nancy would recall.

Poppy in his earliest days.

Through the decades Bush loved to win but took care to camouflage his competitiveness. One Christmas his brother Bucky was given a handheld labyrinth game in which players were supposed to manipulate the board in order to maneuver a small marble into a hole at the end of a maze. Bucky shared it with Bush, who couldn't quite make it work.

The next morning, Bush asked for the game again. This time the older brother handled it brilliantly. "Wow, Pop, you're really good," Bucky said.

"Oh yeah," Bush replied, "I'm pretty good at this kind of thing." Later Bucky learned that Bush had secretly practiced late into the previous night. "That was Pop," Bucky recalled. "He adored competing but didn't want you to know he'd ever worked at it."

Late in life, Bush would reflect on the forces that drove him. "You have goals, and you want to meet them," he recalled, quickly adding: "Without letting it show through in everyday life." That was the key: Never let anyone think you were striving for success even as you strove for success. Such was the code of Grove Lane and Walker's Point.

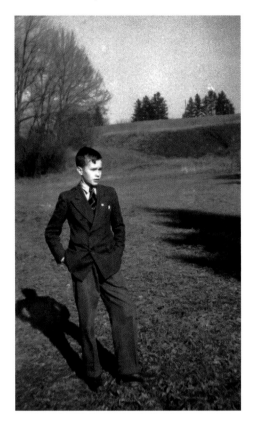

Bush, his sister, Nancy, recalled, was "the star of the family." Their brother Prescott, or Pressy, had injured his eye in a childhood mishap, an accident that made sports difficult for the eldest son. Poppy Bush stepped into that breach, becoming a strong athlete, a good student, and the most gracious of competitors. Bush began his formal education at Greenwich Country Day School, where he was popular with classmates and faculty alike. "How well I can recall—and see you to this day—running for a touchdown against Harvey . . . those ear flops flapping in the wind!" a teacher named Arthur Grant wrote Bush in the vice-presidential years. "How wonderful!"

There were black-and-orange uniform sweaters, mandatory Latin, ice hockey on the neighboring Rockefeller ponds in winter, sledding down the great hill behind the main school building, Gilbert and Sullivan musicals, pet shows in which a student could enter "anything from a mouse to a polar bear," and an absorbing, yearslong marbles tournament. "Very competitive," Bush recalled. "We played for agates." One fellow alumnus remembered the marbles competition as formative. "It was cutthroat," said the former student. "Wall Street moguls might have gotten their early trading experience by trading marbles at Country Day."

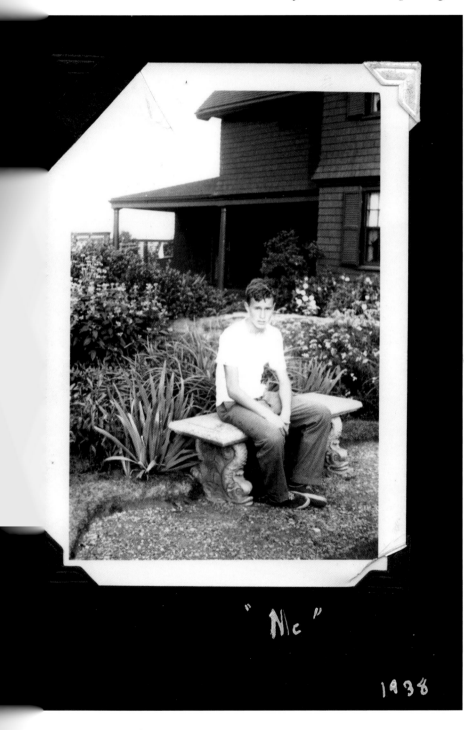

"Nc"

1938

A charming youngster, Bush had a quick wit. "George always was coordinated, even as a little guy," Prescott Jr. said in a 1988 interview with Fitzhugh Green, a family friend and biographer. As Green observed, "In his siblings' eyes George Bush was a happy, generous and loving brother."

He was warm and also witty. "He had a good pair of eyes, good hands, natural reactions, and he caught and hit the ball well," Prescott Jr. recalled. "He's always been quick and bright. I used to get so furious I'd want to pound him when we were kids. He was smart and a terrible tease."

Poppy would stand outside the living room of the family's house on Grove Lane in Greenwich while Nancy practiced her piano. He would, Nancy recalled, "jeer the tune. I would run to Mother and say, 'Mother, he's attacking my Bach!' She would say, 'Oh, dear, don't worry. He doesn't mean to tease you—not much.'"

Bush always remembered his elementary school's Latin classes ("which I kind of liked, actually," he recalled), but was more engaged by team efforts, be it soccer or singing. "I wasn't a very good student, kind of middle rank," Bush recalled. "I loved team sports. Loved them all. Even Glee Club—other people singing."

Founded in 1778 by Samuel Phillips, Jr., Phillips Academy Andover, where Bush matriculated in 1937, was a product of Puritan New England. One of the institution's tasks, Phillips had said, was to teach "the fall of Man—the Depravity of Human Nature—the Necessity of Atonement." E. Digby Baltzell, the University of Pennsylvania sociologist who played a key role in making the term "WASP" a familiar one (his works include 1964's *The Protestant Establishment: Aristocracy and Caste in America*) listed Andover as one of the sixteen American schools that "serve the sociological function of differentiating the upper classes from the rest of the population." With Andover, the truth is slightly more complicated, for the school from its beginnings sought, albeit in a relative way, to educate, in the school's phrase, "youth from every quarter." In a *Saturday Evening Post* piece on the school, headmaster Claude M. Fuess took on the image of a boarding school as hopelessly insular and elitist and was quoted listing his "seven deadly sins of independent schools": snobbishness, bigotry, provincialism, reaction, smugness, stupidity, and inertia. "During a fortnight's visit to the school, we saw few, if any, indications of the seven sins cited by Dr. Fuess," the magazine reported.

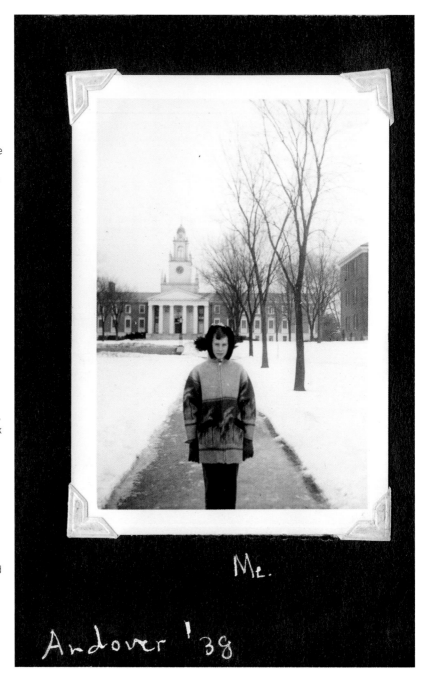

Me.

Andover '38

The Library

'38

Armillery Sphere.

Cricket and the Book of Common Prayer were features of life at Groton and other New England institutions modeled on Eton, the fabled English school in the shadow of Windsor Castle. Bush's Andover, however, sought to be more democratic and more Puritan than elitist and Anglican. Groton's Latin motto translated as "To serve Him is to rule"; Andover's as "Not for Self." Bush was educated in a culture in which one was summoned to greatness in slightly less grandiose terms than he might have heard at another, more Victorian school. That he had grown up in a largely Victorian household while being exposed to a more modern tone at Andover had an important layering effect, giving him the most traditional of foundations as well as introducing him to some boys who had not grown up in privileged circumstances in Greenwich.

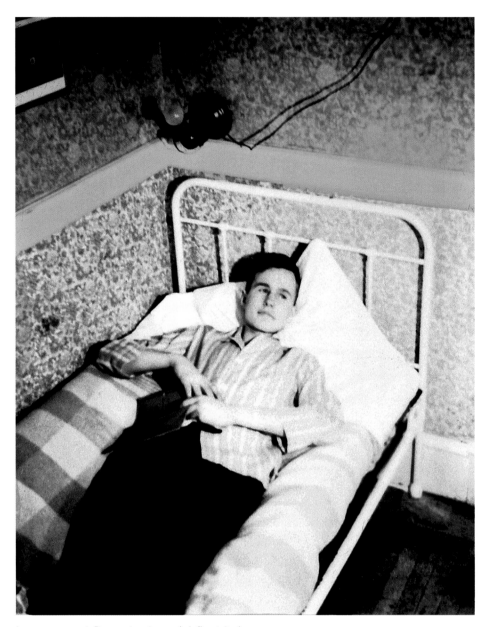

In a rare moment, Poppy at rest, even briefly, at Andover.

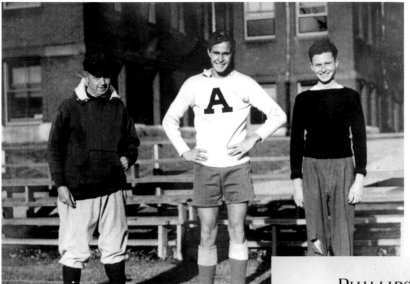

Among other sports, Bush loved soccer, carrying on at Andover the affection for team efforts that he had developed at Greenwich Country Day. Such contests met his mother's test: Avoid, at all reasonable cost, an obsession with the "Great I Am."

PHILLIPS ACADEMY
ANDOVER, MASSACHUSETTS

THE ATHLETIC ASSOCIATION ADVISORY BOARD AWARDS THE

Basket-Ball **A** TEAM OF 19**42**
TO

G. H. W. Bush

Robert A. Furman
CAPTAIN

Ernest D. Obermeyer
MANAGER

Ray A. Shepard.
CHAIRMAN ATHLETIC ADVISORY BOARD

Bob Flato
SECRETARY ATHLETIC ADVISORY BOARD

PHILLIPS ACADEMY
ANDOVER, MASSACHUSETTS

THE ATHLETIC ASSOCIATION ADVISORY BOARD AWARDS THE

Base-Ball **A** TEAM OF 19**42**
TO

G. H. W. Bush, Captain

George Walker Bush
CAPTAIN

P. C. Welch
MANAGER

Ray A. Shepard.
CHAIRMAN ATHLETIC ADVISORY BOARD

Bob Flato
SECRETARY ATHLETIC ADVISORY BOARD

Bush finished Andover with many athletic laurels, but the road had not been without difficulty. He'd started school young—just thirteen—and had been forced to withdraw from Andover in the spring of 1940 after checking into the infirmary five times during the 1939–40 school year, missing thirteen days of classes. He had tried to do too much, too fast, going out for baseball when he was still ill. As his academic rank fell, he contracted a staph infection serious enough for his parents to withdraw him from school on Saturday, April 13, 1940, and take him for treatment at Massachusetts General. He'd spend a large part of his life overstretched, hungry to keep moving, to stay in the game, to hit the next mark. But the success would come at a price.

Baseball would prove to be Bush's favorite youthful sport. He played first base at Andover and later at Yale. Bush appreciated the grace of the sport, and its interweaving of individual and team performance—both were vital—appealed to his complex view of life, one in which the self should be pushed to excel but in the interest of a common mission, not just for personal glory. He would have agreed with the future president of Yale and baseball commissioner A. Bartlett Giamatti, who wrote of the game: "Baseball is part of America's plot, part of America's mysterious, underlying design—the plot in which we all conspire and collude, the plot of the story of our national life. Our national plot is to be free enough to consent to an order that will enhance and compound—as it constrains—our freedom. That is our grounding, our national story, the tale America tells the world. Indeed, it is the story we tell ourselves." And it is an adventure: "In baseball, the journey begins at home, negotiates the twists and turns at first, and often founders far out at the edges of the ordered world at rocky second— the farthest point from home. . . . If baseball is a narrative, an epic of exile and return, a vast, communal poem about separation, loss, and the hope for reunion—if baseball is a Romance Epic—it is finally told by the audience. It is the Romance Epic of homecoming America sings to itself." And it was an epic that George H. W. Bush loved to sing.

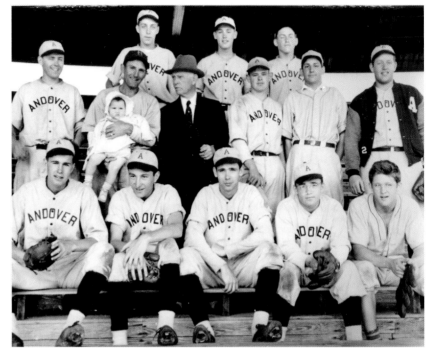

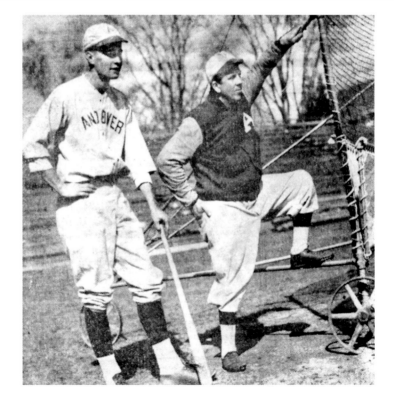

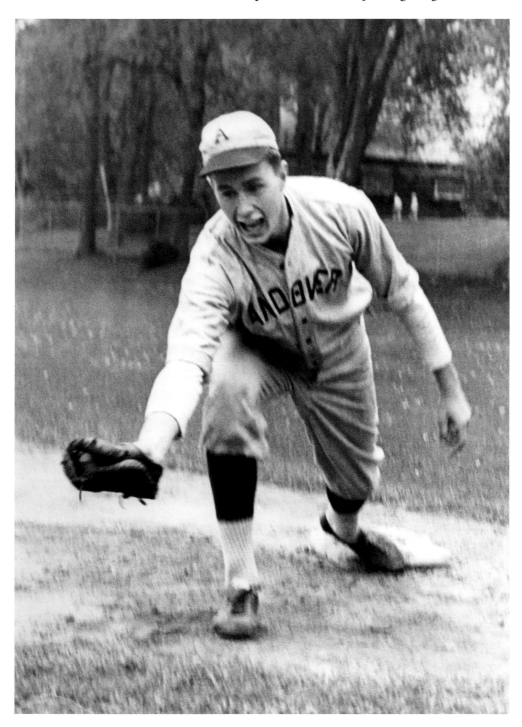

Bush's Andover transcript as he headed toward graduation in June 1942. Because of illness, he had a somewhat up-and-down academic career in prep school. In a report to Yale, Andover described Bush this way: "He is very much of a gentleman, is thoroughly honest, has a high sense of cooperation, and is very responsive to suggestion. He tries hard to do a good job, is intellectually honest, and disciplines himself well and with ease. . . . There is little evidence that he is greatly interested in any of his studies, but he works conscientiously and regularly. . . . A first-rate individual in every respect, and highly recommended."

After Pearl Harbor, Bush was determined to join World War II as soon as he conceivably could. On the day of his high school graduation—which was also his eighteenth birthday—George H. W. Bush enlisted in the U.S. Navy. "After Pearl Harbor, it was a different world altogether," he remembered. "If the government fails, we will fail," the student newspaper had written, "and likewise if we fail in our duty at the present time we jeopardize the steadfastness of the government's cause." It was, the paper declared, "a desperate life and death struggle."

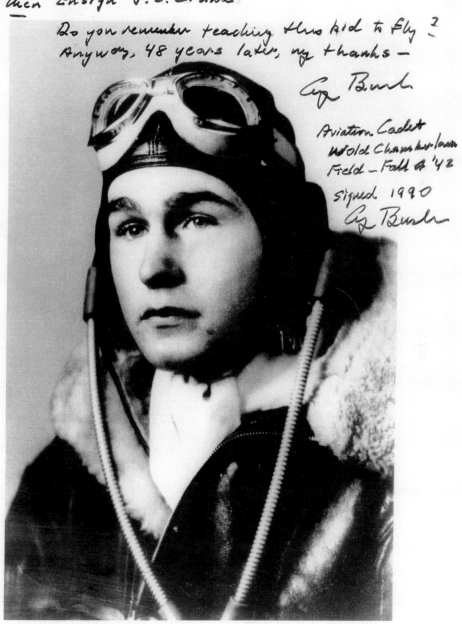

To then Ensign J.C. Crowe.

Do you remember teaching this kid to fly?
Anyway, 48 years later, my thanks —

Gge Bush

Aviation Cadet
Wold Chamberlain
Field — Fall of '42

Signed 1990

Gge Bush

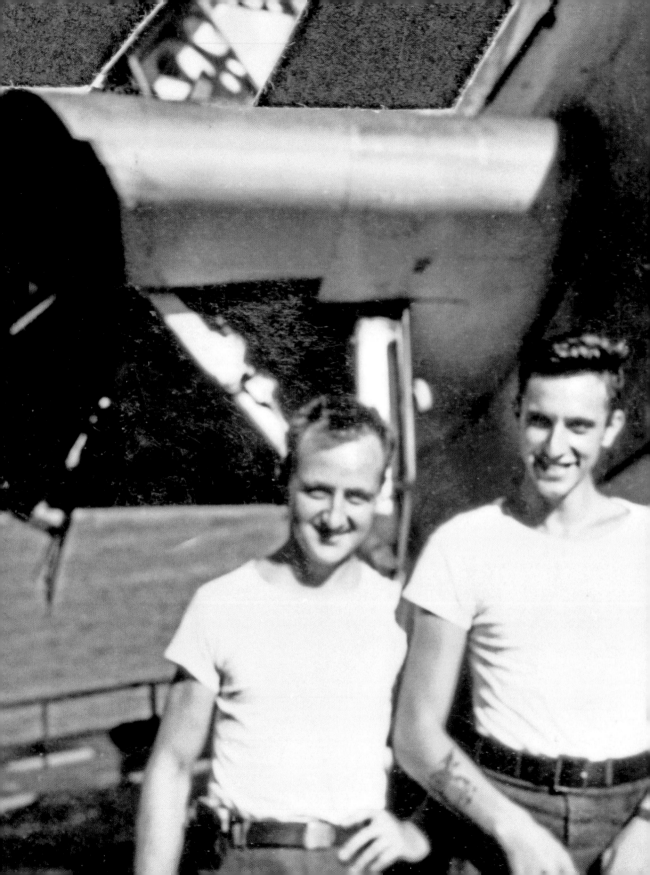

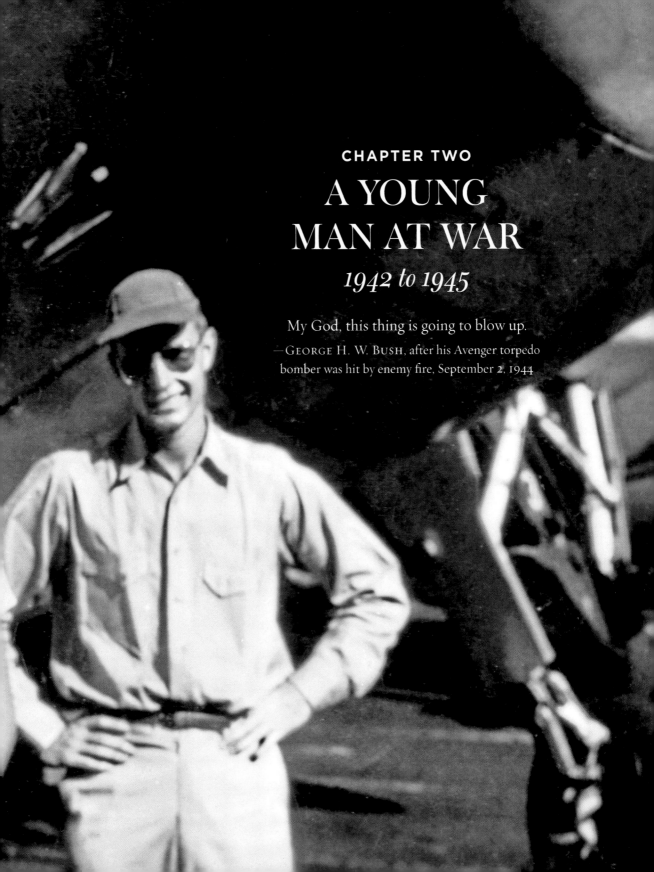

CHAPTER TWO

A YOUNG MAN AT WAR

1942 to 1945

My God, this thing is going to blow up.
—GEORGE H. W. BUSH, after his Avenger torpedo
bomber was hit by enemy fire, September 2, 1944

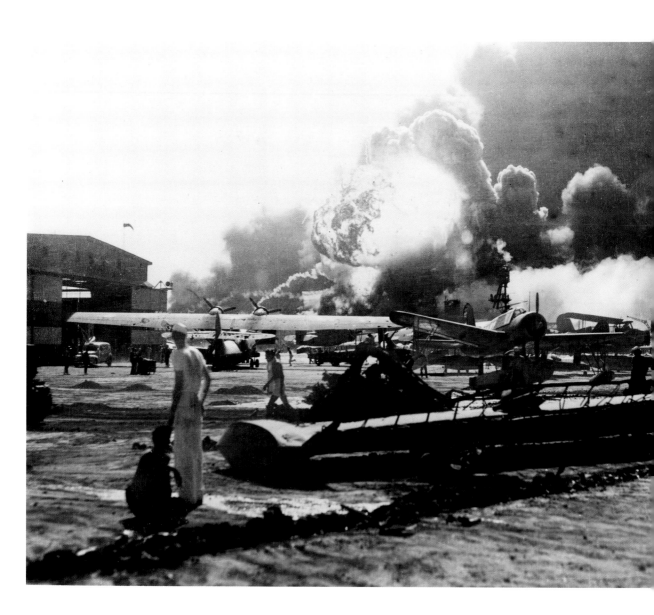

THE NEWS CAME between two and three o'clock in the afternoon. It was Sunday, December 7, 1941, and Poppy Bush was walking past Cochran Chapel on the Andover campus when word reached him that the Japanese had attacked Pearl Harbor. "My God," Bush recalled thinking at the time. "This changes everything." The enormity of the event was clear. "After Pearl Harbor, it was a different world altogether," Bush recalled. "It was a red white and blue thing. Your country's attacked, you'd better get in there and try to help."

In an address to Congress on Monday, December 8, 1941, President Roosevelt predicted triumph—but not immediately, and only after much sacrifice. "No matter how long it may take us to overcome this premeditated invasion, the American people in their righteous might will win through to absolute victory," the president said. "Hostilities exist. There is no blinking at the fact that our people, our territory, and our interests are in grave danger."

Bush was ready to join the fight. "What I wanted to do was to go in, serve, become a pilot," he recalled. "I just wanted to be part of it. I even considered going into the Royal Canadian air force.... You could get through much faster and become a pilot." He chose the U.S. Navy's aviation program instead. "I knew what I wanted to do," he recalled. "It was an easy call—no second-guessing, no doubts." His father once asked him if he was certain he should go straight in after high school—many of his peers were getting a bit of college in preparation for a long war—and he said he was. "By the time he mentioned it, I was pretty far gone and he never tried to talk me out of what I wanted to do," Bush recalled.

Andover's 1942 commencement fell on Bush's eighteenth birthday—Friday, June 12. The iconic Andover man Secretary of War Henry L. Stimson took the occasion to make a few remarks to the graduates. Two years before, at the 1940 ceremonies, Stimson had spoken out against isolationism. "Today our world is con-

Sunday, December 7, 1941, was, as President Roosevelt told Congress and the nation, a "date which will live in infamy." The Japanese attack on Pearl Harbor brought America into the global struggle against fascism; later that week, Nazi Germany's declaration of war on the United States meant years of titanic fighting were at hand both in the Pacific and in Europe. "Everybody had to do their part," George H. W. Bush recalled. "You just did it." And his duty was clear. Joining the navy in Boston on the day of his Andover graduation, he signed up for flight training. Chapter-opening spread: Bush with Joe Reichert and Leo W. Nadeau.

World War II was inarguably one of the largest events in human history. It began in the 1930s with conventional weapons and tactics that grew out of the experience of the Great War of 1914–18 and would end, in 1945, with the development and deployment of atomic weapons of previously unimaginable destructive power. As Bush would note, he was part of a generation for whom life was now characterized by a sense of "heightened awareness"— a sense that history was moving rapidly as the nature of reality itself was changing. Under giants such as FDR, Winston Churchill, Dwight D. Eisenhower, George C. Marshall, and Douglas MacArthur, the young men of Bush's age were the means by which the forces of democracy took their stand against the depravations of dictatorships and the mechanizations of genocide. After December 1941, there was a moral clarity about World War II. In Eisenhower's phrase, the whole Allied struggle was a "Great Crusade." It was not a sentimental one, for the toll was so tragically high, but the war pitted light against dark, and good against evil, in an unmistakable way.

fronted by the clearest issue between right and wrong which has ever been presented to it on the scale in which we face it today," Stimson had said. "The world today cannot endure permanently half slave and half free." Now, with America fully in the war, Bush recalled Stimson's talking about "how the American soldier should be brave without being brutal, self-reliant without boasting, becoming a part of irresistible might without losing faith in individual liberty."

After commencement he went to Boston to be sworn into the navy. Orders for Bush, officially a seaman second class, to report to Chapel Hill, North Carolina, arrived on Wednesday, July 22, 1942; he was assigned to the Sixth Battalion, Company K, Second Platoon.

His father saw him off. They walked together into Pennsylvania Station. It was the first time Bush had ever seen his father cry. "So off I went," Bush recalled, "scared little guy."

HE HAD A visitor one day in Chapel Hill—Barbara Pierce, of Rye, New York, whom Bush had met at a Christmas dance in Greenwich in the weeks after Pearl Harbor. She was, he said later, "a strikingly beautiful girl." Their romance moved quickly; he kissed her on the cheek "in front of the world" after his prom at Andover the next spring. "I floated into my room," Barbara recalled, "and kept the poor girl I was rooming with awake all night while I made her listen to how Poppy Bush was the greatest living human on the face of the earth."

To Bush, the war years were a time of "heightened awareness," the sense that everything mattered, that life was to be lived, in Bush's phrase, "on the edge." At ages nineteen (Poppy) and eighteen (Barbara), they were engaged at Walker's Point; the news was published in the New York newspapers on Sunday, December 12, 1943. "I love you, precious, with all my heart and to know that you love me means my life," Bush wrote Barbara that day, continuing:

> *How often I have thought about the immeasurable joy that will be ours some day. How lucky our children will be to have a mother like you—*

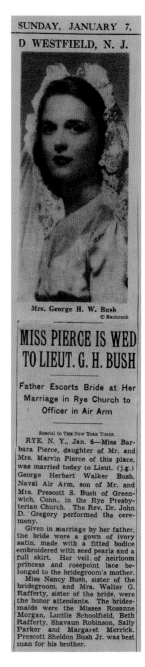

SUNDAY, JANUARY 7,
D WESTFIELD, N. J.

Mrs. George H. W. Bush
© Bachrach

MISS PIERCE IS WED TO LIEUT. G. H. BUSH

Father Escorts Bride at Her Marriage in Rye Church to Officer in Air Arm

Special to THE NEW YORK TIMES.

RYE, N. Y., Jan. 6—Miss Barbara Pierce, daughter of Mr. and Mrs. Marvin Pierce of this place, was married today to Lieut. (j.g.) George Herbert Walker Bush, Naval Air Arm, son of Mr. and Mrs. Prescott S. Bush of Greenwich, Conn., in the Rye Presbyterian Church. The Rev. Dr. John D. Gregory performed the ceremony.

Given in marriage by her father, the bride wore a gown of ivory satin, made with a fitted bodice embroidered with seed pearls and a full skirt. Her veil, of heirloom princess and rosepoint lace belonged to the bridegroom's mother.

Miss Nancy Bush, sister of the bridegroom, and Mrs. Walter G. Rafferty, sister of the bride, were the honor attendants. The bridesmaids were the Misses Rosanne Morgan, Lucille Schoolfield, Beth Rafferty, Shavaun Robinson, Sally Parker and Margaret Merrick. Prescott Sheldon Bush Jr. was best man for his brother.

Bush was trained to fly the single-engine Avenger torpedo bomber, built by Grumman Aircraft Engineering Corporation and General Motors. The plane had seen some action at Midway in 1942 and became a more central player by the time of the Battle of Guadalcanal later that year. Stateside, after Bush flew his first successful solo training flight, he wrote his mother. "Off I zoomed," Bush reported in the fall of 1942. "Everything seemed so free and easy and really wonderful. Mum, it was the first time I have climbed out of the plane without worrying or having a touch of discouragement."

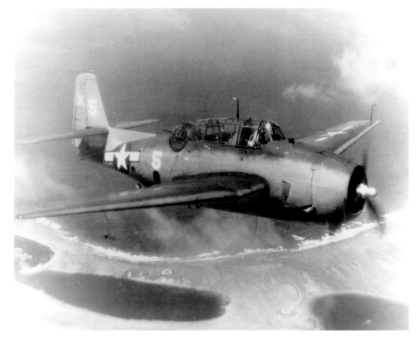

As the days go by the time of our departure draws nearer. For a long time I had anxiously looked forward to the day when we would go aboard and set to sea. It seemed that obtaining that goal would be all I could desire for some time, but, Bar, you have changed all that. I cannot say that I do not want to go—for that would be a lie. We have been working for a long time with a single purpose in mind, to be so equipped that we could meet and defeat our enemy. I do want to go because it is my part, but now leaving presents itself not as an adventure but as a job which I hope will be over before long. Even now, with a good while between us and the sea, I am thinking of getting back. This may sound melodramatic, but if it does it is only my inadequacy to say what I mean. Bar, you have made my life full of everything I could ever dream of—my complete happiness should be a token of my love for you. . . .

I'll tell you all about the latest flying developments later. We have so much to do and so little time to do it in. It is frightening at times. The seriousness of this thing is beginning to strike home. . . .

Goodnite, my beautiful. Everytime I say beautiful you about kill me but you'll have to accept it—

Saturday, September 2, 1944, was the day that he would think of for the rest of his life. Lieutenant junior grade George Herbert Walker Bush, a torpedo bomber pilot flying off the USS *San Jacinto,* was assigned a combat mission to take out a radio tower on the peak of Mount Yoake on Chichi-Jima in the Bonin Islands. He was joined by a gunnery officer, William G. "Ted" White, and a radioman, John "Del" Delaney. They joked about whether they'd have to bail out.

Here is how he told the story to his parents in a letter afterward:

Bush was introduced to the Avenger in Fort Lauderdale, Florida, in 1943, where he practiced bombing runs over Lake Okeechobee. The Avenger was forty feet long, sixteen feet high, and had a fifty-two-foot wingspan. Bush then rehearsed carrier landings on the USS *Sable* in Lake Michigan. He served in the VT-51 squadron over the next year and was assigned to VT-153 in 1945 in advance of the prospective final assault on Japan—an undertaking rendered moot after President Truman ordered the atomic attacks on Hiroshima and Nagasaki.

Yesterday was a day which will long stand in my memory. I was on a bombing hop with Delaney as my radioman and Lt. (j.g.) Ted White as my gunner. He did not usually fly, but I asked him if he would like to go with me and he wanted to. We had the usual joking around in the ready room about having to bail out etc.—at that time it all seemed so friendly and innocent but now it seems awful and sinister.

I will have to skip all the details of the attack as they would not pass the censorship, but the fact remains that we got hit. The cockpit filled with smoke and I told the boys in back to get their parachutes on. They didn't answer at all, but I looked around and couldn't see Ted in the turret so I assumed he had gone below to get his chute fastened on. I headed the plane out to sea and put on the throttle so as we could get away from the land as much as possible. I am not too clear about the next parts. I told them to bail out, and then I called up the skipper and told him I was bailing out. My crewmen never acknowledged either transmission, and yet the radio gear was working—at least mine was and unless they had been hit back there theirs should have been, as we had talked not long before. I heard the skipper say something but things were happening so fast that I don't quite remember what it was. I turned the plane up in an attitude so as to take pressure off the back hatch so the boys could get out. After that I straightened up and started to get out myself. At

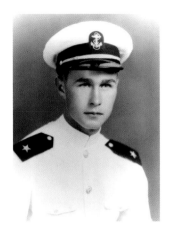

Bush's interest in the navy had begun with a visit to Fleet Week in New York in 1937, a trip that made a "real, profound impression"—so much so that he had briefly considered seeking appointment to the U.S. Naval Academy at Annapolis.

that time I felt certain that they had bailed out. The cockpit was full of smoke and I was choking from it. I glanced at the wings and noticed that they were on fire. I still do not know where we got hit and never will. I am now beginning to think that perhaps some of the fragments may have either killed the two in back, or possibly knocked out their communications.

Fortunately I had fastened all my straps before the dive and also I had left my hatch open, something I hadn't been doing before. Just the day before I had asked the skipper and he advised leaving it open in a dive. The jump itself wasn't too bad. I stuck my head out first and the old wind really blew me the rest of the way out. I do remember tugging at my radio cord which I had forgotten to unplug. As I left the plane my head struck the tail. I now have a cut head and bruised eye but it is far from serious. After jumping, I must have pulled the ripcord too soon for when I was floating down, I looked up at the canopy and several of the panels were all ripped out. Just as I got floating down, I saw the plane strike the water. In the meantime, I noticed there was a life raft down in the water. Not until later did I discover that it was mine that was supposed to be attached to my lifejacket. I had forgotten to hook it on, and when I left the plane it had come loose and had fallen into the water. Fortunately, the wind didn't carry me too far away from the raft. The entrance into the water was not too bad. I had unloosened several of my chute straps so that when it came to getting out of the harness I wouldn't have too many buckles to undo under the water. I went fairly deep under when I hit, but not deep enough to notice any pressure or anything. I shook the harness and the wind carried the chute away on the water. The wind was blowing towards shore, so I made every effort to head the other way. The skipper saw me and he saw my raft, so he made a pass over it to point it out to me. . . . Fortunately, the fall hadn't injured the boat, so it inflated easily and I struggled into it. I then realized that I had overexerted myself swimming, because suddenly I felt quite tired. I was still afraid that the wind would take me in closer so I began paddling. It was a hell of a job to keep the water out of the raft. In fact I never did get it bailed out completely. At first I was scared that perhaps a boat would put out from the shore which was very close by, but I guess our planes made them think twice about that. A few fighter planes stayed nearby the whole time until I was rescued and you can imagine how comfortable that was. One of them came right over me and dropped me some

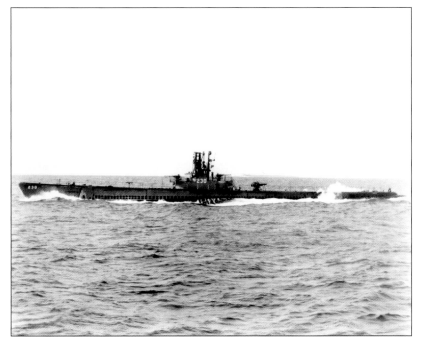

The USS *Finback,* the submarine that rescued Bush from the waters off Chichi-Jima on Saturday, September 2, 1944.

medical supplies which were most welcome, since I had no idea how badly cut up I was. It turned out to be slight, but did use the iodine anyway. I had some dye marker attached to my life jacket and also there was some in the raft so I sprinkled a bit of that on the water so the planes could see me easily. I took inventory of my supplies and discovered that I had no water. The water had broken open when the raft fell from the plane I imagine. I had a mirror and some other equipment, and also was wearing my own gun and knife. . . .

I floated around for a couple of hours during which time I was violently sick to my stomach, and then the planes started zooming me, pointing out my position to my rescuers. You can imagine how happy I was when I saw this submarine hove into view. They pulled me out of the raft and took me below where they fixed me up in grand style. As I write this I am aboard the sub— don't know how long I will be here, or when I will get back to the squadron.

much much love to you all,
your ever devoted and loving son,
Pop

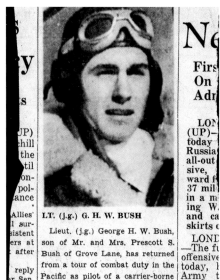

LT. (j.g.) G. H. W. BUSH

Lieut. (j.g.) George H. W. Bush, son of Mr. and Mrs. Prescott S. Bush of Grove Lane, has returned from a tour of combat duty in the Pacific as pilot of a carrier-borne Avenger torpedo-bomber in the Navy's Air Group 51.

Most recent engagement in which Lieut. Bush and the air group participated was the Second Battle of the Philippines when

"We live by the day—a wholesome life, at times seemingly futile, but looking at it philosophically, I wouldn't change positions with any fellow in civilian life," Bush wrote his sister, Nancy, from training in Chapel Hill, North Carolina, in 1942. "The Navy itself is great, but what we are here for is even greater, and if at all times I can keep my objective in view I am hopeful of a successful conclusion to this one year [flight] course. . . . I'm afraid if I fail for any reason my disappointment will be very deep. I am proud to be here, Nance, and as I said before wouldn't change for the world."

The loss of White and Delaney stayed with him until his last day. "It worries me—it terrifies me," Bush said decades later, reflecting on the proposition that he could have done something differently, something that would have ensured their survival on that desperate Saturday in September 1944.

By every measure Bush had handled the crisis correctly, but that was only partly consoling. "My mother and dad had drilled into us the lesson that we were never to let anyone down, and here I was, alive while they were gone," Bush recalled. "Their families . . ." He stopped, tearing up. "I wondered—wonder still—whether I did all I could. Could I have made a water landing? But I couldn't have—we were too damaged. I know I did the right thing, telling everyone to bail out. But that doesn't make the suffering of the other families any less."

Aboard the *Finback,* Bush wrote his parents: "I try to think about it as little as possible, yet I cannot get the thought of those two boys out of my mind." Late in life, he recalled: "It was transforming. Transforming in the sense that you realize how close death can be. You realize, painstakingly so, the responsibility you had for the life of somebody else. . . . All of a sudden you realize what life and death are about."

Eligible to return stateside for shore duty, he refused to leave the Pacific theater. "I didn't want to go home," Bush recalled. "I wanted to finish my mission. It never occurred to me not to rejoin the unit, get back in the fight, back in the air."

He was awarded the Distinguished Flying Cross for the mission. "I finished the bombing run, which was no 'heroic' thing," he said late in life. "They wrote it up as heroism, but it wasn't—it was just doing your job."

THE WEDDING HAD been scheduled for December 1944, but the exigencies of war kept Bush in transit past the planned date. He finally reached the East Coast on Christmas Eve, calling Barbara

from New York City as he made his way out to Greenwich. "There were tears, laughs, hugs, joy, the love and warmth of family," Bush recalled. Then, on Saturday, January 6, 1945, on an icy day in Rye, George Bush and Barbara Pierce were married in the Pierces' Presbyterian church.

They were stationed in the Lewiston-Auburn area of Maine when the news broke of FDR's death in Warm Springs, Georgia, on Thursday, April 12. "I remember crying, I remember weeping, even though I had not been raised in a pro-Roosevelt household by a long shot," Bush recalled. "We were sick," Barbara recalled. "Neither of us had ever voted—we were too young—and we probably would have voted for the other fellow, but Roosevelt was our President, the Commander-in-Chief of a country at war, and we joined the world in mourning. We felt truly lost, very young and alone."

Bush was supposed to sail out to take part in the invasion of mainland Japan. "Everything I'd experienced in my year and a half of combat in the Pacific told me it was going to be the bloodiest, most prolonged battle of the war," Bush recalled. "Japan's war leaders were unfazed by massive raids on Tokyo. They seemed bent on national suicide, regardless of the cost in human life."

In August 1945, word of the American atomic attacks on Hiroshima and Nagasaki arrived when the Bushes were stationed at Naval Air Station Oceana in Virginia Beach, Virginia. On the evening of Saturday, September 1, President Truman announced Japan's unconditional surrender. "Within minutes," Bush recalled, "our neighborhood streets were filled with sailors, aviators, their wives and families celebrating late into the night."

He was so young, and yet had seen—and done—so much. "I'll always wonder, 'Why me? Why was I spared?'" Bush recalled. He would spend the rest of his life striving to prove that he was worthy of his reprieve.

IT WAS TIME for the delayed college education. And he loved Yale, where he matriculated in early 1946. But of course George H. W. Bush would. Here he was, married to the perfect girl, home

Yale was a national emblem of elite education, a university famed for its teaching, its athletics, and its special place in America's social hierarchy.

safe from war, surrounded by friends and friends-to-be, interested in his studies (economics and sociology), and playing first base on the university's baseball team. "I remember working far harder at Yale than I would have if I hadn't been in the service and gotten married," Bush told the *Yale Daily News* forty years after he graduated. "I went through Yale in two and one half years—driven by the fact that I wanted to get out and support my little family." He graduated Phi Beta Kappa, played in two College World Series, and was tapped by Skull and Bones, the elite secret senior society. And he had a son: On Saturday, July 6, 1946, Barbara gave birth to George Walker Bush.

As familiar as New Haven was—Bushes and Walkers had gone there for generations now—Bush was restless. He had a standing offer from his uncle Herbie Walker, a great fan of his, to work for G. H. Walker & Company in St. Louis. "I am not sure I want to capitalize completely on the benefits I received at birth—that is on

the benefits of my social position," Bush wrote a friend. "Doing well merely because I have had the opportunity to attend the same debut parties as some of my customers does not appeal to me."

Texas did appeal. The move there was suggested by Neil Mallon, a friend of Prescott Bush's. The young Bush should get out of the East, at least for a while, he advised, and try his hand in the oil business. There were fortunes to be made, and an element of the Bush code was that each generation should make its own mark. "Texas would be new and exciting for a while—hard on Bar perhaps—and heaven knows many girls would bitch like blazes about such a proposed move," Bush wrote. "Bar's different though. . . . She lives quite frankly for Georgie and myself. She is wholly unselfish, beautifully tolerant of my weaknesses and idiosyncrasies, and ready to faithfully follow any course I cho[o]se. . . . I have had a chance to make many shrewd moves in my young life, but when I married Bar I hit the proverbial jackpot."

Upon his graduation in the class of 1948, Bush got behind the wheel of a red Studebaker—a gift from his parents—and went west.

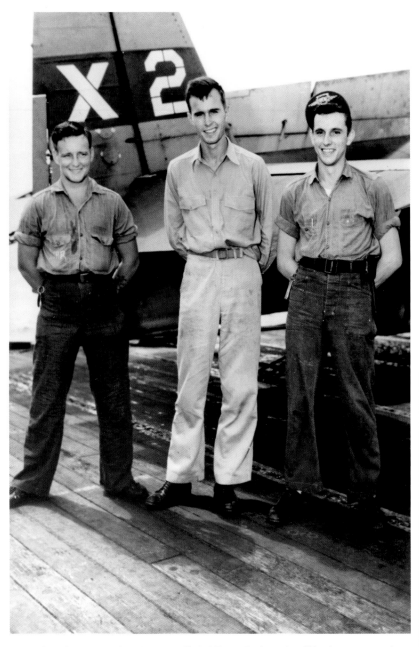

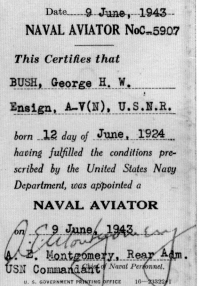

Bush with two crewmen—radioman Joe Reichert (left) and turret gunner Leo W. Nadeau (right). Two others—Ted White and John "Del" Delaney—would be flying with Bush when their Avenger was shot down over Chichi-Jima in September 1944. "It was the first time I'd been anyplace but the playing fields of Greenwich Country Day or Andover," Bush recalled. In a letter home from the war, he wrote: "I have gotten to know most of the fellows in the platoon. They are a darned good-hearted bunch. . . . There are so many different types here."

On Wednesday, June 9, 1943, in Corpus Christi, Texas, Bush received his wings as a naval aviator. "From what I can gather I will be the youngest flying officer (maybe officer) in the Navy," he wrote his mother. "I'm not proud of being young—but it's a fact so I've been told. The youngest in the Army is 19."

DEPARTMENT OF THE NAVY

Date___9 June, 1943__

NAVAL AVIATOR No C-5907

This Certifies that

BUSH, George H. W.____

Ensign, A-V(N), U.S.N.R.____

born 12 day of June, 1924

having fulfilled the conditions pre-scribed by the United States Navy Department, was appointed a

NAVAL AVIATOR

on 9 June, 1943

A. E. Montgomery, Rear Adm.

USN Commandant *Chief of Naval Personnel.*

U. S. GOVERNMENT PRINTING OFFICE 16—23322-1

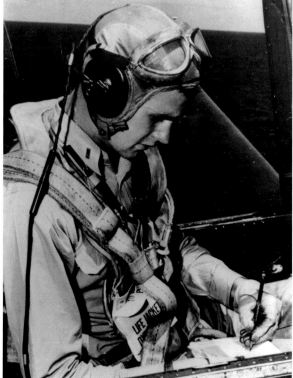

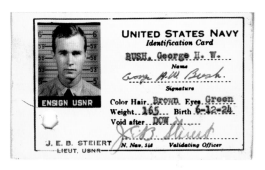

UNITED STATES NAVY
Identification Card

BUSH, George H. W.
Name

George H.W. Bush.
Signature

Color Hair..BROWN..Eyes..Green..
Weight...165...Birth..6-12-24..
Void after...DOW..

ENSIGN USNR

J. E. B. STEIERT, N. Nav. 514 *Validating Officer*
LIEUT. USNR

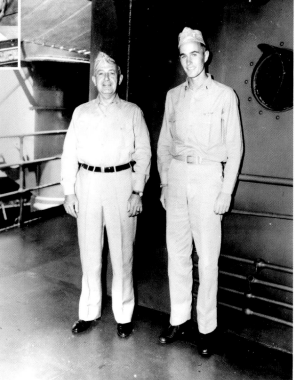

"As the days go by the time of our departure draws nearer," Bush wrote Barbara in December 1943. "We have been working for a long time with a single purpose in mind, to be so equipped that we could meet and defeat our enemy. I do want to go because it is my part, but now leaving presents itself not as an adventure but as a job which I hope will be over before long. . . . I'll tell you all about the latest flying developments later. We have so much to do and so little time to do it in. It is frightening at times. The seriousness of this thing is beginning to strike home." He would soon ship out for the Pacific aboard the USS *San Jacinto,* which was commissioned in the Philadelphia Naval Shipyard in late 1943. At right, Bush with Admiral James L. Kauffman, circa 1944.

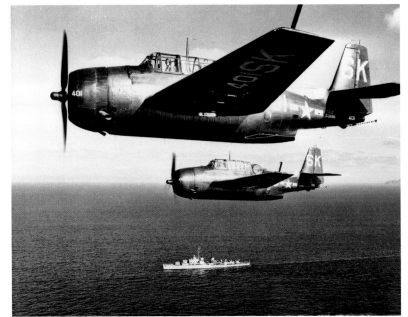

Two Avengers in flight; Bush with fellow officers and enlisted men.

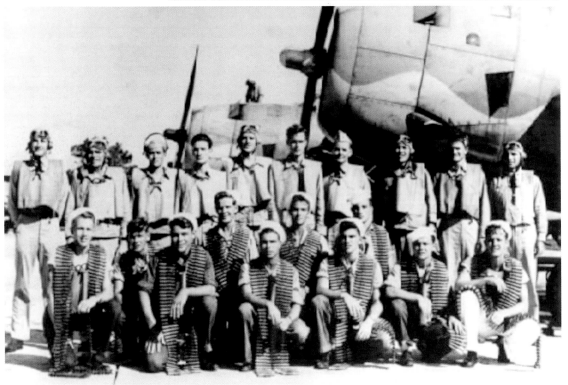

Lieutenant Junior Grade William G. "Ted" White (right), a gunnery officer, was a Yale alumnus (class of 1942) and a member of Skull and Bones, the university's elite senior society. Prescott Bush and White's father knew each other, and now their sons were both assigned to VT-51.

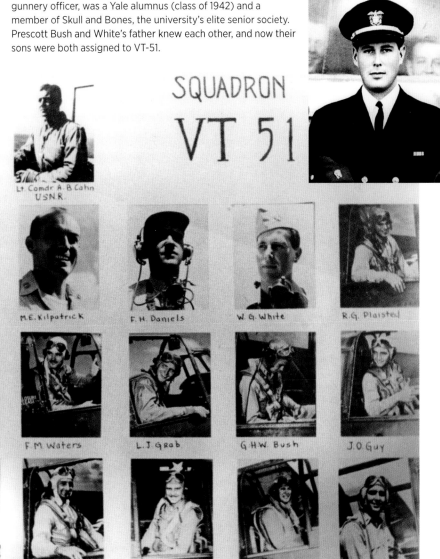

SQUADRON

VT 51

H.M.Martin S.N

Comdr H H Hale U.S.N

Lt. Comdr A. B.Cahn U.S.N.R.

Jr D > Melvin

L.R. HoLE

M.E. Kilpatrick

F. H. Daniels

W. G. White

R.G. Plaisted

West

H.G. Boren

F. M. Waters

L. J. Grab

G.H.W. Bush

J.O. Guy

M.G. Moore

R. R. Houle

J. J. Roquepau

C.H.Woie

W.M. M

The squadron officers of VT-51 and the senior officers of the *San Jacinto* as it sailed into combat operations in 1944. Bush flew his first mission over Wake Island accompanied by Nadeau and Delaney. "We were all tense because it was our first . . . and we didn't know what to expect," Nadeau recalled. "I don't think there was any time we were in the air when the adrenaline wasn't flowing, but much as we dreaded that first flight, we knew we had to do it. Luckily, George seemed confident, which relaxed me and Del somewhat."

Bush is the fourth officer from right (standing). This photograph of officers and crew aboard the *San Jacinto* was taken in the Gulf of Paria, off Trinidad, as the carrier made its way to the Panama Canal en route to San Diego, Hawaii, and at last Majuro Harbor, in the Marshall Islands, where the ship joined the fleet in May 1944. Bush loved the seaborne camaraderie, playing games and doling out nicknames. His own was "Georgeherbert-walkerbush," said fast—a play on his background in Greenwich and at Andover. One casualty of the war, though, was the widespread use of "Pop" or "Poppy." An old friend startled Bush in October 1944 by calling him "Pop." It was, Bush said, "the first time in ages" he'd heard that. "With everyone it's George and I really have grown used to it," he noted. Soon reality set in. After action at Wake Island, he told his mother: "It is quite a feeling, Mum, to be shot at I assure you. The nervousness which is with you before a game of some kind was extremely noticeable but no fear thank heavens."

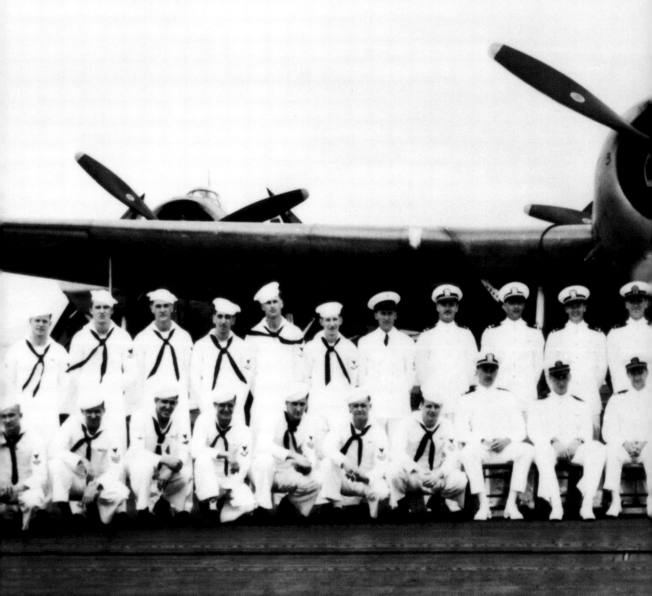

The USS *Finback,* commanded by Robert R. Williams, Jr., an Annapolis graduate, was on what was known as "lifeguard duty" in the Bonin Islands on Saturday, September 2, 1944. After three and a half hours on a raft in the sea, Bush saw the sub emerge from the depths. "I thought maybe I was delirious," he recalled. Chichi-Jima was enemy territory; Bush later learned that the island was the scene of horrifying war crimes against American prisoners of war— including cannibalism. Chief Petty Officer Ralph Adams swam to Bush's raft, and a team pulled the downed pilot onto the sub. "Welcome aboard, sir," said Don Kohler, a torpedoman second class. "Happy to be aboard," Bush replied. "Let's get below," Kohler said. "The skipper wants to get the hell out of here." It was 11:56 A.M. Bush's first priority was to tell his rescuers about his crew. "Commenced search of area on chance they had jumped over water," the *Finback*'s log reported. It was no use. White and Delaney were gone. The sub's crew shot Bush's raft to pieces and left the debris in the sea.

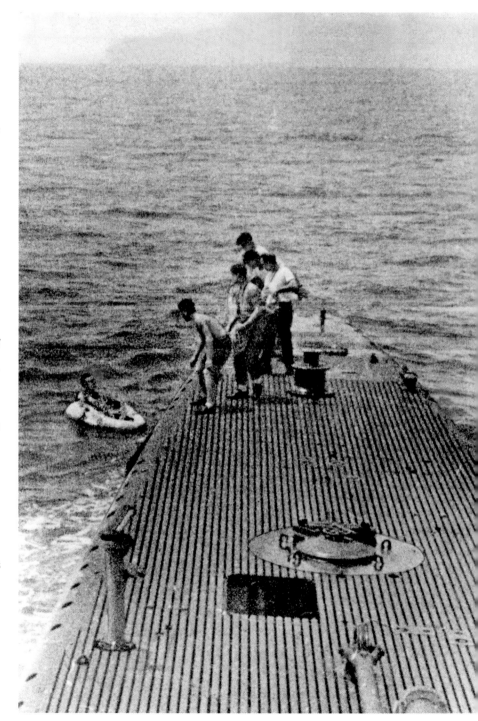

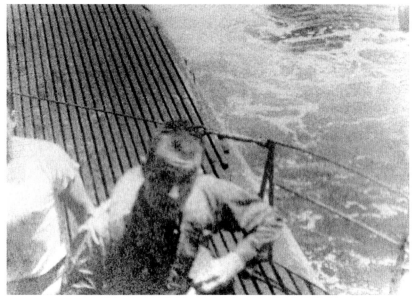

Life on the *Finback* presented a different kind of stress than a carrier: There was only so much one could do when a depth charge fell, which created a feeling of passivity that Bush disliked. He stood two watches a day to keep himself occupied and to get some fresh air when the sub was on the surface. To pass the time before reporting back to the *San Jacinto*, Bush pitched in as a censor for the enlisted men's letters, a task that gave him an unusual glimpse into the lives of ordinary Americans.

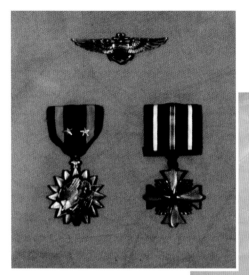

Bush's aviator wings and military decorations. He never discussed the war, he recalled, until he found himself in the political arena where candidates were expected to tell their stories. Even then, Bush was not wholly comfortable casting himself as a hero. His experience, rather, was just the performance of his duty.

After Chichi-Jima, Bush, who was to receive the Distinguished Flying Cross, wrote to the families of Ted White and Del Delaney. In reply, a Delaney sister, Mary Jane, told Bush: "You mention in your letter that you would like to help me in some way. There is a way, and that is to stop thinking you are in any way responsible for your plane accident and what has happened to your men. I might have thought you were if my brother Jack had not always spoken of you as the best pilot in the squadron. I always had the greatest confidence and trust in my brother Jack's judgment. . . . I want to thank you for your beautiful letter and the kind things you said about Jack. It was a message of sadness, but you made it much easier to bear."

United States Pacific Fleet

COMMANDER SECOND CARRIER TASK FORCE,

PACIFIC FLEET

☆ ☆ ☆

In the name of the President of the United States, the Commander, Second Carrier Task Force, United States Pacific Fleet, presents the DISTINGUISHED FLYING CROSS to

LIEUTENANT (JUNIOR GRADE) GEORGE HERBERT WALKER BUSH
UNITED STATES NAVAL RESERVE

for service as set forth in the following

CITATION

"For distinguishing himself by heroism and extraordinary achievement while participating in aerial flights in line of his profession as pilot of a torpedo plane during the attacks by United States Naval Forces against Japanese installations in the vicinity of the Bonin Islands on 2 September 1944. He led one section of a four plane division which attacked a radio station. Opposed by intense anti-aircraft fire his plane was hit and set afire as he commenced his dive. In spite of smoke and flames from the fire in his plane, he continued in his dive and scored damaging bomb hits on the radio station, before bailing out of his plane. His courage and complete disregard for his own safety, both in pressing home his attack in the face of intense and accurate anti-aircraft fire, and in continuing in his dive on the target after being hit and his plane on fire, were at all times in keeping with the highest traditions of the United States Naval Service."

J. S. McCAIN
Vice Admiral, U. S. Navy

Temporary Citation

September 8th

Dear Mum and Dad,

Back once agian, I have just come off my early
motning watch and breakfeast won't be ready for a while so
I shall write a little more. I have taken to sleeping even more
than when I first came aboard. I now sleep for three hours in the
Am and then try to sleep at least twox in the the afternoon.
I don't usually get in the sack at nite before 10 or 11 so I have
to make up for it all in all. I try to get about 8 or 9 hours of sleep
a day.

Haven't been doing a great deal out of the
ordinary- just daydream the time away. It is such fun to think about
getting home, the wedding and all that. I find myself bursting forth
into song up on the bridge. I am not sure the others up there
appreciate my efforts too much, but if they ever complain I am
going to tell them that my mother feels I am potentially a second
Caruso- and I don't mean Frank Caruso either.

My eye has completely healed, save for a tiny scar
and, the worst part, one chunk of eyebrow is missing. It is sort
of a laugh, but I do hope it grows back in. There is just skin
where there should be eyebrow.

One thing I do miss aboard here is my daily
shower which I loved aboard the ship. Water cannot be produced
as abundantly aboard this boat, so naturally we have to con-
serve whenever and wherever possible. One shower per week is
the ration. Tomorrow I can take mine-wow do I need it(unattractive)
The shower is in a tiny little room but by being very cagey
about it you can manage to get well cleaned up. The clothes
situation is far from serious since all we wear is sandals,
undies and pants-no shirts, just undershirts for meals.

I hope you have not been worrying up till the time
you received these letters. This may be the first you have heard
of my experience, I don't know . I try to think about it as little
as possiblr, yet I cannot get the thought of those two boys out
of my mind. It is so different, reading about people getting killed
etc. Even when Jim and Dick Houle were lost, though I did feel
it deeply, it did not affect me ii as this has. Oh, I am O.K. -I do
want to fly again and I shall not be scared of it, but I know
I shall never bee able to shake the memory of this incident,
and I don't believe I want to completely. They were both such fine
people.

Well I smell the breakfeast cooking so I will
secure this for now. xxMuch love to you all,

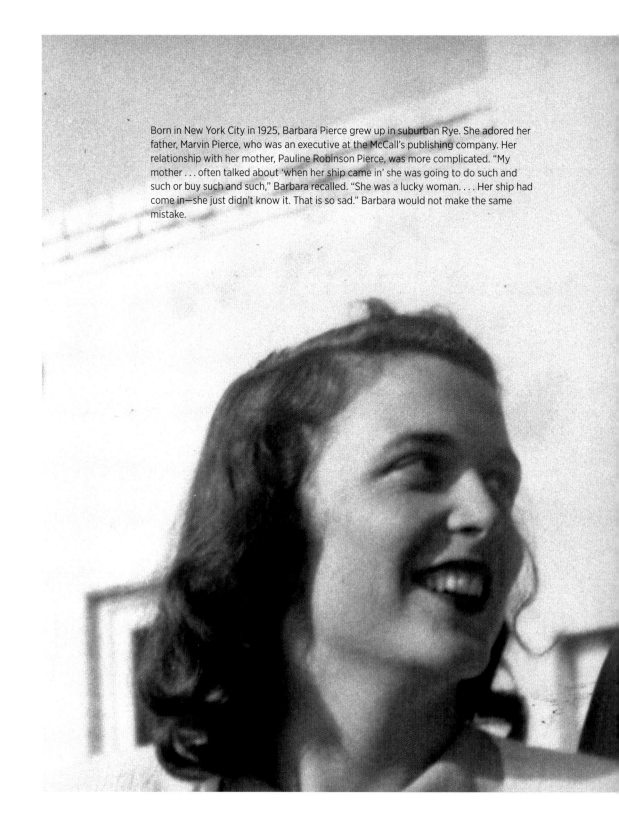

Born in New York City in 1925, Barbara Pierce grew up in suburban Rye. She adored her father, Marvin Pierce, who was an executive at the McCall's publishing company. Her relationship with her mother, Pauline Robinson Pierce, was more complicated. "My mother . . . often talked about 'when her ship came in' she was going to do such and such or buy such and such," Barbara recalled. "She was a lucky woman. . . . Her ship had come in—she just didn't know it. That is so sad." Barbara would not make the same mistake.

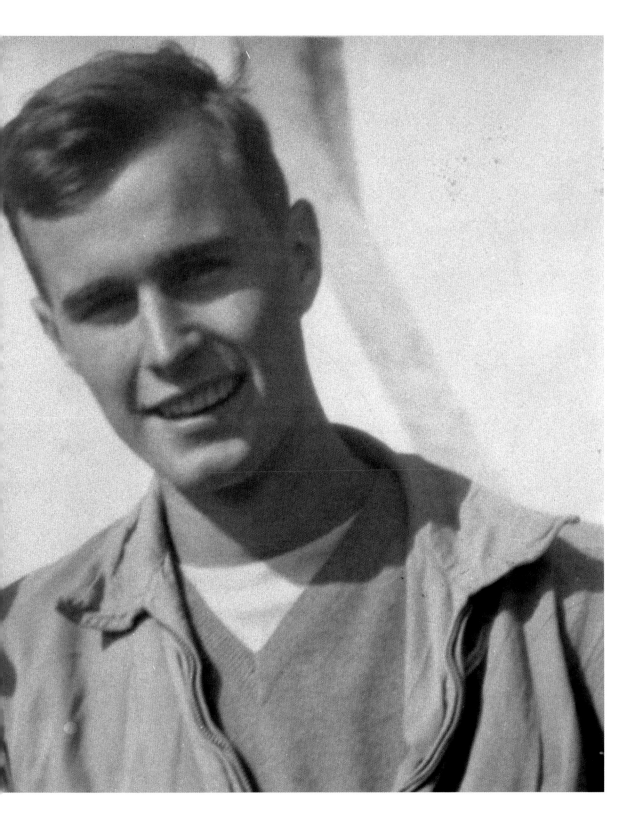

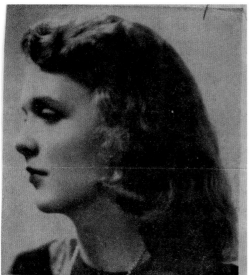

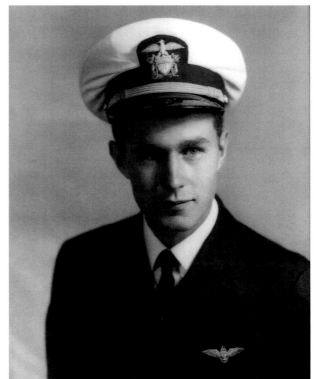

MISS BARBARA PIERCE, daughter of Mr. and Mrs. Marvin Pierce of Rye, N. Y., will marry Ensign George Herbert Walker Bush, Naval Air Corps, son of Mr. and Mrs. Prescott S. Bush of Greenwich, Conn. Miss Pierce was graduated from Ashley Hall, Charleston, S. C., and is a student at Smith college, Northampton, Mass. Her father is executive vice president of McCall corporation. Mr. and Mrs. Scott Pierce of Radcliffe road and Mrs. James E. Robinson of Columbus and the late Judge Robinson are her grandparents. Ensign Bush, an alumnus of Phillips Exeter academy at Andover, Mass., received his wings in June at Corpus Christi, Tex. He is a grandson of Mr. and Mrs. George Herbert Walker of New York and of Samuel Prescott Bush of Columbus and the nephew of Maj. and Mrs. James Smith Bush of Dayton and of Capt. and Mrs. G. H. Walker Jr. of Oakwood avenue.

The Captain and Officers
of the U. S. S. San Jacinto
cordially invite you to attend a Dinner Dance
on December 15th, 1943, at 7.30 P. M.
Warwick Hotel, Philadelphia

R.S.V.P.
THE PROSPECTIVE COMMANDING OFFICER
U. S. S. SAN JACINTO, NEW YORK SHIPBUILDING CORP.
CAMDEN, NEW JERSEY

They met at a Christmas dance at the Greenwich Country Club in 1941. The romance advanced rapidly, and Bush gave Barbara an engagement ring at the commissioning of the *San Jacinto* in December 1943. Barbara had joined Dorothy Bush on the trip to Philadelphia; Mrs. Bush brought along the ring. "I love you, precious, with all my heart and to know that you love me means my life," Bush wrote Barbara on the day the engagement was announced. "How often I have thought about the immeasurable joy that will be ours some day. How lucky our children will be to have a mother like you."

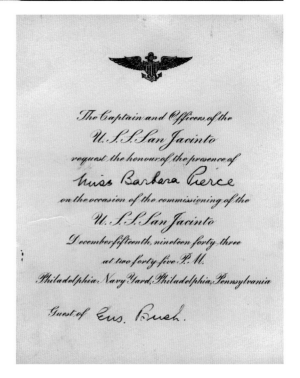

The Captain and Officers of the
U. S. S. San Jacinto
request the honour of the presence of
Miss Barbara Pierce
on the occasion of the commissioning of the
U. S. S. San Jacinto
December fifteenth, nineteen forty-three
at two forty-five P. M.
Philadelphia Navy Yard, Philadelphia, Pennsylvania

Guest of Ens. Bush.

Barbara Pierce - Ashley Hall - Charleston, S. C.

Friday-

Dear Poppy-
 I think it was perfectly swell of you to write me to the dance and I would love to come or go or whatever you say. I wrote mama yesterday or the day before and, rather logically, I haven't heard from her, BUT I'm sure she is going to let me. *(come or go, etc.)* I really am excited, but scared to death, too. If you hear a big noise up there, don't worry, it's just my knees knocking.

The letter Barbara wrote to Bush to accept his invitation to the senior prom at Andover in the spring of 1942. She was a student at Ashley Hall in Charleston, South Carolina; her trip to Phillips Academy proved momentous. She had just turned seventeen. After the dance, Barbara recalled, "Pop walked me home and, in front of the world, leaned down and kissed me on the cheek. I floated into my room and kept the poor girl I was rooming with awake all night while I made her listen to how Poppy Bush was the greatest living human on the face of the earth."

The wedding had been planned for December 1944, but the date slipped until Saturday, January 6, 1945, when Bush had trouble making it all the way home from the Pacific. He finally reached home on Christmas Eve 1944—and Barbara met him at the station in Rye. "One might well ask why our parents would sign permission slips for us to get married at the ages of nineteen and twenty," Barbara recalled. "I know that our children have asked that question. The answer: In wartime, the rules change. You don't wait until tomorrow to do anything." The wedding was held at the First Presbyterian Church in Rye. *The New York Times* described Barbara's "gown of ivory satin, made with a fitted bodice embroidered with seed pearls and a full skirt." Her veil—"of heirloom princess and rosepoint lace"— had been Mrs. Bush's when she married Prescott in Kennebunkport in 1921.

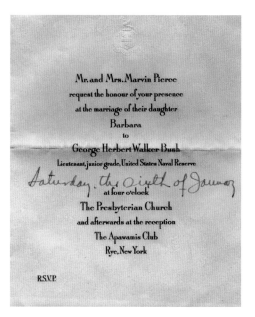

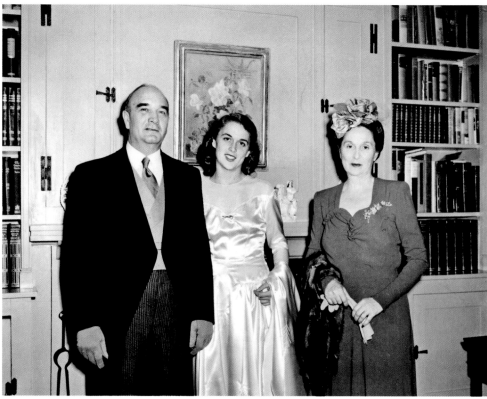

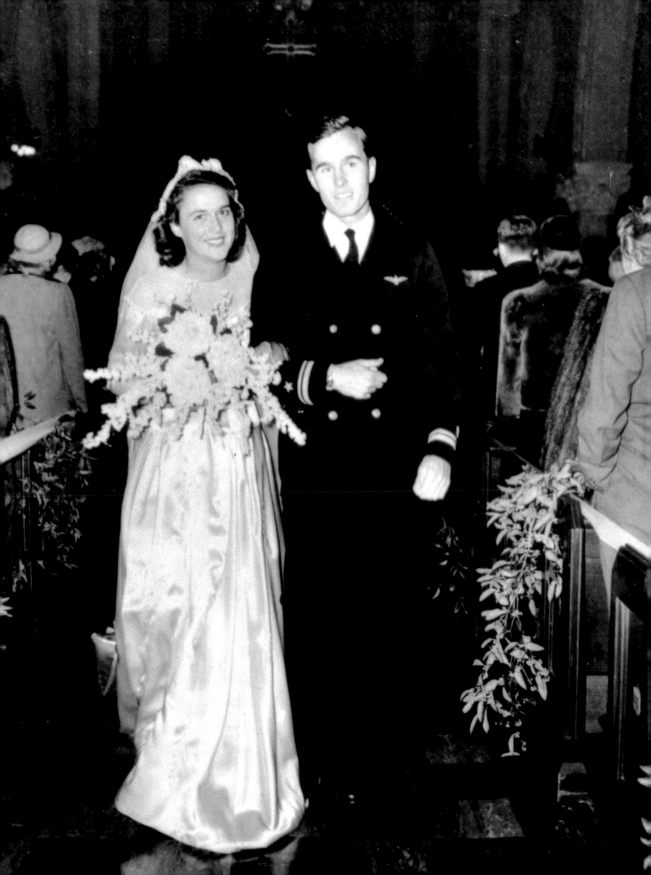

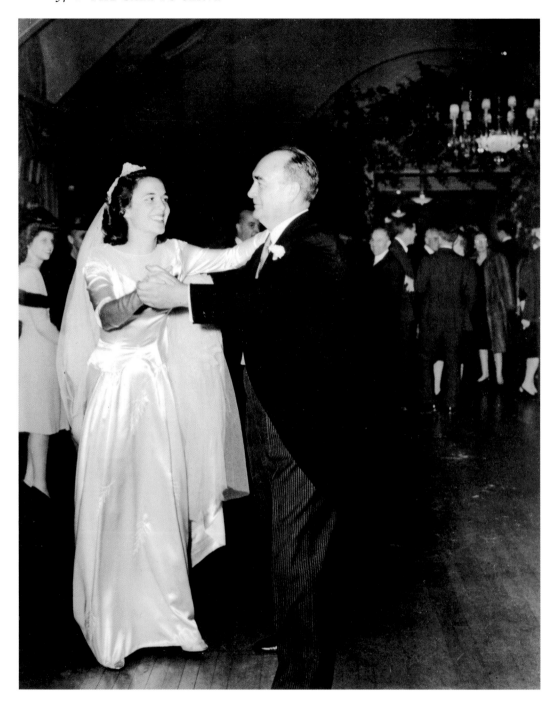

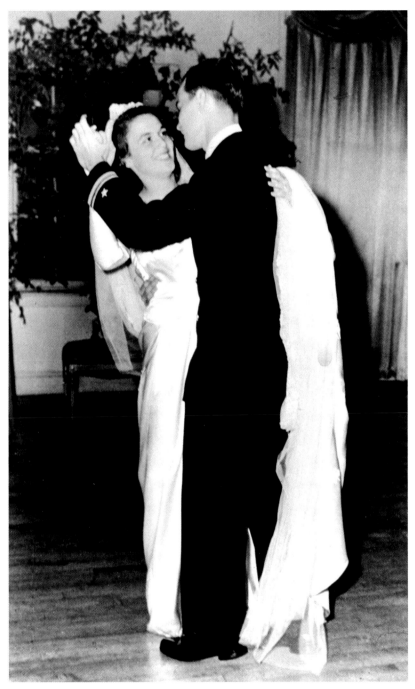

The wedding reception was held at the nearby Apawamis Club. It was, Barbara recalled, largely "a party of women, not men, because of the war." The maids of honor had been Nancy Bush and Barbara's sister, Martha; Prescott Jr. had served as his brother's best man. Barbara danced with her father and her groom at what she recalled as "a lovely reception" before the newlyweds went to New York City. There, at Radio City Music Hall, they watched *Meet Me in St. Louis,* the Judy Garland movie, and traveled to the Cloisters at Sea Island, Georgia, where they were the only young couple. As Barbara remembered it, there were dance lessons, which bored Bush, who would disappear midstep during the rhumba. The respite from war was brief: Soon Bush was assigned to a new combat squadron, VT-153, and was training for new operations in the Pacific. At Naval Air Station Grosse Ile in Michigan, he and Barbara paid fourteen dollars a week for a room (without kitchen privileges). "It is a sort of lonely existence for poor Bar," Bush wrote his parents, "but she doesn't complain at all, and I am just in heaven having her here."

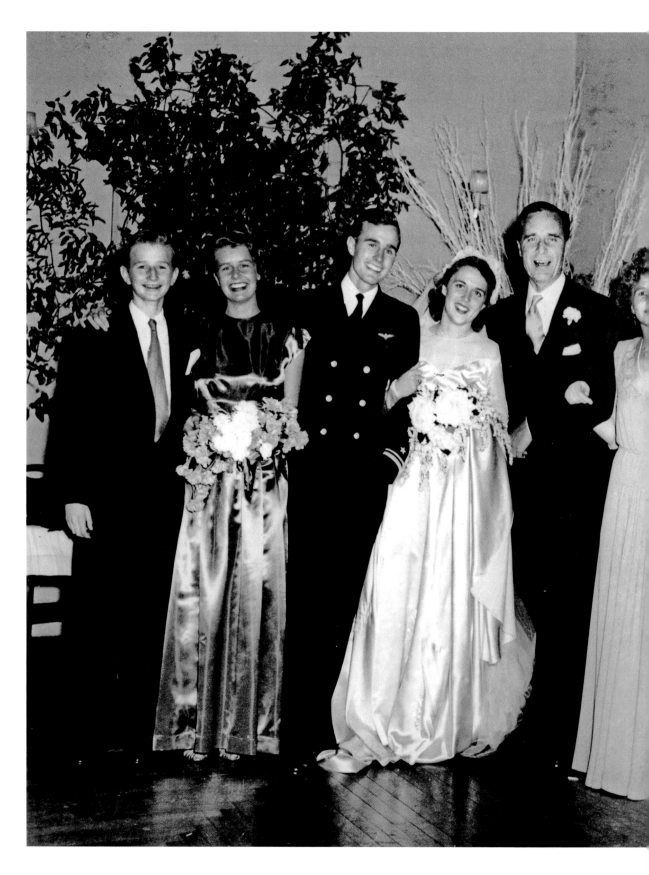

The Bush family gathers at Barbara and George's wedding in Rye, New York, on Saturday, January 6, 1945. From left: Jonathan Bush; Nancy Bush; George H. W. Bush; Barbara Pierce Bush; Prescott Bush; Dorothy Bush; Prescott Bush, Jr.; Prescott's wife, Elizabeth Kauffman Bush; and William Trotter "Bucky" Bush. Barbara and George Bush would be married for seventy-three years, their lives stretching from World War II naval bases to New Haven, Connecticut; Odessa, Midland, and Houston, Texas; California; Washington, D.C.; New York City; and Beijing. Late in life, Barbara drafted a letter of advice to her children that reflected the lessons she'd learned through the decades. "For heaven's sake enjoy life. Don't cry over things that were or things that aren't. Enjoy what you have now to the fullest. In all honesty you really only have two choices; you can like what you do *OR* you can dislike it. I chose to like it and what fun I have had. The other choice is no fun and people do not want to be around a whiner. You can always find people who are worse off and we don't have to look far! Help them and forget self!"

YALE UNIVERSITY

This certifies that

George Herbert Walker Bush

has been admitted to the Freshman Class

entering Yale University in 1941.

Edward S. Noyes
Chairman of the Board of Admissions.

New Haven, Connecticut *July 16,* 1941.

The Class will meet for organization in Woolsey Hall, Saturday, September 20, 1941, at 10.00 A.M., daylight saving time.

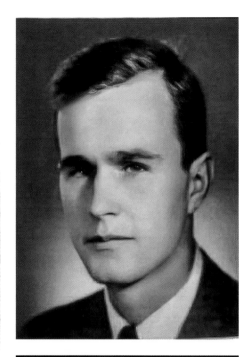

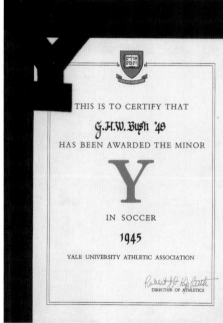

THIS IS TO CERTIFY THAT

G.H.W. Bush '48

HAS BEEN AWARDED THE MINOR

Y

IN SOCCER

1945

YALE UNIVERSITY ATHLETIC ASSOCIATION

Robert J.H. Kiphuth
DIRECTOR OF ATHLETICS

Bush matriculated at Yale in November 1945. He was perhaps the biggest of big men on campus, racing through to graduation in the spring of 1948. More than half of the student body in 1945 had come from military service—about 5,000 out of 8,500. "Some of us are tottering veterans in our early and mid-twenties trying to keep up with the . . . minors we found when we came back," the Yale yearbook wrote of the class of 1948.

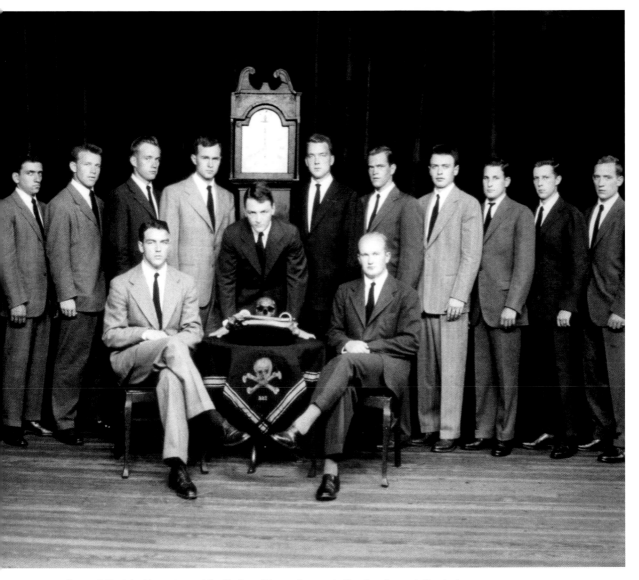

Prescott Bush had been tapped for Skull and Bones, the most elite of senior societies; in due course, so was Poppy Bush. In the forbidding "tomb" of the clubhouse on High Street in New Haven, the chosen few often forged lifelong bonds through a culture of candor about one's hopes and fears. It was counterintuitive: a society of Yale men—usually seen as somewhat repressed—speaking openly, at least to one another, amid a climate of mystical rituals, language, and customs. To be the "last man tapped" was the greatest of undergraduate honors, and Bush had long hoped to win that elusive prize. Which he did.

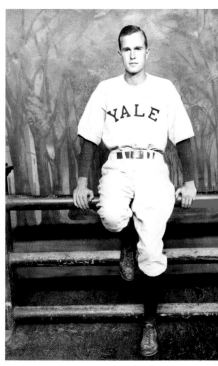

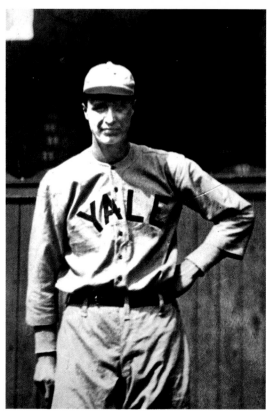

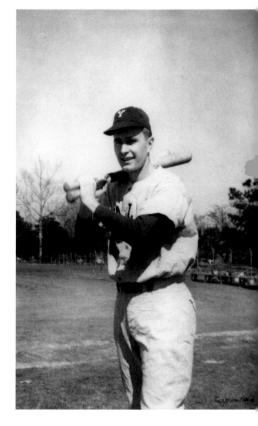

National Collegiate Athletic Association

BASEBALL CHAMPIONSHIP SERIES

Southside Park, Winston-Salem, N. C.

Tuesday, Wednesday, Thursday, Friday
JUNE 15-18, 1948

SPONSORED BY WINSTON-SALEM JUNIOR CHAMBER OF COMMERCE

National Collegiate Athletic Association

Baseball Championship Series

Hyames Field

Western Michigan College
Kalamazoo Mich.

Friday and Saturday
June 27-28, 1947

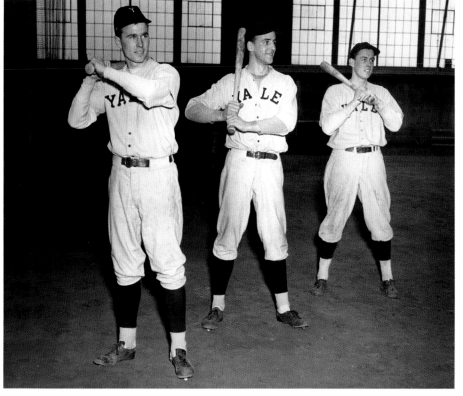

He followed his father, Prescott, in making the varsity baseball team at Yale and played in the first two College World Series. "After an impressive debut, George Bush, the Eli's classy first baseman, is hitting .167, but he has developed into a long ball hitter and has given enemy outfielders a lot of running exercise," the *New Haven Evening Register* reported in the spring of 1946. "I was team captain in '48, happy to be called a 'classy first baseman,' but was strictly in the lower half of the batting order when it came to hitting," Bush recalled. "'Good field, no hit' was the way they described my kind of ballplayer in those days—at least when I started my playing years at Yale. But with practice I improved from season to season. By my senior year a better description of my style would have been 'Good field, fair hit.'" The Yalies lost both championship series, but Bush noted that the life-and-death experiences of war put the usual undergraduate dramas in perspective. "We knew there were worse things that can happen to you in life than losing a ballgame," Bush recalled.

He got one passing sign of interest from the pros—and never forgot it. "Once, after an especially strong day at bat in a game at Raleigh, North Carolina—I think I was four for five, with a couple of extra-base hits—some scouts approached me as I left the field," Bush recalled. "But that was the first and last nibble I ever got from the pros."

"After watching you play since the season started," the grounds-keeper, Morris Greenberg, wrote Bush, "I am convinced the reason you are not getting more hits is because you do not take a real cut at the ball. I am confident that if you would put more power behind your swing, you would improve your batting average 100%." Bush was grateful for the advice. "I'd been so wound up in batting techniques—how to meet, pull, hit the ball to the opposite field—that I was swinging defensively," Bush recalled. "Not striking out much, but strike out or ground out, the bottom line's the same: no risk, no gain." Bush's career average ultimately rose to .280.

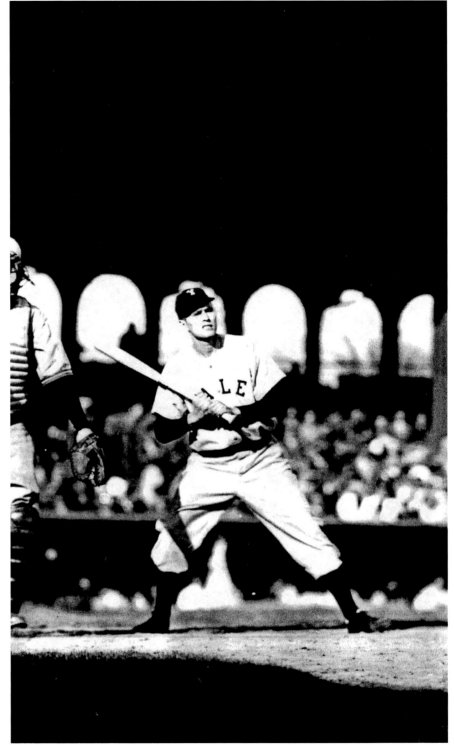

Bush preferred Lou Gehrig's steadiness to Babe Ruth's showiness, but was delighted to accept the manuscript copy of Ruth's autobiography for Yale. "When Ruth turned the manuscript over to me, his hand trembled and his voice could barely be heard," Bush recalled. "It was obvious that he was dying of cancer; but some of the young, free-spirited 'Babe' was still there, very much alive. 'You know,' he said, winking, 'when you write a book like this, you can't put *everything* in it.'"

GONE WEST

1948 to 1962

We all just wanted to make a lot of money quick.

—GEORGE H. W. BUSH

Bush's Texas years are the stuff of legend, the tale of a privileged young man who eschewed the comforts of the investment business to work in the heat and dust of Odessa and Midland, along with stints in California. The scion of Greenwich moved his little family into a duplex they shared with two prostitutes. Pauline Pierce, Barbara's mother, sent her daughter boxes of soap that, Barbara recalled, "she assumed were available only in civilized parts of the country. She did not put Odessa in that category."

The family grew on Tuesday, December 20, 1949, with the birth of a daughter, Pauline Robinson Bush. "Beautiful hazel eyes, soft blond hair," Bush recalled. In early 1953, in Midland, John Ellis Bush, called "Jeb," was born. Not long afterward, Robin, at three, was diagnosed with leukemia. "I didn't know what the hell leukemia was," Bush recalled. His first question, typically: "What do we do about it?"

The Bushes took Robin to Memorial Sloan Kettering Hospital in New York City. There were bone marrow tests, oxygen tents, and cortisone injections. At times, Bush recalled, "God, the poor little girl was panicked, crying." At others she was her smiling, charming self. "Robin does unfortunately have Leukemia, and although there is little hope for her we have taken her to Memorial Hospital for treatments," Bush wrote an acquaintance in August 1953. "She has responded satisfactorily, and our big hope is that some new cure will be discovered for this horrible disease."

That hope would not be realized. Barbara stayed at Robin's side month after month. Bush commuted between New York and Midland. Finally, in October, with both parents at her side, Robin died. "One minute she was there, and the next she was gone," said Barbara. "I truly felt her soul go out of that beautiful little body."

In the late 1950s, after the births of Neil Bush (1955) and Marvin Bush (1956), Bush was in New York on business. One evening he went "out on the town," and only when he was heading in for the night did he think, "You could well have gone to Greenwich tonight,"

Chapter-opening spread: Dorothy and Prescott Bush visit Barbara, George, and George W. in Texas in 1949. The younger Bushes had struck out for the Permian Basin just after graduation from Yale in 1948. They took up residence first in Odessa and then in Midland, where Bush was learning the oil business from the ground up, the protégé of his father's friend Neil Mallon. "I didn't want to do anything pat and predictable," Bush recalled. "I'd come of age in a time of war, seen different people and cultures, known danger, and suffered the loss of close friends. . . . I couldn't see myself being happy commuting into work, then back home, five days a week."

It was an era of tragic contrasts. The Bushes lost Robin in 1953 and endured to build a good, prosperous, meaningful life in Midland and later in Houston, where Bush went into the offshore oil business. "I push it away—I push it back," Bush recalled of Robin's loss.

to see Robin at her grave. The thought, he wrote his mother, Dorothy, "struck me out of the blue, but I felt no real sense of negligence.... I like ... to think of Robin as though she were a part, a living part, of our vital and energetic and wonderful family of men and Bar." How long, he wondered, would this sense of Robin as a perpetual three-year-old last? "We hope we feel this closeness [to Robin] when we are 83 and 82. Wouldn't it be exciting at that age to have a beautiful 3 and a half year old daughter? ... She doesn't grow up. Now she's Neil's age. Soon she'll be Marvin's—and beyond that she'll be all alone, but with us, a vital living pleasurable part of our day-to-day life."

His imagination thoroughly engaged, his heart open, he wrote Dorothy:

There is about our house a need. The running, pulsating restlessness of the four boys as they struggle to learn and grow; the world embraces them . . . all this wonder needs a counter-part. We need some starched crisp frocks to go with all our torn-kneed blue jeans and helmets. We need some soft blond hair to off-set those crew cuts. We need a doll house to stand firm against our forts and rackets and thousand baseball cards. We need a cut-out star to play alone while the others battle to see who's "family champ." We even need someone . . . who could sing the descant to "Alouette," while outside they scramble to catch the elusive ball aimed ever roofward, but usually thudding against the screens.

We need a legitimate Christmas angel—one who doesn't have cuffs beneath the dress.

We need someone who's afraid of frogs.

We need someone to cry when I get mad—not argue.

We need a little one who can kiss without leaving egg or jam or gum.

We need a girl.

We had one once—she'd fight and cry and play and make her way just like the rest. But there was about her a certain softness.

She was patient—her hugs were just a little less wiggly.

Like them, she'd climb in to sleep with me, but somehow she'd fit.

She didn't boot and flip and wake me up with pug nose and mischievous eyes a challenging quarter-inch from my sleeping face.

No—she'd stand beside our bed till I felt her there. Silently and comfortable, she'd put those precious, fragrant locks against my chest and fall asleep.

Her peace made me feel strong, and so very important.

"My Daddy" had a caress, a certain ownership which touched a slightly different spot than the "Hi Dad" I love so much.

But she is still with us. We need her and yet we have her. We can't touch her, and yet we can feel her.

We hope she'll stay in our house for a long, long time.

Love

Pop

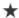

Midland Child Dies In New York Hospital

Three-year-old Robin Bush, daughter of Mr. and Mrs. George Bush of Midland, died Monday in a New York hospital following an illness of several months.

The father is president of the Bush-O v e r b e y Oil Development Company here and the grandfather is U. S. Senator Prescott Bush of Connecticutt.

The child was stricken with leukemia last May and taken to New York for treatment. She was a native of Midland.

Private funeral services will be held Wednesday in Christ Church at Greenwich, Conn. In addition to the parents, two brothers, George W. Bush and John Bush of Midland, survive.

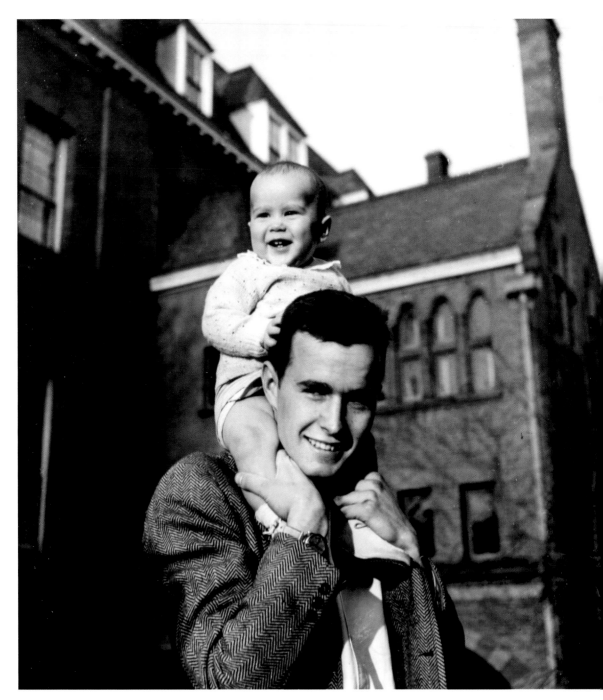

Born on Saturday, July 6, 1946, in the first wave of the baby boom, George Walker Bush (called "Georgie" by his parents in childhood) spent his first two years in New Haven, Connecticut, and his formative years in Odessa and Midland. The biggest contrast with his father, the forty-third president would say, was that Bush 41 went to Greenwich Country Day School while he attended San Jacinto Junior High. "George and I were mad about our baby," Barbara recalled. "My mother said she hated to be in the room with the baby, for if she took her eyes off him, George looked hurt."

The children of Barbara and George Bush. Counterclockwise from top: George H. W. Bush with George W.; Marvin, Jeb, Neil, and Doro; George W. with Robin. For all the vicissitudes and pressures of political life at the highest levels, the Bushes maintained a remarkably stable family life from decade to decade. Much of the credit goes to Barbara Bush, who served as what her husband called "the Enforcer." After she left Smith College, Barbara never sought to complete her schooling. "I had every opportunity to finish my education," she recalled. "George would have been very supportive. I chose, instead, to have a big family."

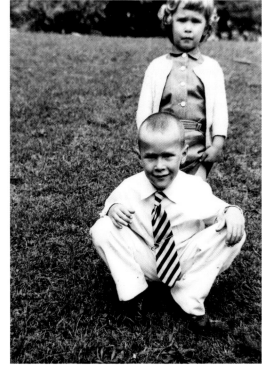

Dad and Georgie -
Greenwich 1948 -

Prescott Bush with his grandson George W. Bush in Greenwich, Connecticut, in 1948, the year the younger Bushes moved to Texas. Prescott could be an intimidating figure to his children and grandchildren. Asked about how George W. had viewed his grandfather, George H. W. Bush once replied, "Scared to death of him, as we all were." The aura of dignity was only enhanced after Prescott was elected to the U.S. Senate in 1952. George W. always remembered having to wear a coat and tie to the table on Grove Lane—a custom that was, to say the least, less often observed in Midland. Below: George W. and Robin with their parents.

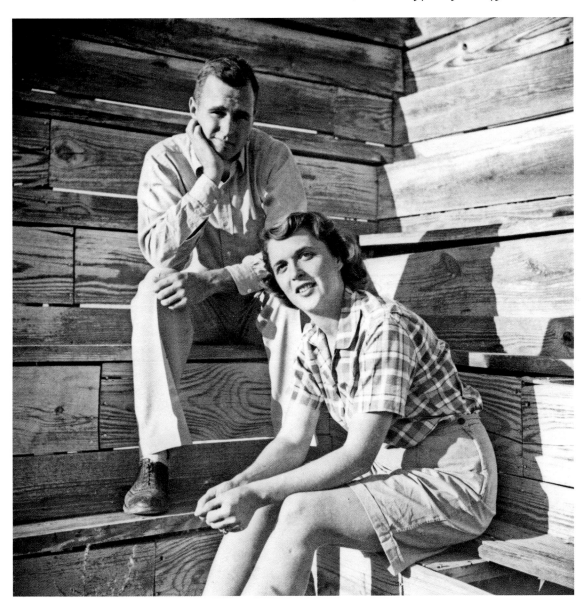

Barbara Bush was a steadfast partner in the many adventures of George H. W. Bush. "She is something, Mum," Bush wrote Dorothy Bush from Texas in 1948, "the way she never complains or even suggests that she would prefer to be elsewhere. She is happy, I know, but anyone would like to be around her own friends, be able to take at least a passing interest in clothes, parties etc. She gets absolutely none of this. It is different for me. I have my job all day long with new things happening, but she is here in this small apt. . . . I continue to be amazed at her unselfishness, her ability to get along with absolutely anyone, and her wonderful way with Georgie."

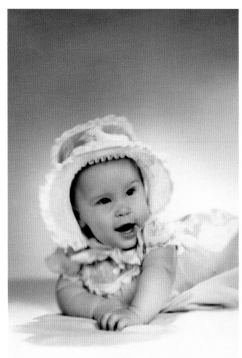

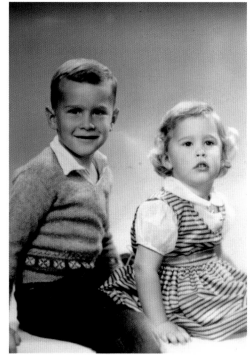

Born in Compton, California, on Tuesday, December 20, 1949, Pauline Robinson "Robin" Bush was the Bush's second child. The family was spending the year working at different Dresser companies—Dresser owned the concern that had brought Bush to Texas—when Robin arrived. Back in Midland in early 1953, Robin was tiring easily and so Barbara took her in to see Dr. Dorothy Wyvell, the children's pediatrician. "When we went into the doctor's office and sat down, all I knew was that Robin had been in for a checkup because she'd been acting listless," Bush recalled. "But I knew something was seriously wrong before Dr. Wyvell said a word. She was normally a person of great composure, a reassuring presence whenever one of the kids got sick. But that day her eyes were misting, and she was having a hard time putting her thoughts into words. Some tests had been run to see what was the matter with Robin, the doctor finally said. The results were back. Robin was a very sick child. She had leukemia." The Bushes took Robin to New York for treatment, but to no avail: She died in October 1953 and was buried in Greenwich. Decades later Robin would be reinterred at her parents' gravesite on the grounds of George H. W. Bush's presidential library in College Station, Texas. "Her death was very peaceful," Barbara recalled. "One minute she was there, and the next she was gone. I truly felt her soul go out of that beautiful little body. For one last time I combed her hair, and we held our precious little girl. I never felt the presence of God more strongly than at that moment."

The oil business came to the Midland region in a real way in 1922. In a 1988 campaign autobiography, Bush quoted the Texas historian Gus Clemens, who wrote of a May 1922 strike called "the Miracle of St. Rita": "[T]here was a great hissing sound, followed by a deafening roar and the crash of debris on the roofs. Running outside, the drillers watched in awe as a tremendous head of oil spewed above the weather-beaten derrick and drifted across the prairie, coating everything in greenish-black. . . . The well gushed three times on the 28th, twice on the 29th, and settled down to one gusher a day by the 30th. . . . On June 10th, the Orient Railroad ran a special train to the site carrying more than 1,000 people. When the gusher came at 4:40 P.M., the crowd stood spellbound as petroleum spewed above the derrick with a roar so loud that people had to shout in each other's ears." Predictably, boom-and-bust was the order of the decades. "World War II kept the wells pumping, and by 1945 Midland's population had grown to 14,000," Bush recalled. "With the end of the war, the area braced for another economic downturn, but new discoveries would attract worldwide attention, leading Midland into its greatest growth period."

Western Sign Co.

MIDLAND

VETERANS OF FOREIGN WARS

WELCOMES YOU

POPULATION OVER 25,000

HEATH & TEMPLETON PLUMBING CO.
Phone 2533

W.E. PITTMAN OIL FIELD HAULING

STEAK HOUSE
RUBY SOMERFORD
24 HRS.

ELITE
MEMBER AAA APPROVED
MOTEL
WEST ON HWY. 80

CAPITAL OF THE WEST

Bush left his first job in the oil business, as a salesman for Ideco, a division of Neil Mallon's Dresser Industries, to form the Bush-Overbey Oil Development Company, with offices in Midland's Petroleum Building. John Overbey was Bush's partner; they had gotten to know each other in the tight-knit world of Midland. The two families lived on what was known as Easter Egg Row, named for the pastel colors of the houses. Bush worried about how his patron, Mallon, would react, but Mallon was all for it. "He heard what I'd come to say, then took off his glasses to clean them, collecting his thoughts," Bush recalled of his meeting with Mallon in Dallas. "Then he got up and went into the next office, returning with a legal-size yellow pad. He began writing, talking quietly as he wrote. 'I really hate to see you go, George,' he said, working his way down the pad, 'but if I were your age, I'd be doing the same thing—and here's how I'd go about it.' In the next half hour I got a crash course not only in how to structure but how to finance an independent oil company. . . . I left Neil's office with a tremendous weight off my shoulders. Of course, the real weight had just been added."

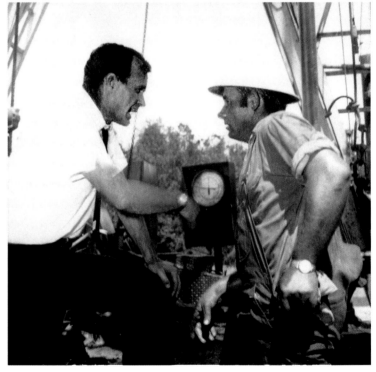

Bush-Overbey soon merged into a new entity, Zapata, with Bill and Hugh Liedtke as partners; Zapata Off-Shore grew out of that. The name had come from the Marlon Brando movie *Viva Zapata!,* which was showing in Midland at the time. "It [the company name] ought to start with either an A or a Z," Hugh Liedtke said, "so it comes either first or last in the pages [of the telephone book] under 'Independent Oil Operators.'" Bush was most interested in the offshore business, and launched drilling barges designed by R. G. LeTourneau, whom Bush described as a "gruff, eccentric, kind of George Patton of engineering."

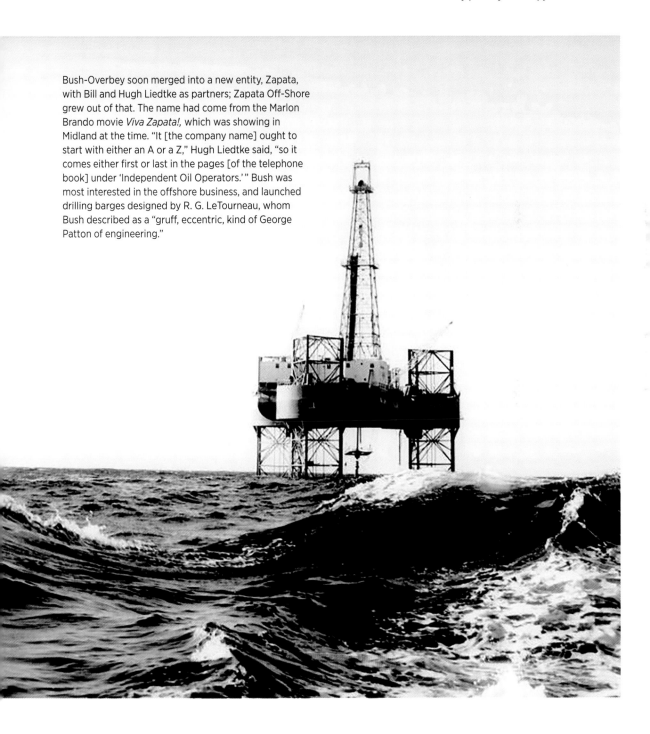

"The experience of dealing with people helped me enormously," Bush recalled of his Zapata days. "I learned a great deal about leadership, and I learned about the economic system. I had studied in college about supply and demand, risk and reward, profit and loss, the importance of labor and morale."

He continued: "But I didn't realize how all those things work together until I was making decisions that involved life and death, and survival of the business. . . . But I think I learned the most about people. . . . It made a lasting impression on me."

| GEORGE H. W. BUSH. | T. D. TANKSLEY JR. | EDWARD J. DRAKE. |

—Associated Press Photos.

'5 Outstanding Young Texans of 1956' Announced by State Junior Chamber

GRAND PRAIRIE, Dec. 29 (Ⓟ)— The Texas Junior Chamber of Commerce announced Saturday its selection of the "five outstanding young Texans of 1956."

They are George Herbert Walker Bush, 32, in the oil industry at Midland; Edward J. Drake, 32, an attorney in Dallas; Dr. Harry Maurice Shytles Jr., 35, a physician in Sherman; Bill Southwell, 31, in the manufacturing industry in San Antonio, and T. D. Tanksley Jr., 31, agricultural agent.

A banquet honoring the five will be held in Abilene Jan. 12.

F. E. Hightower, Texas Jaycee president, announced.

The Texas Jaycee organization has sponsored this selection program for 17 years. Those honored must be between 21 and 35.

The panel making the selection was composed of a number of educators and others.

Bush is head of several oil companies, including Zapata Petroleum Corporation, Zapata Offshore Company and Zapata Drilling Corporation. He is a director of the Independent Producers Association of America.

Drake is a member of the law

firm of Brady, Drake and Yates. He also is Dallas County Democratic chairman.

Dr. Shytles is president of the Essin Clinic, a member of several medical associations and committees, and a medical consultant for the Veterans Administration and Air Force. He is a charter member of the Texas Commission on higher education.

Southwell is an executive in the Southwell Company, which does an international business. He is an official in several industry organizations and has an outstanding Junior Chamber of Commerce service record.

Youths taught by Tanksley have won numerous awards in state and national competiton. He is a member of the State Textbook Committee and this month joined headquarters staff of Texas A&M Extension Service as livestock specialist.

| DR. HARRY M. SHYTLES JR. | BILL SOUTHWELL. |

—Associated Press Photos.

STOCK EXCHANGE VISITOR—George H. W. Bush, left, vice president of the Zapata Petroleum Corporation of Midland, sits at the New York City keyboard, nerve center for the American Stock Exchange. Common shares of Zapata stock have been admitted to ASE trading. Edward T. McCormick, market president, observes the initial Zapata purchase report covering 200 shares at 16 1/2.

Bush was always popular and affable. His rise in Texas commerce and in politics was rooted in the same qualities that had made him a beloved figure in the East and during the war—his grace, his empathy, and his energy. There was a price: He suffered from ulcers, which he blamed on the stresses of keeping a boom-and-bust business afloat, once collapsing in a London hotel while embroiled in litigation. For all his outward ease, he never let up on himself.

George W. grew up seeing his father in the most heroic of lights. The elder Bush was always moving in a swirl of his own creation; the eldest son would gaze at his mother's scrapbooks about World War II, about baseball at Andover and at Yale, and would join his father on occasional business trips around Texas. The son liked to joke that he'd inherited his father's eyes and his mother's mouth—George W. became a quipster, quick with a joke to lighten any situation. Part of this stemmed from the dark days and years after Robin's death, when George W. felt responsible for keeping Barbara's spirits up in that tragic time. Because of the age gap between George W. and his other siblings—he was seven years older than Jeb, and more than a dozen years older than Doro—the eldest son said he sometimes felt more like an uncle, a feeling that was underscored when he left Texas for Andover in 1960.

The birth of Dorothy Walker Bush, called "Doro," in 1959 was an answered prayer. The Bushes had moved from Midland to Houston late in the decade in order to allow Bush to focus on his offshore interests. "You can imagine how thrilled we are to have a baby girl in the family," Bush wrote a friend. "Barbara came home yesterday and the boys all gathered around and looked over the new baby with great concern. She looks just like all the others." A relative reported seeing Bush outside the hospital nursery, "his head against the window, tears of joy running down his face."

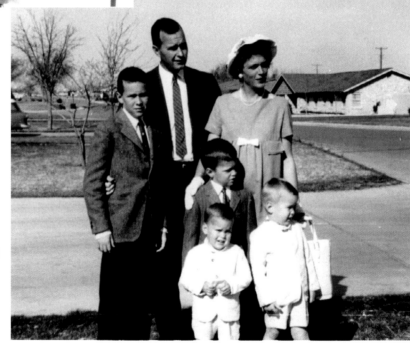

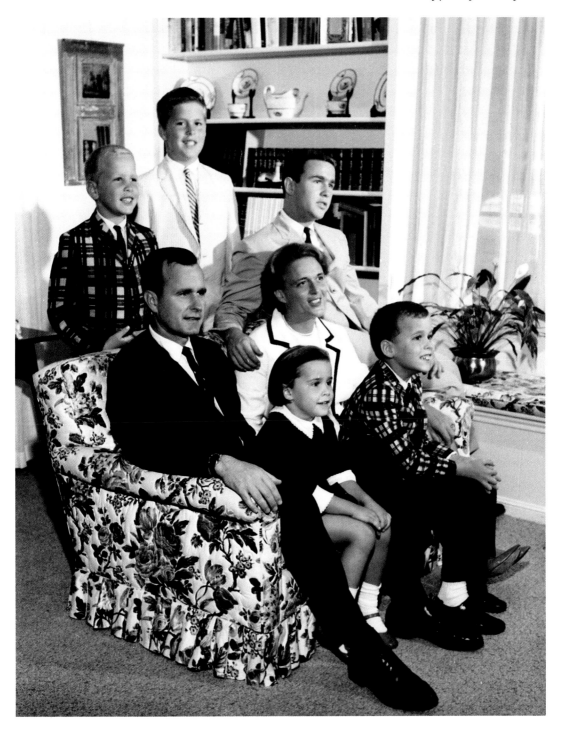

"The boys all became very active in Little League and school activities," Barbara Bush recalled of the 1959 move to Houston. "I spent half of the next ten years doing what every mother in America does: taxiing children to the doctor, the dentist, birthday parties, baseball games, tennis matches, and so on. When I look at my date book from those years, they're all baseball games and what fields they'll be played on. The boys were good players, and I felt torn in two, racing from game to game. When they weren't playing organized ball, they were in our backyard. We had a pool, a small baseball field, trees to climb, and tires hung for all the children to swing on. . . . The boys played in the nearby bayou and had several hair-raising experiences, most of which ended with trips to the emergency room for stitches." Her only caveat about those years: "George and I didn't have time to do a lot together. He was busy building a business, which involved a lot of travel, and we had five young children and a new house, which meant a lot of expenses. Needless to say, we rarely went out."

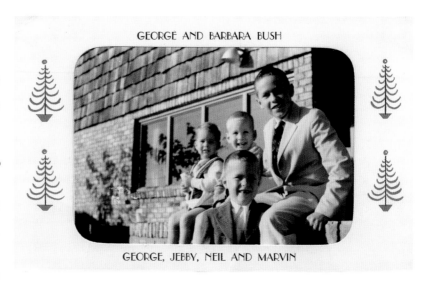

GEORGE AND BARBARA BUSH

GEORGE, JEBBY, NEIL AND MARVIN

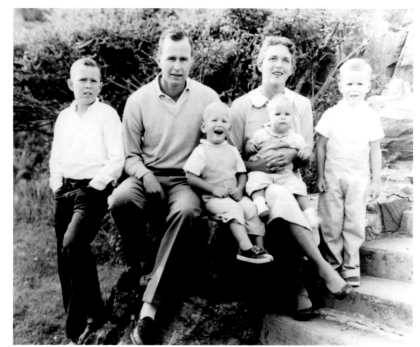

By 1963—their fourth year in Houston—Bush was thinking about seeking the chairmanship of the Harris County Republican Party, which was then divided between regular Republicans and John Birch Society extremists. "All is well with the Bush clan," he told his Yale friend Lud Ashley. "Georgie is an upper-middler (class of 64) at Andover. He's doing OK there. The three other boys fight and go all the time—they're really active—Dorothy is enchanting. She is a wild dark version of Robin. . . . I am running—yes for Chairman of the Republican Party of Harris County. . . . I think I'll win—though I now have misgivings. Actually it is a challenging job and one which, if done right, could show results." His task was to keep the party in the mainstream in what was still a largely Democratic state, though Republican John Tower had won the special election to fill newly elected Vice President Lyndon B. Johnson's U.S. Senate seat.

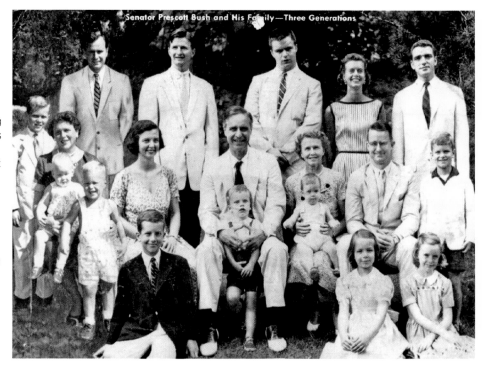

Senator Prescott Bush and His Family—Three Generations

As moderator of the Greenwich town meeting—a largely civic post—Prescott Bush had long been interested in public service. Asked in 1946 to consider seeking a seat in the U.S. House, Bush was told by his partners at Brown Brothers Harriman, an investment firm, that the House felt too small. "Look, if this was the Senate we'd back you for it and we'd like to see you do it," they said, "but for the House, don't do it." An opportunity to run for the Senate emerged in 1950, in a race to fill out two years of an unexpired term. Bush jumped at the chance.

On the Sunday before the election in November 1950, Prescott Bush was attacked for his support of birth control— a fairly standard Republican position in the politics of the time. The blast was effective in the heavily Roman Catholic state, and Bush narrowly lost the general election. "We felt terribly about the outcome after the way Dad worked at it," George H. W. Bush wrote from Texas after the race. "I do feel he made a lot of friends though, and I think he will be hard to beat if he runs again in 1952."

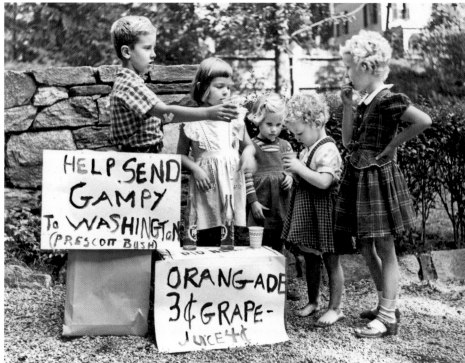

HELP SEND GAMPY TO WASHINGTON (PRESCOTT BUSH)

ORANG-ADE 3¢ GRAPE-JUICE 4¢

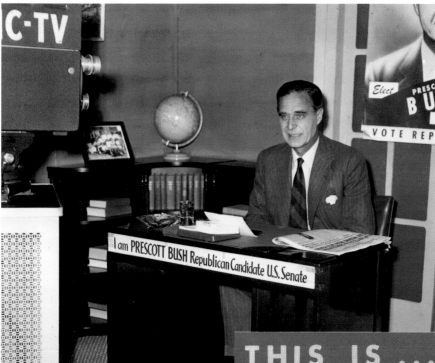

Prescott sought a Senate seat from Connecticut again in 1952. He bravely stood up against the demagogic tactics of Senator Joe McCarthy. "I must say, in all candor," Bush told a rally in Bridgeport—an event with McCarthy in attendance—that "some of us, while we admire his objectives in his fight against Communism, we have very considerable reservations about the methods which he sometimes deploys." Bush would go on to defeat the Democratic nominee, Abraham Ribicoff, by thirty thousand votes.

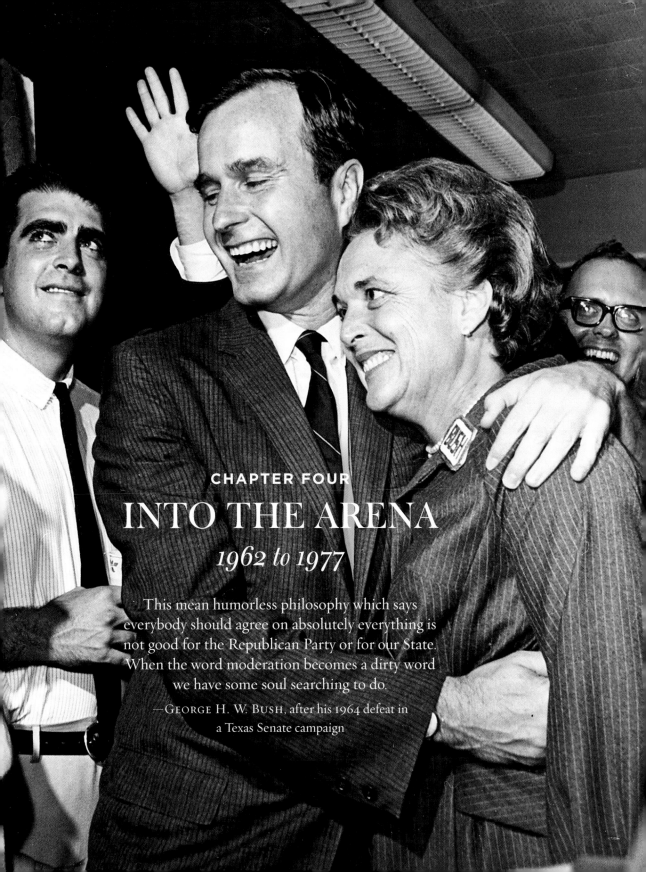

CHAPTER FOUR

INTO THE ARENA

1962 to 1977

This mean humorless philosophy which says
everybody should agree on absolutely everything is
not good for the Republican Party or for our State.
When the word moderation becomes a dirty word
we have some soul searching to do.

—George H. W. Bush, after his 1964 defeat in
a Texas Senate campaign

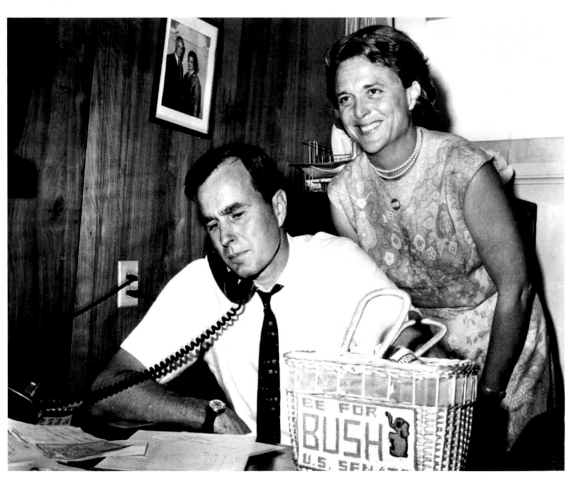

I N THE LATE 1950s, the family moved to Houston. The idea was for Bush to focus on offshore drilling, but by 1962 politics was becoming a more consuming concern. Part of the impetus was his father's service in the U.S. Senate; Prescott had won a seat from Connecticut in 1952, the year of Dwight Eisenhower's presidential victory, and George H. W. Bush had watched his father's career with pride and fascination. Senator Bush understood the appeal. "Once you've had the exposure to politics that I had . . . I mean, intense exposure," Prescott Bush recalled, "it gets in your blood, and then when you get out, nothing else satisfies that in your blood. There's no substitute for it."

The senator was no stranger to the passion and action of the time. He opposed the anticommunist campaign of Wisconsin senator Joseph McCarthy, speaking out against McCarthy's tactics in 1952 and then voting for McCarthy's censure in 1954. A progressive Republican, the senior Bush occupied largely centrist ground on the American spectrum, supporting public initiatives such as Eisenhower's Interstate Highway System.

His Texas son was living in different political terrain. Prescott Bush was a New England Republican in an era in which Republicans in New England could thrive. George H. W. Bush was in a state where Republican victories were remote and rare, which led the Texas businessmen and power brokers George and Herman Brown to ask Bush if he'd consider becoming a Democrat. "They mentioned several possibilities, including a chance at a U.S. Senate seat, if I crossed over and became a Democrat," Bush recalled. "The transition, they said, would be painless: In Texas there are really two Democratic parties—conservative Democrats on one side, liberal Democrats on the other. I'd just take my place at the conservative end of the Democratic spectrum." Had Bush been a nakedly ambitious man, the shift to the Democrats would have been an easy step and would have likely been

After winning the chairmanship of the Harris County GOP, Bush would run four campaigns in the 1960s—two for the U.S. Senate, in 1964 and in 1970, and two for the U.S. House from Texas's Seventh Congressional District, in 1966 and in 1968. Chapter-opening spread: The Bushes on the November night in 1966 when he won his seat in the House. Opposite: Images from the two Senate campaigns, both of which he would lose to Democrats. "Privately my own political philosophy had long been settled," Bush recalled. "I supported much of Harry Truman's foreign policy in the late 1940s. But I didn't like what he and the Democratic Party stood for in the way of big, centralized government—the attitude that 'Washington knows best' and the policies and programs it produced."

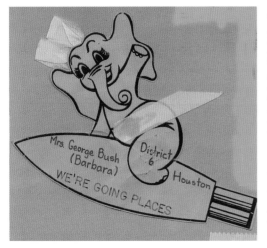

a smoother path to power. As much as he loved politics and desired office, however, Bush had his principles, and he would not abandon them. And so Bush said no. "Privately my own political philosophy had long been settled," he recalled. "I supported much of Harry Truman's foreign policy in the late 1940s. But I didn't like what he and the Democratic Party stood for in the way of big, centralized government—the attitude that 'Washington knows best' and the policies and programs it produced."

More and more Texans were coming to see things in roughly the same light. Eisenhower won the state twice, and the Republican John G. Tower had prevailed in the special election to fill Lyndon B. Johnson's Senate seat after LBJ was elected vice president in the 1960 race. In that context, Bush was particularly open to the appeal that was made to him in Houston in the spring of 1962 to run for chairman of the Harris County Republican Party in Houston.

The task at hand was clear: Build on Eisenhower's and Tower's successes while keeping the right-wing fringe, embodied in the anticommunist John Birch Society, out of power. Local Republicans thought Bush the perfect man for the job, and he jumped into the county race. He won the chairmanship and set about neutralizing the Birchers— quietly and without drama. "I found out that jugular politics—going for the opposition's throat—wasn't my style," Bush recalled. "It was a lesson carried over from my experience in business. When competition gets cutthroat, everybody loses. Sometimes confrontation is the only way to resolve problems—but only as a last resort, after all

other avenues have been explored." His strategy: Focus on the "nuts-and-bolts of party organization."

It was an example of his essentially empathetic nature. Always aware of what "the other guy" might be thinking and feeling, Bush disliked showiness and standoffs. He brought that personal style to the substance of grassroots politics in Harris County and would tend to revert to that posture down the decades. It made him a figure of good governance, if not always of winning politics.

The competing demands of those two related but still distinct realms—governance and campaign politics—were on display for Bush in his very first large competitive race, the 1964 battle for the U.S. Senate in Texas. As the Republican nominee, he challenged incumbent senator Ralph Yarborough, a populist Democrat. Though temperamentally moderate, Bush ran from the right in the party dominated at the time by Barry Goldwater, the conservative Arizona senator who defeated a liberal contender, Nelson Rockefeller, for the 1964 presidential nomination. "The nuts," Barbara remarked in the fall of 1963, "will never love" her husband, but the nuts were a reality to be dealt with, and Bush dealt with them by seeming to share many of their convictions. Like Goldwater, Bush opposed important provisions of the Civil Rights Act of 1964 and President Johnson's Medicare program. Yet his move rightward was not especially convincing, establishing another long-term pattern: Conservatives in the Goldwater mold would never really trust Bush, a man they saw as a soft elitist.

Nineteen sixty-four was the Democrats' hour. President Johnson polled 61.1 percent to Goldwater's 38.5 percent, losing only Arizona and five states of the Old Confederacy: Alabama, Georgia, Louisiana, Mississippi, and South Carolina. In Texas, Bush managed to win 44 percent of the vote against Yarborough, running ahead of

Opposite: Political mementos from the scrapbooks of Barbara Bush, including a badge of Bush's from the 1964 Republican National Convention at the Cow Palace in San Francisco that nominated Barry Goldwater and booed Nelson Rockefeller. Culturally more at home with New England Republicanism, Bush was more of a Sunbelt conservative than many commentators acknowledged—much to Bush's perennial frustration. To run in Texas, he insisted, one needed to be a Texas Republican. It wasn't much more complicated than that.

Rep Bush announces candidacy

By FELTON WEST
Chief, State Capital Bureau

AUSTIN — Ending one of the longest guessing games in Texas politics, Congressman George Bush put himself in the race Tuesday for the Republican nomination for Democrat Ralph W. Yarborough's United States Senate seat.

After making his announcement in a state capitol news conference, the 45-year-old Houston Republican started a fast flying tour of the state to spread the tidings at news conferences and receptions in nine other cities Tuesday and Wednesday.

His first stop was a news conference and

Please see Bush, page 8

George Bush ends speculation

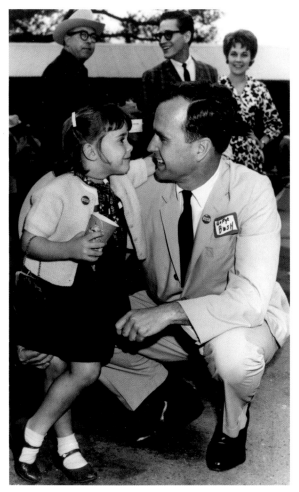

In carpool one day, a friend of Doro's told her that she had seen her father on television the night before. "Oh, you know," Doro replied, "it was about that erection he's going to have." In the 1966 House race, Bush defeated a popular Democrat, Frank Briscoe.

Goldwater's national showing. "I got murdered," Bush recalled of the Yarborough campaign. A week after the election, he wrote: "The Birchers are bad news and I don't like them a bit. They gave me a fit here in Houston and in other places in Texas and I think in retrospect I should have cracked down on them more. This mean humorless philosophy which says everybody should agree on absolutely everything is not good for the Republican Party or for our State. When the word moderation becomes a dirty word we have some soul searching to do."

That soul searching, interestingly, included thoughts from Ronald Reagan, the television host, former film actor, and General Electric corporate spokesman who had given a widely praised half-hour speech for Goldwater in late October. In a forum for William F. Buckley, Jr.'s, *National Review*, Reagan observed: "We represent the forgotten American—that simple soul who goes to work, bucks for a raise, takes out insurance, pays for his kids' schooling, contributes to his church and charity, and knows there just 'ain't no such thing as free lunch.'"

Comfortable in his skin, Reagan knew his base, and he saw the era in terms of a long "war for freedom"—freedom, in Reagan's view, from Communism abroad and from an allegedly intrusive federal government at home. Bush, in Texas, was less certain of what the future held. Struggling for a congenial political identity, he was not wholly at home with the changing GOP base. Reagan was a Goldwater Republican; Bush, an Eisenhower one. And the future was likely to belong more to the working-class Sunbelt than to the country-club East.

"GEORGE BUSH, HOUSTON businessman," *The New York Times* reported in March 1965, "is rated by political friend and foe alike as the Republicans' best prospect in Texas because of his attractive personal qualities and the strong campaign he put up for the Senate last year." Next up: a bid for the newly drawn Seventh Congressional District in Houston. Bush's ambitions were clear, at least in private. In a conversation with a potential Republican rival, Ross Baker, Bush said: "I'd like to be President. The chances are slight, but please don't limit me." Baker agreed to bow out.

It is striking that Bush, in his early forties, defeated in his only bid for office, was so set on scaling what he'd often call "the highest mountain in the world": the presidency. Yet there it was, the ambition, the *goal,* of reaching the pinnacle. And he kept after it.

In a memorandum for the 1966 campaign, Harry Treleaven, an ad man from J. Walter Thompson, laid out the Bush media strategy for the House race. "There'll be few opportunities for logical persuasion," Treleaven wrote, "which is all right—because probably more people vote for irrational, emotional reasons than professional politicians suspect." Candidates were now products, or what later generations would think of as personal brands. "Political candidates are celebrities," Treleaven wrote, "and today, with television taking them into everybody's home right along with Johnny Carson and Batman, they're more of a public attraction than ever."

Bush's brand in 1966—a big Republican year—was of a cheerful, energetic moderate conservative. Not threatening, not glowering, but upbeat and optimistic. "Too long, Republicans have been oblivious to poverty, the Negro ghettoes, inadequate housing, medical care needs, and a million other pressing problems that face our people," Bush said to the Texas Young Republican Federation in 1966. "I want conservatism to be sensitive and dynamic," Bush told *The Wall Street Journal,* "not scared and reactionary." It worked. On the same day Ronald Reagan was elected governor of California, Bush defeated the Democratic nominee for the House seat, Frank Briscoe, 57 to 42 percent.

Bush's most notable moment in his four years in the House came

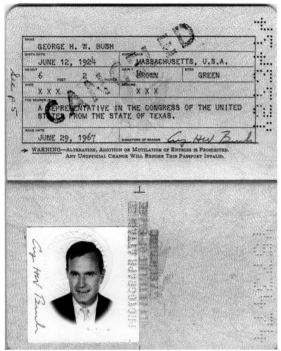

The interior of Bush's 1967 congressional passport.

in the wake of an American tragedy: the assassination, in the spring of 1968, of Martin Luther King, Jr. A bill to end racial discrimination in the housing market, the Fair Housing Act of 1968, had been languishing in Congress when the civil rights leader was murdered in Memphis. Six days after the shooting, Congressman Bush voted in favor of the bill.

Many in his district were furious. "There was a really rich guy here [in Houston]," Bush recalled. "His family was huge stockholders in Texaco or some huge oil company. And he was just ugly about it. 'We didn't put you up there to do this kind of thing—to sell out to the n———.' He couldn't have been uglier and meaner, and that just made me more determined to do what was right."

The showdown came in Houston, at Memorial High School on Wednesday, April 17, 1968. Bush told the audience that the "base and mean emotionalism" of his racist attackers "makes me bow my head in sadness." He continued:

> In Vietnam I chatted with many Negro soldiers. They were fighting, and some were dying, for the ideals of this Country; some talked about coming back to get married and to start their lives over.
>
> Somehow it seems fundamental that this guy should have a hope. . . .
>
> In these troubled times, fair play is basic. The right to hope is basic.

The chaotic presidential election of 1968 between Richard Nixon and Hubert Humphrey also gave Bush a chance to speak out against extremism, in this case against the third-party bid of the segregationist Alabama governor George C. Wallace. Wallace, Bush said, "is

conservative on the issue of race alone—of keeping someone in his place." With his vote for fair housing and his words against Wallace, who would poll a disturbingly high 13.5 percent of the popular vote, Bush did the right thing once in office, atoning, to some extent, for his opposition to the Civil Rights Act during the 1964 campaign. This, too, would be a pattern in Bush's life: running right on the trail, then acting courageously once in office.

The next office he wanted? That elusive seat in the Senate. In the spring of 1969, Bush went to see former president Johnson at the LBJ Ranch in Stonewall, Texas, to ask his advice. What did Johnson think—should Bush stay in the House, or risk a race for the Senate? "Son," Johnson said, "I've served in the House. And I've been privileged to serve in the Senate, too. And they're both good places to serve. So I wouldn't begin to advise you what to do, except to say this—that the difference between being a member of the Senate and a member of the House is the difference between chicken *salad* and chicken *shit*." The former president paused. "Do I make my point?"

For Bush, the 1970 Senate campaign felt right. He thought it would be a rematch against Yarborough, but John Connally, the former Democratic governor and power broker, helped bring another young congressman, Lloyd Bentsen, into the race, which Bentsen ultimately won by running as a conservative Democrat.

Thus began a new and formative chapter in Bush's life: a series of appointive jobs at the highest levels that would enable him to argue, in 1980, that he would be "A President We Don't Have to Train."

FROM THE AMBASSADORSHIP to the United Nations to the chairmanship of the Republican National Committee to envoy to China to director of Central Intelligence, Bush was a survivor in the wars of the Washington of Nixon and Ford. In this fraught time of changing geopolitical realities, an enduring Cold War with the Soviets, Watergate, and CIA scandals, Bush held posts that taught him the details of diplomacy, the intricacies of governance, the centrality of human relationships, and the possibilities—as well as the limits—of public action.

Throughout, remarkably, Bush and many in the political world thought it entirely plausible that he would one day be president. And "remarkably" is the right word, for Bush had no traditional political base. Presidents tended to be those who had won elections, often in large, complicated states. (As an army general, Eisenhower was an exception, as was Herbert Hoover, who had been a member

of the cabinet, but the point holds.) Bush had *lost* the two statewide races he had run, and yet the expectation that he was destined for the highest office was always there, even among his numerous rivals. In announcing Bush's appointment to the United Nations in February 1971, President Nixon alluded to the possibility of a greater future ahead for Bush. Citing a conversation with Ways and Means chairman Wilbur Mills, Nixon said: "Chairman Mills pointed out that William McKinley at one time had been defeated for office in Ohio running for the Congress. Two years later, however, William McKinley went on to be elected as Governor of Ohio, and then went on to be elected as President of the United States. Now, I don't know whether Chairman Mills was suggesting that defeat, therefore, was good for George Bush and that his future may be somewhat like William McKinley's."

After a turn in New York at the United Nations and on the global stage, Bush was summoned to Camp David to meet with the newly reelected Nixon. Senator Bob Dole of Kansas had been chairing the Republican National Committee, but Nixon wanted a fresh face at the RNC as he sketched out nothing less than a new fusion party of Republicans and disaffected Democrats. Bush, the president believed, would be useful in the role—a prospect that left Bush largely cold. The UN ambassadorship was like a rolling mixer with important (or at least important-seeming) stakes. The RNC chairmanship was the grubbiest of political jobs and would mean Bush would go from the pinnacle back to precinct-level politics. But Bush was a

traditionalist, and he believed it his duty to salute the president when asked.

There was something else, too: what had become known as Watergate, an unfolding series of scandals and likely criminal activity associated with the Nixon White House's political espionage operations. Bush's miserable task in 1973 and into the summer of 1974 was to defend President Nixon amid seemingly endless revelations of wrongdoing. A party man, Bush did it—but he was uncomfortable in the role. "I feel battered and disillusioned," he wrote in late July 1974. At last came the White House tape that captured Nixon's ordering a cover-up of the investigation of the Watergate break-in, a recording that cost the president the support of figures such as Barry Goldwater—and George H. W. Bush. On Wednesday, August 7, 1974, Bush wrote Nixon.

Dear Mr. President,

It is my considered judgment that you should now resign. I expect in your lonely embattled position this would seem to you as an act of disloyalty from one you have supported and helped in so many ways.

My own view is that I would now ill serve a President, whose massive accomplishments I will always respect and whose family I love, if I did not now give you my judgment.

Until this moment resignation has been no answer at all, but given the impact of the latest development, and it will be a lasting one, I now firmly feel resignation is best for this country, best for this President. I believe this view is held by most Republican leaders across the country.

This letter is made much more difficult because of the gratitude I will always have for you.

If you do leave office history will properly record your achievements with a lasting respect.

To Bush, the constitutional order—however imperfect—was resilient. Wrong had been done in Nixon's White House, but right

had prevailed. "Personalities will change," Bush wrote, "and our system will have proved that it works—more slowly than some would want—less efficiently than some would decree—but it works and gives us—even in adversity—great stability."

To his sons, Bush summarized the lessons of Watergate:

Listen to your conscience. Don't be afraid not to join the mob—if you feel inside it's wrong.

Don't confuse being "soft" with seeing the other guy's point of view.

In judging your President give him the enormous credit he's due for substantive achievements. Try to understand the "why" of the National Security concern; but understand too that the power accompanied by arrogance is very dangerous. It's particularly dangerous when men with no real experience have it—for they can abuse our great institutions.

Avoid self-righteously turning on a friend, but have your friendship mean enough that you would be willing to share with your friend your judgment.

Don't assign away your judgment to achieve power.

It was a measure of Bush's standing in Washington and in the party more generally that he was in the running to be chosen as Gerald Ford's vice president. He came in second (Nelson Rockefeller of New York was appointed), and then talked to President Ford about possibly becoming White House chief of staff. That was not to be, and Ford offered Bush a range of diplomatic postings—London, perhaps, or Paris. At this point—likely exhausted first by Watergate and then by the whirlwind of speculation about what role he might play—Bush suggested something about as far afield from Washington as one could get: becoming America's envoy to China.

In a historic move, Nixon had opened diplomatic relations with the vast nation in 1972. Bush would not have the rank of ambassador—relations would not be fully "normalized" until the Carter administration—but he functioned as America's highest-ranking diplomat in Beijing from 1974 to 1975. He loved the post; it was Yale and the United Nations all over again, with a premium

on personal relationships. Bush also learned patience in China by experiencing how the country viewed politics and history in the longest of terms.

Back in Washington in the fall of 1975, while Bush was bicycling around Beijing and learning to live with the opaque nature of Chinese life and politics, the Ford administration was resetting itself as the president prepared to seek election in 1976—a year that would bring a primary challenge to the largely centrist Ford from the right from Ronald Reagan. An element of the shuffle was the appointment of George H. W. Bush to be director of Central Intelligence—news that surprised the American envoy to China when it reached him in a telegram from Secretary of State Henry Kissinger. "Your message came as a total and complete shock," Bush wrote on Sunday, November 2. "Henry, you did not know my father," Bush wrote. "The President did. My Dad inculcated into his sons a set of values that have served me well in my own short public life. One of these values quite simply is that one should serve his country and his President."

But Bush was not happy about it. As he recalled, he believed that the CIA post meant he would "return to Washington and take charge of an agency battered by a decade of hostile Congressional investigations . . . and charges that ran from lawbreaking to simple incompetence." And the dream of his life—the winning of elections—was likely at an end. "In the best of times the CIA job wouldn't be considered a springboard to higher office, if only because the director of the agency has to be nonpolitical," Bush recalled. "Anyone who took the job would have to give up any and all political activity. As far as future prospects for elective office were concerned, the CIA was marked DEAD END." Yet he did it—out of conscience and out of loyalty to a code of service. This isn't a sentimental reading of the events of the fall of 1975: The contemporary record confirms that Bush knew the CIA job would take him out of the running for the vice-presidential nomination in 1976 and perhaps beyond. "I think this probably spells the end to all politics," Bush, now fifty-one, wrote a friend on Thursday, November 6, 1975.

Bush critics long sought to portray him as a kind of craven figure, an ambitious office seeker who courted presidents in order to win a series of posts that built a résumé but left few substantive footprints. That caricature fails to take note of his self-denying acceptance of the CIA appointment. In that hour, in the middle of his life in the middle of the 1970s, George Bush put country first and himself last. As things turned out, of course, the CIA was not the end of the story—but Bush did not know that then.

A year later, in the 1976 general election, Jimmy Carter of Georgia narrowly defeated President Ford, returning the White House to the Democrats. Bush had been in federal service for a decade, since the 1966 victory in the Seventh District. He'd been in the House, at the United Nations in New York, at the RNC, in China, and at the CIA. Now it was time to go home.

For a moment.

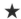

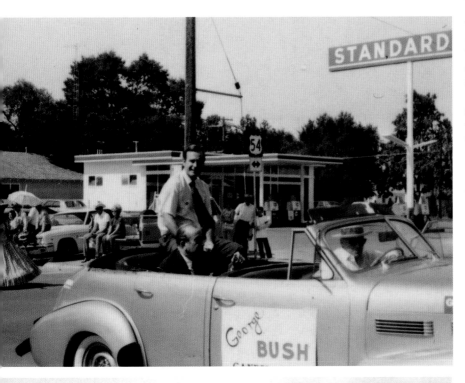

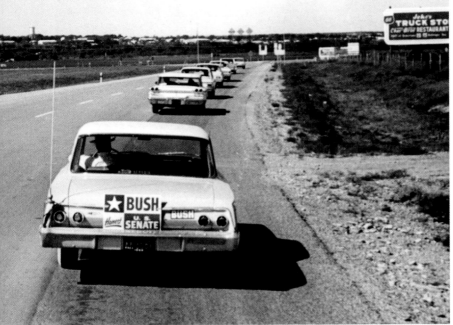

The 1964 Senate campaign against Democratic incumbent Ralph Yarborough was the opening chapter of the rest of the Bushes' lives. It was a blur of handshaking, reception-going, fundraising, speechmaking, and interview-giving. James Leonard, a GOP operative whom Bush hired to manage the race, was unsparing in his counsel to the candidate. "He'd go over to these yokels and call Yarborough a 'profligate spender'—and nobody knew what the hell 'profligate' meant," Leonard recalled. "It sounded like some kind of sexual thing. So I said, 'George, don't use that word again.' I thought he was going to fire me. I pushed him more than he wanted me to—'Do this, do that.' He didn't always like it, but he did it all." One day Bush showed up for a round of campaigning in a striped tie. "'Take that thing off,'" Leonard told him, and Bush, Leonard recalled, looked as if "he wanted to hit me." Bush had bought a Mercedes but sold it in favor of a dark-green Chrysler. "No foreign car driver in our Senator!" Barbara observed. The biggest problem was Bush's eastern background. "George H. W. Bush" became just "George Bush," but the name tweak did nothing to alleviate the Texas conspiratorial whispers that the Ivy League Bush was a tool of the Eastern Establishment. Even Barbara's father, Marvin Pierce, was dragged into things when he was attacked for publishing *Redbook*—the women's magazine that right-wingers claimed was a Communist front. Most of all, though, there was the candidate's seemingly boundless enthusiasm. "I thought I could win," Bush recalled.

Early on in Texas politics, Barbara learned how to make the endless hours of speeches and presentations endurable and even productive: She preferred to sit in the audience, rather than onstage, so that she could unobtrusively needlepoint. Bush once asked her what he should speak about. "About five minutes, George," Barbara replied.

the MAN for the job in the U. S. SENATE

GEORGE BUSH

SUCCESS — from scholar to business executive.

SERVICE — to his country, to his industry, to the rights of the individual.

SINCERITY— in his every act, in his devotion to better government for all.

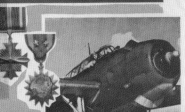

As A W.W. II Navy pilot, Ensign George Bush won three Air Medals and a Distinguished Flying Cross that was awarded for valor in continuing a heroic bombing attack although his plane was in flames. He parachuted into the sea and was rescued by a submarine.

After the war, Bush earned his B.A. in economics in only two and a half years, qualifying for Phi Beta Kappa honor fraternity.

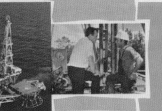

After graduation, he took a job in the oil industry in Odessa. In 1951 he formed his own business in Midland, and later founded Zapata Off-Shore Co., which he now heads.

Under his leadership, Zapata has gained an international reputation as a drilling company and Bush's worldwide travels provide him with an extensive knowledge of his own country and its neighbors throughout the world — a great asset to a prospective senator.

In 1956, the Junior Chamber of Commerce of Texas named non-member Bush as one of the "Five Outstanding Young Texans."

Bush was Midland County Chairman of the Eisenhower-Nixon campaign in 1952 and 1956.

In the belief that the nation's business leaders must take part in political life, Bush carries the conservative message across the state of Texas. From the rose gardens at Tyler to the heartland of the Texas oil and cattle industries, in countless personal contacts and public appearances, Bush has taken a firm stand on every major issue.

George and his wife, Barbara, have five children: Dorothy, 5; Jeb, 11; Neil, 9; Marvin, 7; and George, 18. No accomplishment in business, civic affairs or politics gives George a greater sense of pride than that he feels for his family.

From St. Martin's Episcopal Church which they attend together, to back yard barbecues, to sports which are an important part of their lives, this close-knit family exemplifies the ideal of American family life.

The Bush home, at 5525 Briar Drive in Houston, is also a center of campaign activities with every family member working for George's election.

VOTE FOR GEORGE BUSH *A step in the right direction for integrity and honesty in government.*

Bush was a pioneering Republican in Texas politics—and that after considering, if only briefly, switching parties. The leading Texas businessman George Brown, of Brown & Root Construction Company, argued that Bush should become a part of the conservative wing of the state Democratic Party, thus opening endless possibilities. "The transition, they said, would be painless: In Texas there are really two Democratic parties— conservative Democrats on one side, liberal Democrats on the other," Bush recalled. "I'd just take my place at the conservative end of the Democratic spectrum." But he couldn't do it. The pull of his father's political ties to the Republican Party—Prescott Bush was a serving Republican senator from Connecticut until 1962—and his own disposition made him most comfortable in the GOP. "Philosophically, I was a Republican, and the idea of a party switch didn't sit well with me," Bush recalled. "Besides, fresh winds were blowing in Texas politics. . . . Texas Democrats had grown fat and complacent. I felt they'd lost touch with the people. A new generation of Texans had come up, young people more interested in the future than in horror stories about Reconstruction and Herbert Hoover. These were the voters who could turn Texas into a genuine two-party state."

Bush was buried in the LBJ presidential landslide of 1964. But he had been bitten by the political bug, and by early 1966 had announced his candidacy for the U.S. House from Houston. Bush had just turned forty. He hired J. Walter Thompson, the national advertising agency. "Political candidates are celebrities, and today, with television taking them into everybody's home right along with Johnny Carson and Batman, they're more of a public attraction than ever," wrote Harry Treleaven, an ad man who worked on Bush's House race. "Bush must convince voters that he really wants to be elected and is working hard to earn their vote."

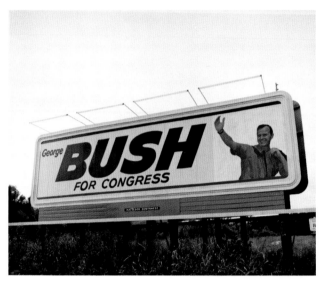

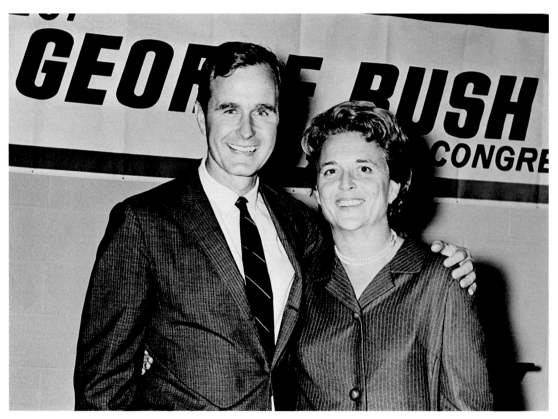

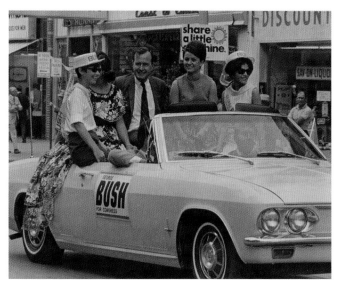

Bush preached a gospel of moderate conservatism. "Too long, Republicans have been oblivious to poverty, the Negro ghettoes, inadequate housing, medical care needs, and a million other pressing problems that face our people," Bush told the Texas Young Republican Federation in 1966. "I want [the Republican Party's] conservatism to be sensitive and dynamic," *The Wall Street Journal* reported Bush as saying, "not scared and reactionary." In the end, he prevailed in the general election, defeating Frank Briscoe 57 to 42 percent on a big night for Republicans nationally. Another winner that evening: Ronald Reagan took the California governorship from Edmund G. "Pat" Brown; and former vice president Richard Nixon, a tireless Republican campaigner in the midterms, believed he saw a path back to power.

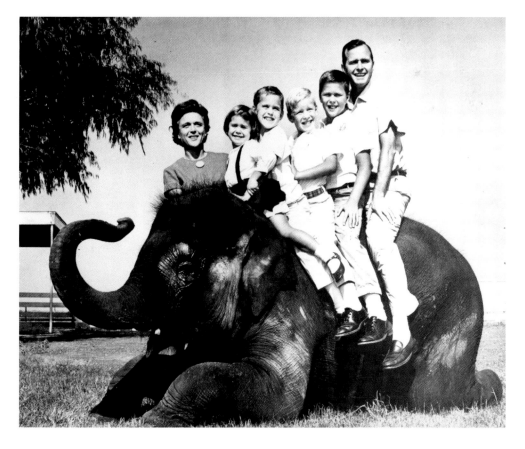

NEIGHBORHOOD Round-Up

Home Edition
Only 5¢

March 15/6?

Staff

Editor! Rob Kerr
Co-Editor! Jeb Bush
Reporter! Randy Swanson
Reporter! Stewart Gates
Reporter! Thad Grundy
Reporter! Mary N. Bush
Reporter! Neil Bush
Reporter! Bill Thawley.

SPORTS

Colts Never Give Up

The Houston Colts never give up. They came from behind every time they've played; 4-0, 5-0, 4-0, and the last game they played, 9-0. The Colts are surely a late inning scoring team.

Planets

Some planets are large,
while some are pretty small,
Jupiter and Saturn are the largest ones,
But there are 9 in all.
Mercury is closest to the sun,
Next is the Evening Star,
Then comes the well-known Earth,
Where ~~every~~, all the people are

Ads

For 5¢ you can fill this space.

SH-21649 for information.

Coming Back

George Bush and Huron Head have come home prep school. There are coming home for spring vacation.

```
        B
        U
 B  U  N  A  B  S
        A       call Saturday
        B
        S
```

Jokes

Boy! Have you had the memory test!
Girl: No.
Boy: What is the color of your shirt?
Girl: Blue
Boy: your dress?
Girl: Red.
Boy! What was the first question I asked?
Girl: What is the color of your shirt.
Boy: Wrong! Have you had the memory test.

A neighborhood newspaper, co-edited by Jeb Bush, and 1966 Bush campaign literature. In Washington, Congressman Bush was remarkably bipartisan in his votes, backing President Johnson–supported bills 53.5 percent of the time. In his second term, under President Nixon, Bush voted with the administration 55 percent of the time—essentially the same percentage. Bush lobbied hard for a rare freshman's seat on the powerful Ways and Means Committee.

George Bush just plain has more of what it takes to be a great Congressman!

A Congressman today — to be really effective — must know a lot about many different things. He needs a *variety* of experience behind him. That's why George Bush is so uniquely qualified to serve in Congress. He's done a lot, seen a lot, solved a lot of problems. George Bush not only knows Texas — he'll know how to get things done in Washington, too. Elect George Bush to Congress — and watch the action!

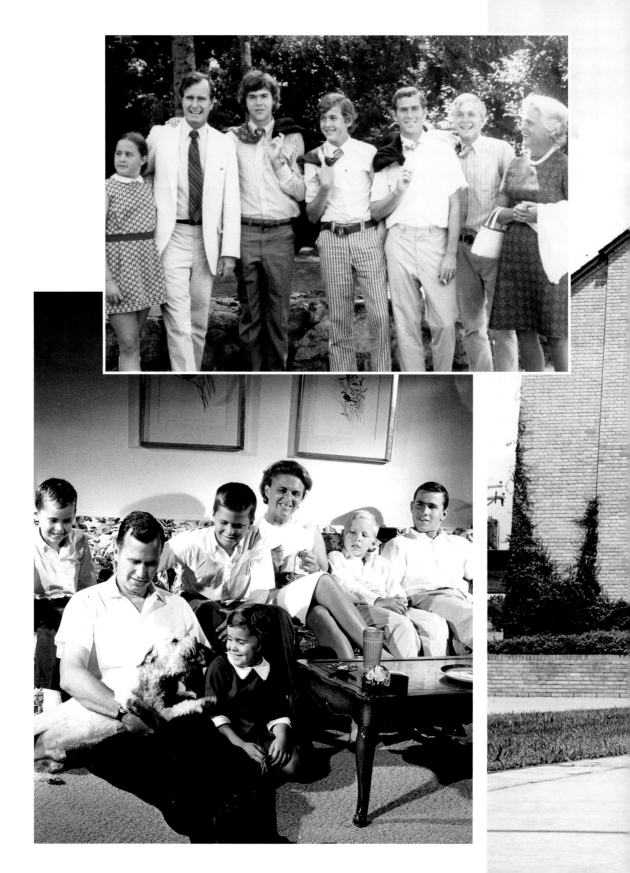

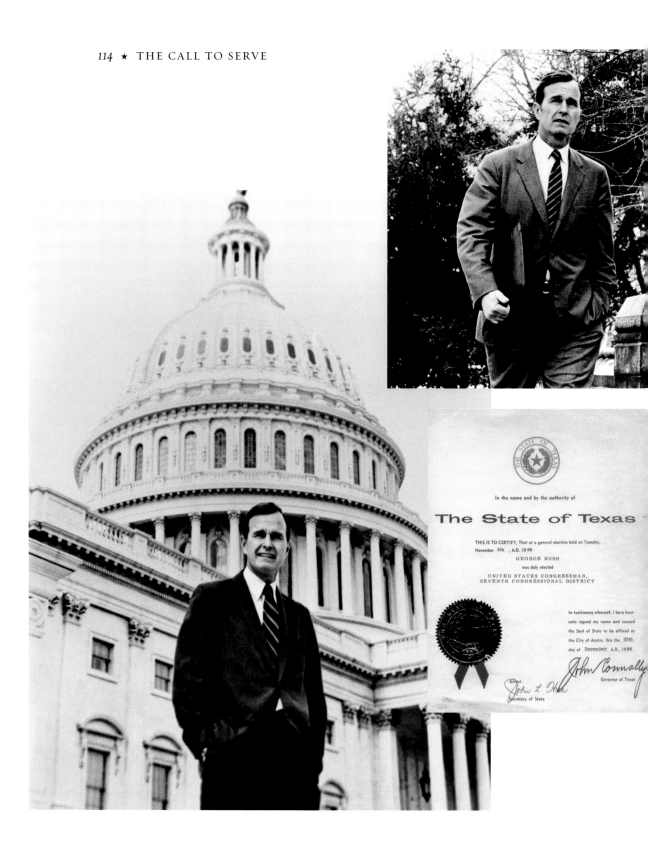

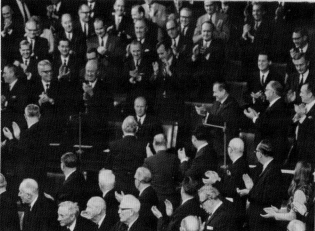

Jan. 1969 PRESIDENT JOHNSONS "STATE OF THE UNION
Address —"

HOUSTON CHRONICLE
Page 8, Section 1 Friday, January 17, 1969

HOUSTON CONGRESSMAN'S WIFE AT WASHINGTON RECEPTION
(L. to r.) Mrs. Jim Collins, wife of the new GOP Representative from Dallas; Mrs. Gerald Ford, wife of the House
Minority Leader; Mrs. George Bush and Mrs. Peter Dominick, wife of the Colorado senator.

Barbara Bush, attractive spouse of Congressman George,
is program chairman for the Republican Congressional
Women's Club in Washington. She was among the guests
recently at a reception at the Woodrow Wilson Library Room
of the Library of Congress.

Barbara and I are having an open house on.

Saturday, January 18th

Time: 6:00 - 8:30

Place: 5161 Palisade Lane, N.W.,
Washington, D.C.

Taxi instructions:

Palisade is only 2 blocks long. It dead
ends into Loughboro Road. It is one block
from Sibley Hospital.

If coming from town or from the Hill, go
out Whitehurst Freeway to Foxhall Road.
Go to the end of Foxhall. Turn left on
Loughboro Road. Turn left on Palisade
(just before Sibley Hospital).

If lost -- call 362-1314 257 signed
 guest book Sat.
Hope you can make it. night.

Note: Come by my office for coffee and a snack on
Monday, January 20th, 1608 Longworth House
Office Building.

1969
Inaugural Ball

THE
INAUGURAL
BALL

WASHINGTON HILTON HOTEL
Monday Evening, January 20, 1969
NINE O'CLOCK
WASHINGTON, D.C.

226

White Tie
Black Tie Optional

Inauguration Ceremonies

January Twentieth 1969

The bearer is a
MEMBER OF THE HOUSE OF REPRESENTATIVES
Admit to the House Wing of the Capitol
and to the Platform

NOT TRANSFERABLE Chairman,
 Committee on Arrangements

Platform

Inauguration Ceremonies

January Twentieth 1969

admit bearer to the Inaugural Stands
East Front of Capitol

THIS CARD DOES NOT Chairman,
ADMIT TO CAPITOL BUILDING Committee on Arrangements

Section D

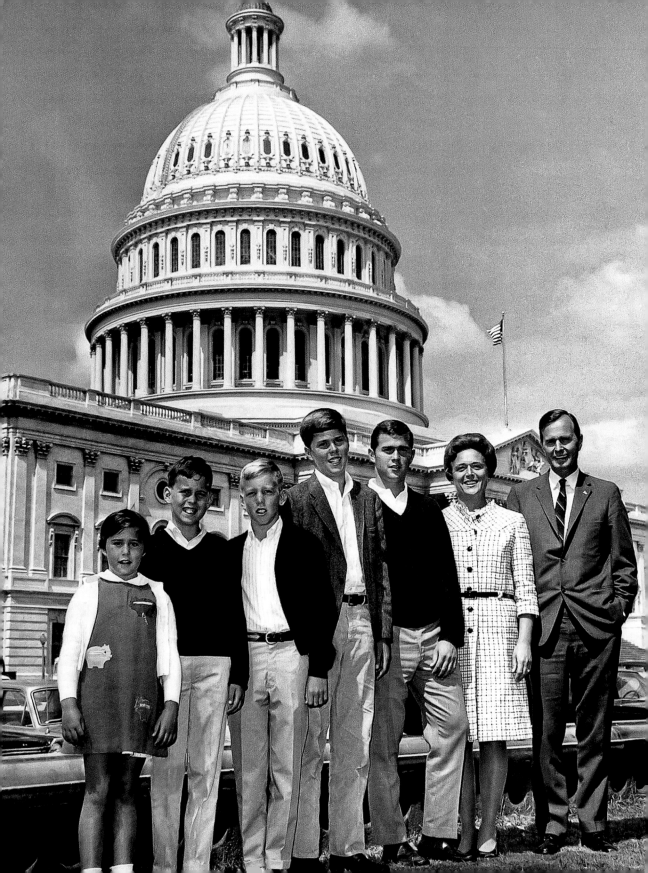

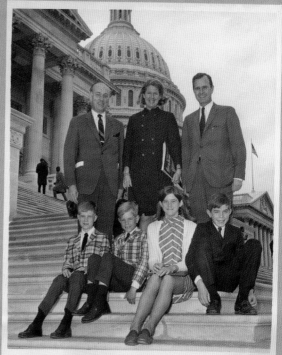

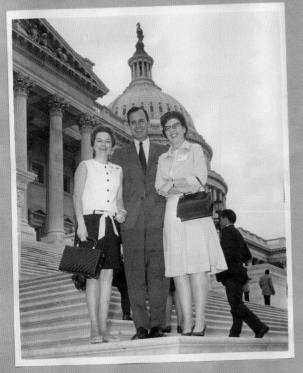

APR 3 1968

The President and Mrs. Johnson

request the pleasure of the company of

Mr. and Mrs. Bush

at dinner

on Monday, April 29, 1968

at eight o'clock

Black Tie

Please send response to
The Social Secretary
The White House
at your earliest convenience

DINNER

Wade
Sauvignon Chesapeake Crabmeat Mousse
Blanc

Mathini Medallion of Veal Zingara
Pinot Noir Duchess Potatoes
 Green Beans Amandine

 Salad Caprice
 Brie

Almaden
Blanc de Blancs
 Strawberry Crêpes

The White House
Monday, April 29, 1968

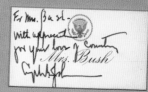

THE VICE PRESIDENT
WASHINGTON

November 30, 1966

Dear Mr. Bush:

I wish to take this opportunity to congratu-
late you on your recent election victory.

I look forward to working with you in the 90th
Congress. Hopefully the coming weeks may be a period
of relaxation for you and your family.

The opening of the new Congress will soon be
upon us.

Best wishes.

Sincerely,

Hubert H. Humphrey
Hubert H. Humphrey

The Honorable George Bush
U. S. Congressman-Elect
Houston Club Building
Houston, Texas

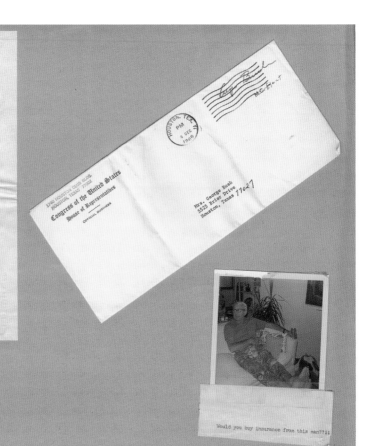

Would you buy insurance from this man??!!

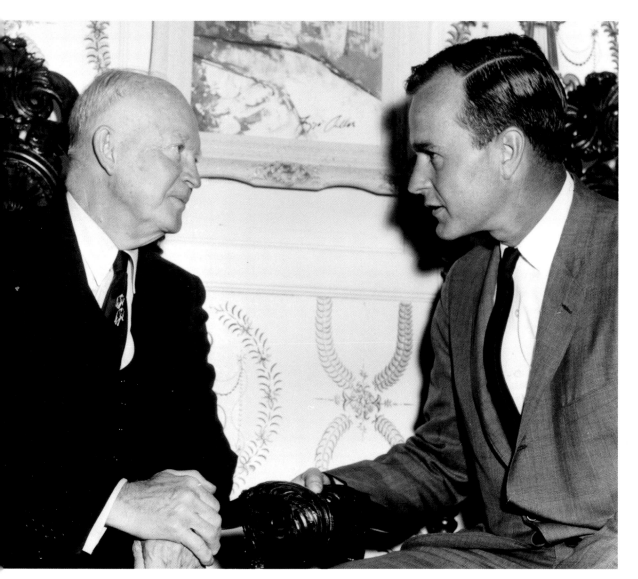

President Eisenhower was a friend and golfing partner of Prescott Bush's—known as the best golfer in the Senate, Bush was a popular figure in such circles—and welcomed George H. W. Bush to the world of Republican politics in 1964. Ike's widow, Mamie, later recalled that Eisenhower, who died in 1969, had a high private opinion of the young Bush and thought his old friend's son had the makings of a future president. For his part, Bush, who hosted the thirty-fourth president's centennial in the White House in 1990, admired Eisenhower's calm approach to the storm of politics, commending Eisenhower's presidential motto: "'Gently in manner, strongly in deed.'"

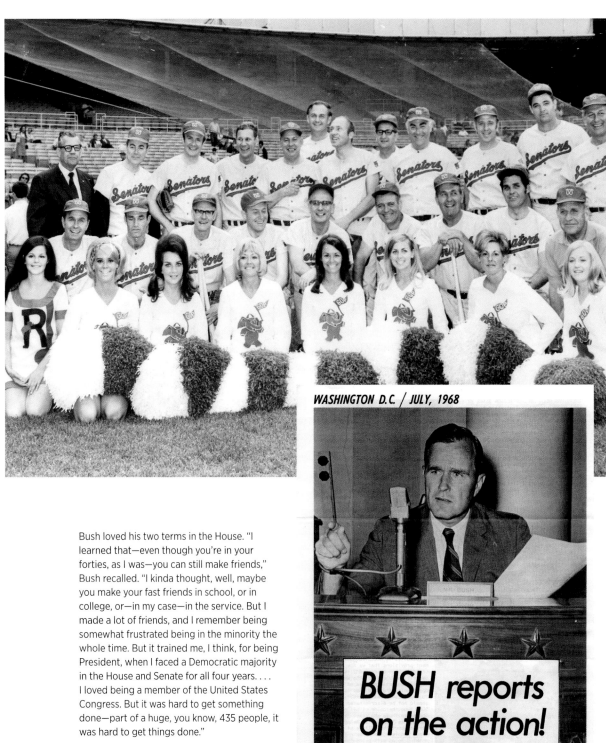

BUSH reports on the action!

Bush loved his two terms in the House. "I learned that—even though you're in your forties, as I was—you can still make friends," Bush recalled. "I kinda thought, well, maybe you make your fast friends in school, or in college, or—in my case—in the service. But I made a lot of friends, and I remember being somewhat frustrated being in the minority the whole time. But it trained me, I think, for being President, when I faced a Democratic majority in the House and Senate for all four years. . . . I loved being a member of the United States Congress. But it was hard to get something done—part of a huge, you know, 435 people, it was hard to get things done."

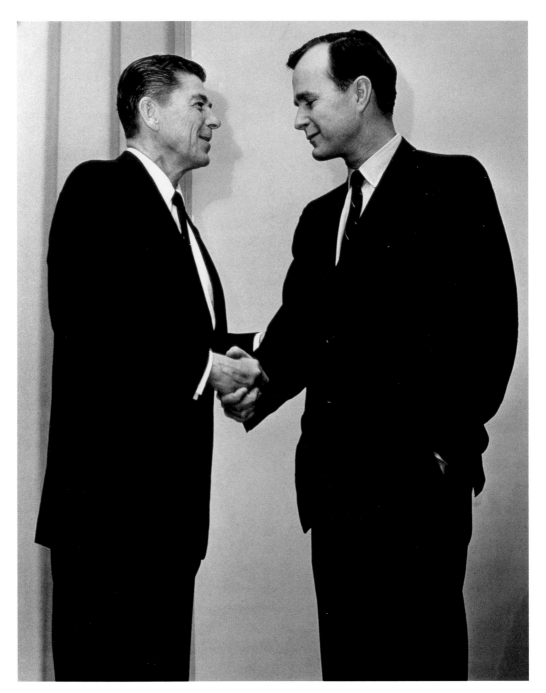

They were very different men. A son of modest circumstances in the Midwest, Ronald Reagan was thirteen years older than George H. W. Bush, who was the child of a monied world in the East. And they represented competing elements of the Republican Party. Reagan was the Sunbelt conservative, comfortable with antigovernment rhetoric; Bush was from the Eisenhower tradition of moderation and restraint. And yet their ultimate political partnership worked—not least because they were both determined that it would.

In the aftermath of Dr. King's assassination in Memphis in the spring of 1968, Bush cast a courageous vote for the Fair Housing Act and visited Resurrection City, an encampment in Washington that was the centerpiece of King's antipoverty Poor People's Campaign. Here he is pictured with the Reverend Ralph Abernathy, King's invaluable ally. Bush's determination to support the 1968 civil rights law was controversial at home in Houston, where angry constituents demanded to know how he could vote for what was seen as a liberal Great Society measure. "I voted for the bill and the roof is falling in—boy does the hate surface," he told a friend. The "base and mean emotionalism" of racist attacks on his decision, Bush said during a public meeting at Memorial High School in April 1968, "makes me bow my head in sadness." After his tour of Resurrection City, he told *The Dallas Morning News:* "I think it is important for members of Congress to know what is happening and to try to understand it."

At Christmastime 1967, Congressman Bush toured Vietnam. The war was increasingly unpopular at home—by March 1968 President Johnson would announce his decision not to seek reelection—and Bush wanted to see the war for himself. He was like many Republicans (and many Democrats): He wanted to support the war effort and was simultaneously worried about fractures on the domestic scene. "We believe in freedom of speech," Barbara wrote after discussing the trip with her husband, "but it does seem tough to have our enemy think that a small group [of antiwar protestors] speaks for our country, and therefore prolong this hideous war. Whether or not this is actually true I don't know, but the military men that G. talked to seemed to feel that this was keeping the enemy away from any peace talks." In Vietnam he met with officers and enlisted men as well as South Vietnamese allies of the American forces. He long understood the division the war caused at home, even alluding to Vietnam as a turning point (toward the worse) in his 1989 inaugural address. "For Congress, too, has changed in our time," Bush would say then. "There has grown a certain divisiveness. We have seen the hard looks and heard the statements in which not each other's ideas are challenged, but each other's motives. And our great parties have too often been far apart and untrusting of each other. It has been this way since Vietnam. That war cleaves us still. But, friends, that war began in earnest a quarter of a century ago; and surely the statute of limitations has been reached. This is a fact: The final lesson of Vietnam is that no great nation can long afford to be sundered by a memory. A new breeze is blowing, and the old bipartisanship must be made new again."

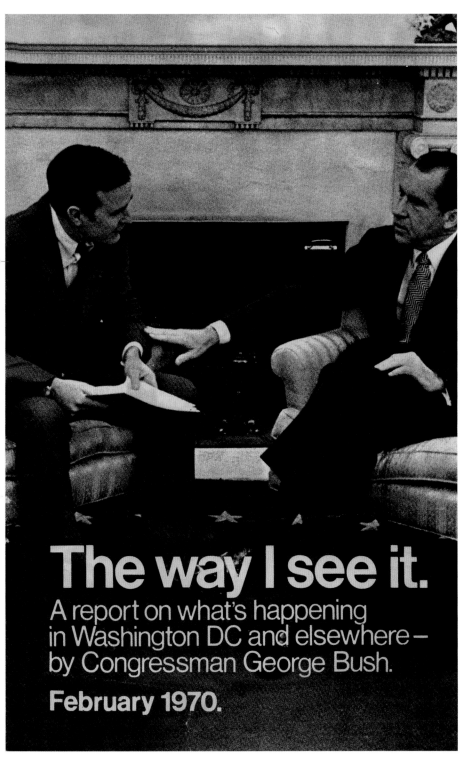

The way I see it.
A report on what's happening in Washington DC and elsewhere – by Congressman George Bush.

February 1970.

As the 1970 midterm elections approached, Bush pondered another run for the U.S. Senate. President Nixon was enthusiastic, as was Barbara. "He just must get to the Senate where he can have the national forum he wants," she wrote in February 1969. Bush was also curious about what Lyndon Johnson thought of his chances. And so the Republican congressman flew to the Democratic former president's ranch in Stonewall, Texas, for a quiet conversation. "Mr. President, I've still got a decision to make and I'd like your advice," Bush said. "My House seat is secure—no opposition last time—and I've got a position on Ways and Means. I don't mind taking risks, but in a few more terms, I'll have seniority on a powerful committee. I'm just not sure it's a gamble I should take, whether it's really worth it." "Son," LBJ replied, "I've served in the House. And I've been privileged to serve in the Senate, too. And they're both good places to serve. So I wouldn't begin to advise you what to do, except to say this—that the difference between being a member of the Senate and a member of the House is the difference between chicken *salad* and chicken *shit*. Do I make my point?" The next month, Bush met with Nixon. The decision was to go. "The President said that he'd like GB to run and would help him," Barbara wrote. To friends, Bush announced: "We are moving into a new decade. The tired, old answers of the past are not good enough for the '70s. Texas needs a positive and constructive voice that will be respected by President Nixon whether in support of his programs or in criticism."

Bush expected to be running against Ralph Yarborough for a second time, but that was not to be. John Connally, the longtime LBJ ally who had been wounded in Dealey Plaza in the attack on John F. Kennedy, was still a Democrat (he would soon switch parties) and feared Bush's rise. In part through Connally's maneuverings, the Texas Democratic Party nominated not Yarborough but forty-nine-year-old Lloyd Bentsen, a former Democratic congressman from the Rio Grande Valley. This was a blow to Bush, who had planned to portray Yarborough as a fading liberal relic of a populist past. Now the choice was fuzzier. *The Dallas Morning News* wrote that a Bush-Bentsen campaign meant that Texans "will be confronted with having to decide between two attractive, well educated, affluent and capable candidates. Bentsen and Bush even look a bit alike. There is not two cents' worth of difference in their basic political philosophies." The Bush team argued that he was the man who could "do more" for Texas. "Our problem was that both men were very much alike," the ad man Harry Treleaven explained to *The Wall Street Journal.* "They're about the same age, both are businessmen, both moderately conservative with about the same views on major issues. So we decided to make effectiveness an issue: Who can do more for Texas? More for the country? More for the people?" The strategy might have worked but for a down-ballot amendment legalizing liquor by the drink that turned out an unusual number of Democrats in East Texas. "Like Custer, who said there were just too many Indians, I guess there were just too many Democrats," Bush joked after he lost 53.5 to 46.5 percent.

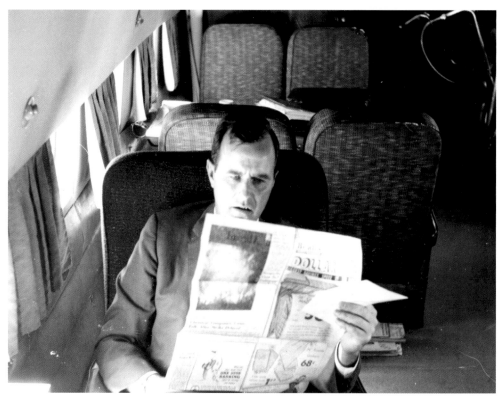

Senors y Senoritas para Bush !!!

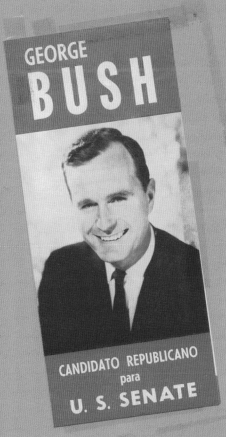

GEORGE BUSH
CANDIDATO REPUBLICANO
para
U. S. SENATE

EL HOMBRE Y CANDIDATO para U. S. SENATE

EXITO En 1943 el tenia 18 años de edad el Teniente Bush recibio sus alas como piloto en la base naval de Corpus Christi. Su valor le gano tres medallas y la cruz de Distincion por seguido el heroico ataque aereo a pesar de estar su avion en llamas.

EXITO Despues de la guerra, Bush obtuvo su Bachiller de Artes en economia en dos y medio anos de estudio llegando a ser cualificado para ser miembro de la sociedad honoraria Phi Beta Kappa.

EXITO Despues de graduar obtuvo empleo en la industria petrolera en Odessa. En 1951 el formo su propio negocio en Midland, y despues fundo la Zapata Offshore Co. la cual el sirve de presidente.

George y su esposa, Barbara, tienen cinco de familia — Dorothy, 4; Jeb, 10; Neil, 8; Marvin, 7; y George 17. Ningun exito en negocios, asuntos civicos o politicos le causan mas orgulla a George, que lo que siente por su familia.

Ellos viven en 5525 Briar Drive en Houston, y juntos atienden a la Iglesia Episcopal de San Martin.

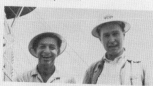

George Bush y Joe Tullos, trabajador de la Zapata en unas de las plataformas de perforacion.

EXITO Bajo su direccion de la Compania Zapata ha obtenido reputacion internacional y las operaciones mundiales de Bush le han dejado un conocimiento de su pais y sus vecinos al derredor del mundo, una gran ayuda a un senador.

Barbara es una buena madre y senora de hogar. Ambos George y su esposa pasan el mas tiempo posible con sus ninos.

VOTE POR GEORGE BUSH para U. S. SENATE

Amigos For BUSH

MADE IN TEXAS BY LATINOS LU 550

THE WHITE HOUSE

WASHINGTON

September 9, 1970

Dear George:

America is at a key point in her history,
and we must have the best available men
and women in the Senate if we are to
continue making progress as a free nation.

You have been an outstanding advocate for
the people in the House of Representatives
where you have served with dedication and
initiative. I have every hope that the
voters of Texas will seize the oppor-
tunity to continue your work on their
behalf and for our nation as a member of
the United States Senate.

With best personal regards,

Sincerely,

Richard Nixon

Honorable George Bush
House of Representatives
Washington, D.C.

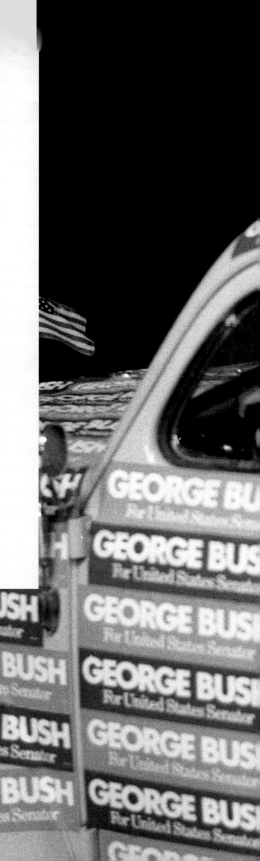

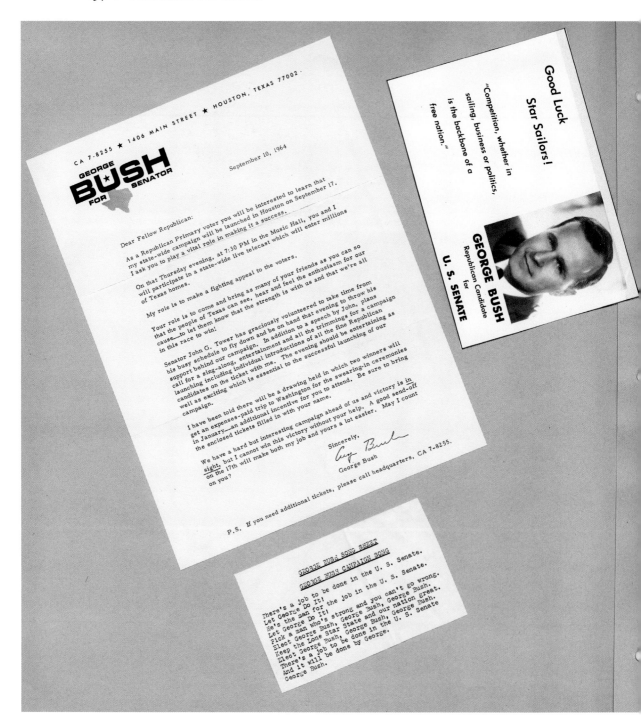

CA 7-8255 ★ 1406 MAIN STREET ★ HOUSTON, TEXAS 77002

GEORGE **BUSH** FOR SENATOR

September 10, 1964

Dear Fellow Republican:

As a Republican Primary voter you will be interested to learn that
my state-wide campaign will be launched in Houston on September 17.
I ask you to play a vital role in making it a success.

On that Thursday evening, at 7:30 PM in the Music Hall, you and I
will participate in a state-wide live telecast which will enter millions
of Texas homes.

My role is to make a fighting appeal to the voters.

Your role is to come and bring as many of your friends as you can so
that the people of Texas can see, hear and feel the enthusiasm for our
cause—to let them know that the strength is with us and that we're all
in this race to win!

Senator John G. Tower has graciously volunteered to take time from
his busy schedule to fly down and be on hand that evening to throw his
support behind our campaign. In addition to a speech by John, plans
call for a sing-along, entertainment and all the trimmings for a campaign
launching including individual introductions of all the fine Republican
candidates on the ticket with me. The evening should be entertaining as
well as exciting which is essential to the successful launching of our
campaign.

I have been told there will be a drawing held in which two winners will
get an expenses-paid trip to Washington for the swearing-in ceremonies
in January—an additional incentive for you to attend. Be sure to bring
the enclosed tickets filled in with your name.

We have a hard but interesting campaign ahead of us and victory is in
sight, but I cannot win this victory without your help. A good send-off
on the 17th will make both my job and yours a lot easier. May I count
on you?

Sincerely,

Geo Bush

George Bush

P.S. If you need additional tickets, please call headquarters, CA 7-8255.

**Good Luck
Star Sailors!**

"Competition, whether in
sailing, business or politics,
is the backbone of a
free nation."

**GEORGE
BUSH**
Republican Candidate
for
U. S. SENATE

GEORGE BUSH SONG SHEET

GEORGE BUSH CAMPAIGN SONG

There's a job to be done in the U. S. Senate.
Let George Do It!
He's the man for the job in the U. S. Senate.
Let George Do It!
Pick a man who's strong and you can't go wrong.
Elect George Bush, George Bush, George Bush.
Keep the Lone Star State and our nation great.
Elect George Bush, George Bush, George Bush.
There's a job to be done in the U. S. Senate
And it will be done by George.
George Bush.

HOUSTON CHRONICLE

Houston's Family Newspaper

SUNDAY

35 cents

Vol. 70 No. 12 SUNDAY, OCTOBER 25, 1970 HOUSTON, TEXAS 77001 Second Class Postage Paid at Houston, Texas ★★ ★★

Pete
Roussell

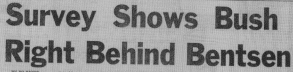

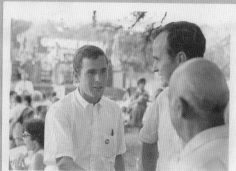

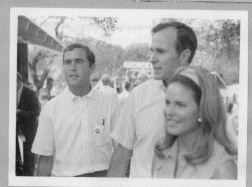

Survey Shows Bush Right Behind Bentsen

BY BO BYERS
Chief, Chronicle Austin Bureau
1/1/6 Houston Chronicle

Austin — Rep. George Bush, Republican, is breathing down the neck of Lloyd M. Bentsen Jr., Democrat, in the U.S. senatorial race. Democratic Gov. Preston Smith holds a firm but not overwhelming lead over Republican challenger Paul Eggers.

Bush, trailing Bentsen only 49.5 to 50.5 in a Chronicle statewide survey completed Thursday, has momentum going for him in most areas of the state and could forge ahead in the final week.

The key factor — as it has been throughout the grueling but generally unexciting campaign — is the size of the voter turnout.

Republicans are counting on a light vote to elect Bush as Sen. Ralph Yarborough's successor. Bentsen's Democratic workers are striving desperately to light the spark they need to get more traditionally Democratic voters to the polls. But, they are gloomy about the outlook.

Indications, based on evaluation of local estimates across the state, are that approximately 1.8 million will vote. This would be less than 44 percent of the registered voters and would enhance Bush's chances.

Smith's margin over Eggers dropped slightly, from 54-46 to 53-47, during the three weeks since the Chronicle made its first survey, but this would give Smith a numerical edge of 108,000 votes.

Bentsen's indicated lead of 18,000 votes is so tenuous the contest must be rated a toss-up. Its outcome could be decided by some unusual development in the few remaining days until voters enter the polls Tuesday, Nov. 3.

Republicans believe President Nixon's visit to Longview and Dallas this Wednesday may have decisive influence in wooing enough voters to put Bush over the top and

(See VISIT, Page 16)

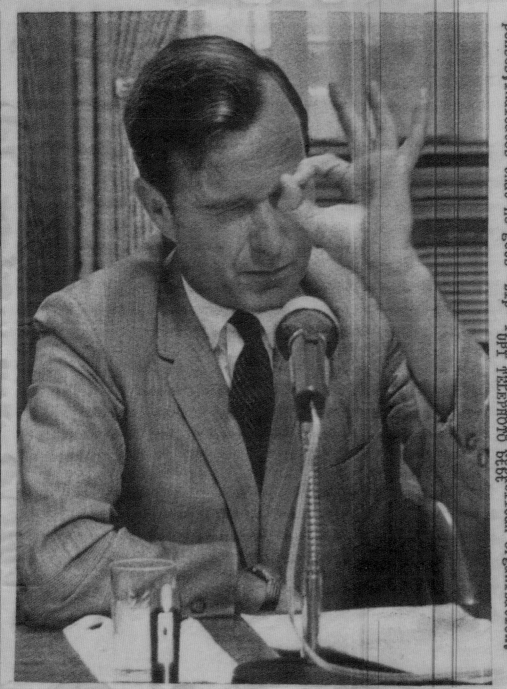

USP061601-6/16/70-AUSTIN,TEX:Congressman George Bush,of Houston,running against Lloyd Bentsen,also of Houston,for the Senate seat now held by Ralph Yarborough, talks with newsmen at a Capitol press conference.Bush,describing campaign expenses,indicates that he gets "zip" for the Republican organization.
UPI TELEPHOTO btbt

3rd 1970

P.S. B's winnin

Beshi + George Bell San Bemis

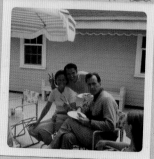

Maine Aug. 1970

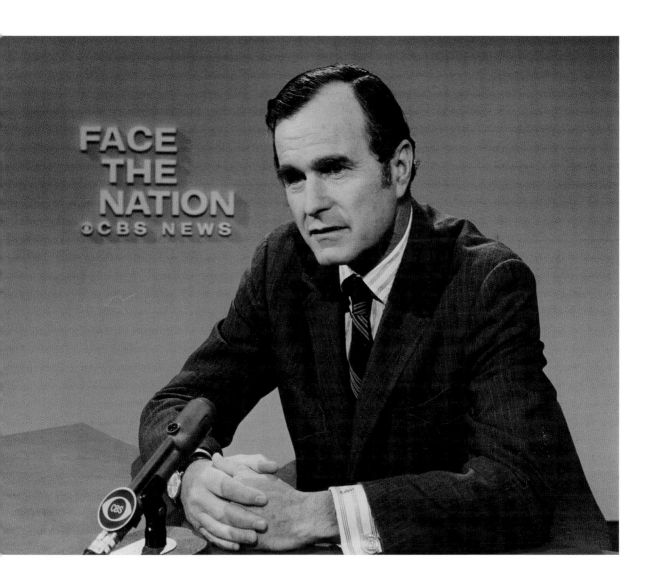

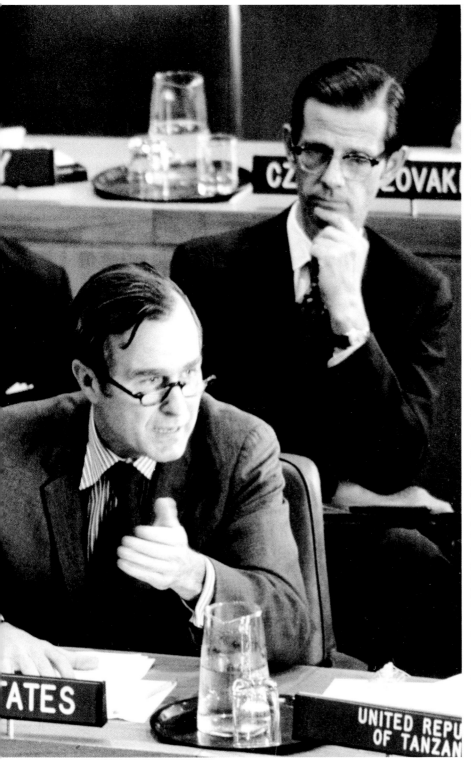

After the second Senate defeat, Bush began to think of the virtues of going to New York City to become ambassador to the United Nations. The idea had first been suggested to him by Charles Bartlett, a Kennedy intimate and Washington correspondent for *The Chattanooga Times.* It would be a global stage, a chance to learn foreign policy, and a chance for Bush to practice his particular brand of personal diplomacy. President Nixon knew he needed to do something for Bush; the president had just decided to appoint John Connally as secretary of the Treasury, enraging Texas Republicans. Taking care of Bush would help calm those waters. Still, Bush nearly didn't get the post: Nixon wanted him to come into the White House as a special assistant in the run-up to the 1972 reelection campaign. In the Oval Office, Bush made the case for the United Nations, arguing that Nixon needed a more energetic defender in the precincts of New York and volunteering to be that voice. For a moment, Nixon demurred, and Bush left the meeting believing he was to become a White House adviser. Then the president changed his mind. Having the polished Ivy Leaguer representing him in Manhattan was appealing. "You've sold the President," chief of staff H. R. Haldeman told Bush, "and he wants to move with it now."

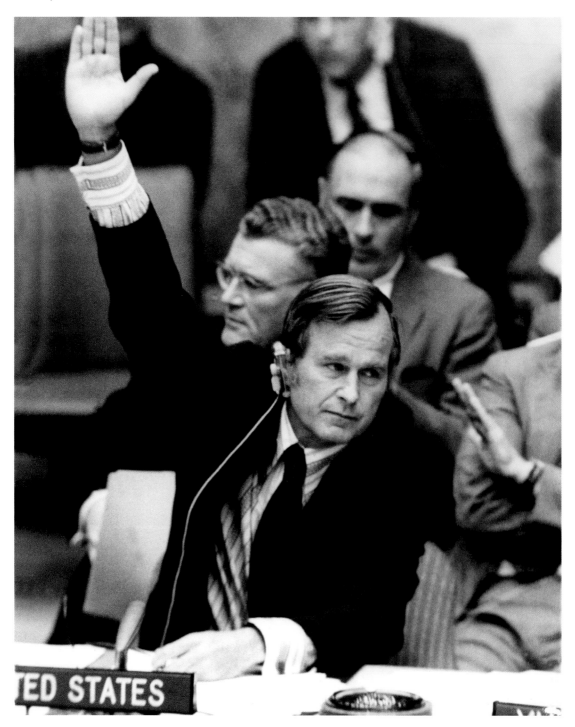

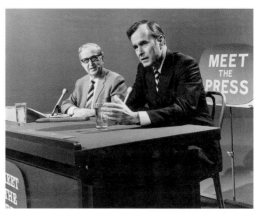

"The fact that one door has been closed for him opens another door," President Nixon said at Bush's swearing-in for the UN post in the State Dining Room in February 1971, "a door of service for him and also for the United States of America, a representative of whom we can all be proud, representing the United States and working in the cause of peace in the United Nations in the years ahead." Bush saw his ambassadorial mission in very public terms. His job, he told Nixon, would be to "spell out" Nixon's "programs with some style and we could preempt that mass news media area—he was operating almost in a vacuum. . . . I felt I could really put forward an image out there that would be very helpful to the administration." He was therefore a frequent guest on network news programs such as NBC's *Meet the Press,* offering the nation and the world a reasonable and attractive face in defense of the president's wide-ranging foreign policy. Though he and Barbara loved life in the ambassadorial apartment in the Waldorf Towers (a neighbor included Mrs. Douglas MacArthur) Bush found the eastern power corridor between Washington and New York to be remarkably bubble-like—an observation he might not have made without the years he'd spent in Texas. "I find it very difficult to be polite when people ask me how I like New York," Bush told his diary in 1971. "It is an unrepresentative city. . . . They are so darn sure they are right on everything."

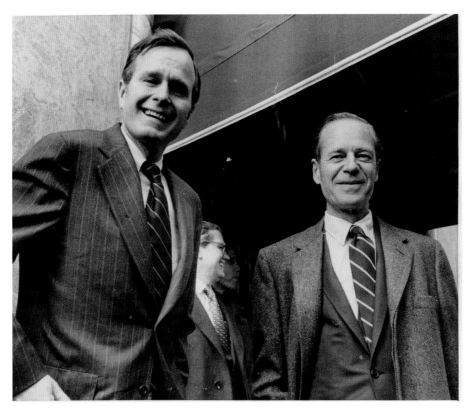

Bush with Charles Yost, the incumbent American ambassador to the United Nations, February 1971.

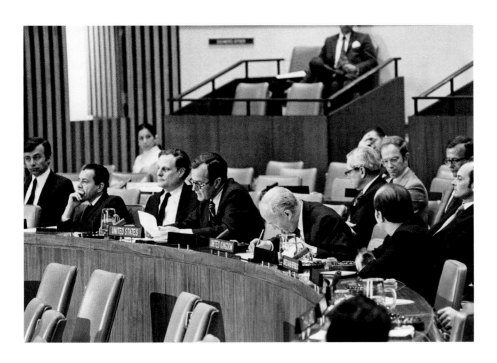

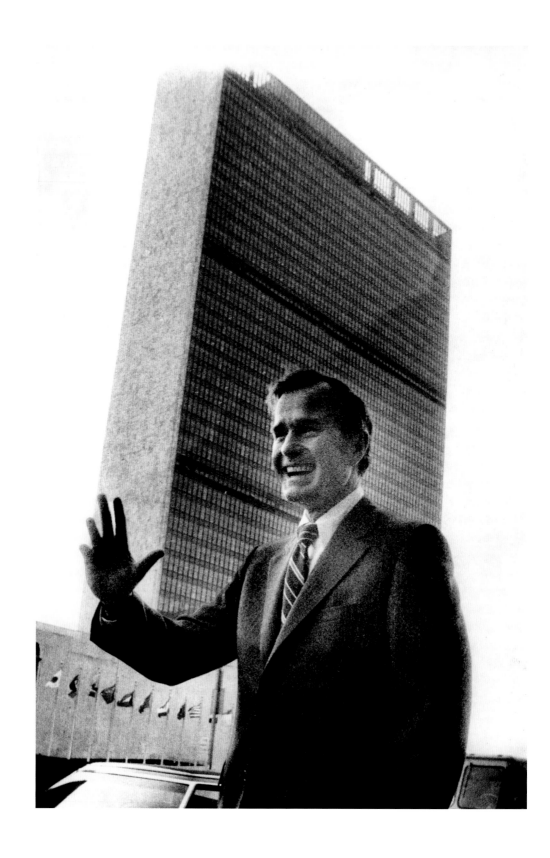

Ambassador Bush greets his father, former senator Prescott Bush, at the U.S. Mission on the East River. The elder Bush died in Greenwich in October 1972. "Mom Bush was wonderful," Barbara wrote. "My heart aches for her. She is so lonely. 51 years of loving Dad. She dreams that he is coming in from golf and then awakens to find that it was just a dream."

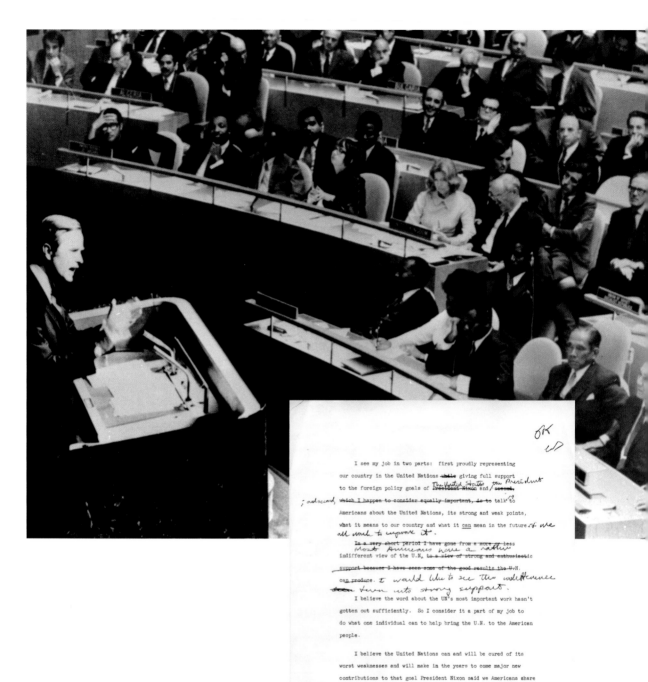

I see my job in two parts: first proudly representing
our country in the United Nations ~~while~~ giving full support
to the foreign policy goals of ~~President Nixon~~ The United States our President and / ~~second~~
; and second, ~~which I happen to consider equally important,~~ ~~is~~ to talk to
Americans about the United Nations, its strong and weak points,
what it means to our country and what it can mean in the future ~~if~~ we
all work to support it.

~~In a very short period I have gone from a more or less~~
Most Americans have a rather
indifferent view of the U.N. ~~to a view of strong and enthusiastic~~
~~support because I have seen some of the good results the U.N.~~
~~can produce.~~ I would like to see this indifference
~~turn~~ turn into strong support.

I believe the word about the UN's most important work hasn't
gotten out sufficiently. So I consider it a part of my job to
do what one individual can to help bring the U.N. to the American
people.

I believe the United Nations can and will be cured of its
worst weaknesses and will make in the years to come major new
contributions to that goal President Nixon said we Americans share
a great interest in: "the livability of our common home, the earth."

Bush's tenure at the United Nations ended after Nixon's landslide 1972 victory, when the president asked him to return to Washington to replace Kansas senator Bob Dole as chairman of the Republican National Committee. "This is an important time for the Republican Party, George," Nixon said at a Camp David meeting. "We have a chance to build a new coalition in the next four years, and you're the one who can do it." Watergate had not yet consumed him and the country, and in this hour of victory Nixon hoped to construct a centrist majority party—and he thought Bush would be a useful figure in the endeavor. "Not all that enthralled [with] RNC," Bush told the president, according to John Ehrlichman's notes, "but I'll do it."

Bush resisted White House pressure to go after President Nixon's critics directly and relentlessly as Watergate unfolded. "I am shocked," Bush remarked upon learning of the White House taping system. Still, as party chairman, he defended the president, calling for patience and for proportion until sufficient facts were in. Jeb Bush, who made calls to small donors to the RNC in the summer of 1973, recalled: "Either people were saying, 'I'm no longer a Republican, so screw you,' or they would say, 'Tell Nixon to stand up for himself.' No one was happy."

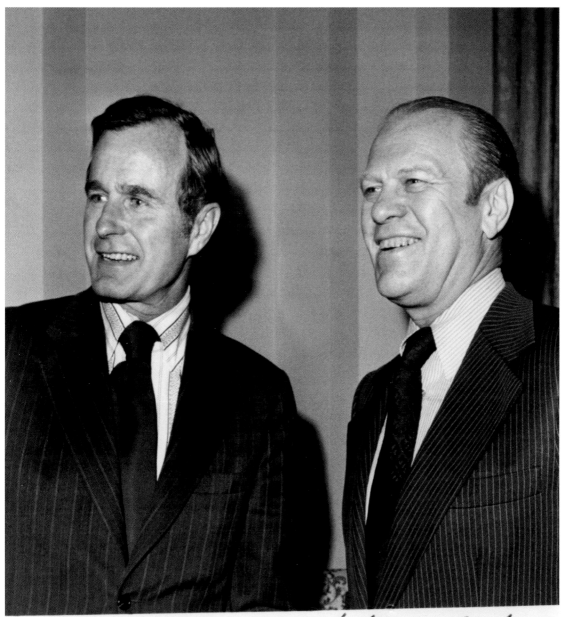

To my very good friend, George Bush,
a great G.O.P. Chairman, in appreciation.
Jerry Ford

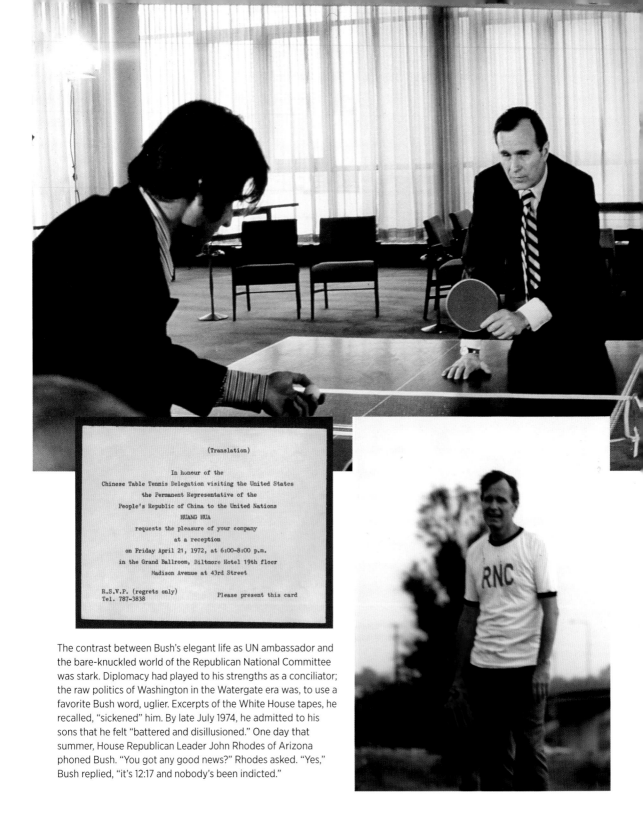

(Translation)

In honour of the
Chinese Table Tennis Delegation visiting the United States
the Permanent Representative of the
People's Republic of China to the United Nations
HUANG HUA
requests the pleasure of your company
at a reception
on Friday April 21, 1972, at 6:00–8:00 p.m.
in the Grand Ballroom, Biltmore Hotel 19th floor
Madison Avenue at 43rd Street

R.S.V.P. (regrets only)
Tel. 787-3838 Please present this card

The contrast between Bush's elegant life as UN ambassador and the bare-knuckled world of the Republican National Committee was stark. Diplomacy had played to his strengths as a conciliator; the raw politics of Washington in the Watergate era was, to use a favorite Bush word, uglier. Excerpts of the White House tapes, he recalled, "sickened" him. By late July 1974, he admitted to his sons that he felt "battered and disillusioned." One day that summer, House Republican Leader John Rhodes of Arizona phoned Bush. "You got any good news?" Rhodes asked. "Yes," Bush replied, "it's 12:17 and nobody's been indicted."

In Watergate-era Washington, as chairman of the Republican National Committee, Bush worked diligently to protect the party's larger long-term interests amid the deepening scandal around President Nixon.

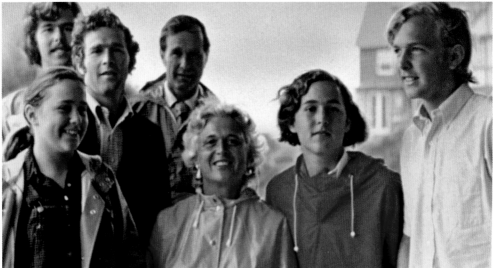

Kennebunkport remained the beating heart of the family. George H. W. Bush would acquire Walker's Point from his uncle's widow, Mary Walker, after he became vice president. "This is a place where we really enjoy ourselves—but more than that, kind of refurbish our souls and get our batteries all charged up and enjoy life really to the fullest," Bush remarked. "It's a point of view. You can feel it in the land and in the water here. . . . I've been coming here every summer since 19—well, I was born in '24. And the only time I missed was in 1944 when, like many of you, I was in the service. That's the only time we missed being here. And there is a certain magic about the place. Our kids live in . . . different states . . . and for them, this is an anchor to windward." He would spend his last summer there in 2018, just after Barbara's death in April and before his own in November of that year.

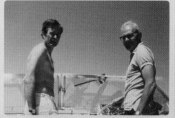

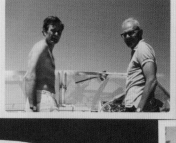

As a memorial to Loulie Wear Walker I can think of nothing that would delight her more than this addition to the beauty of St. Ann's. We six here today who were privileged to be her children know how much any church meant to her and this one in particular. How often over sixty years she came to two services, the ten o'clock surrounded by her family and guests (she enjoyed counting their number) and one Sunday the number included her dog who had wandered in after the service had begun. She was pleased but not surprised when the good Dean said it was quite alright he knew St. Francis would approve.

A woman of steadfast faith, strong convictions, and tender qualities of loving kindness. I think what I associate most with her spirit is that she was always able to give thanks to God. Grace before meals she called The Blessing; and hers never varied, and sorrows when they came did not prevent her still saying "For these and all Thy many blessings, Dear Lord, we give Thee thanks."

The beautiful bronze Plaques which you are about to see were painstakingly planned and given by her eldest son, George Herbert, and executed by Robert Robbins of New York City who specializes in religious art. Some of the verses on the Plaques were taken from her well-marked Bible.

These are no usual gates through which parishioners and tourist will come and go, and it is hoped that some in need may find comfort and strength on their way.

The last verse on the Plaque nearest the rector was sent in by a family friend:

"And deep in their hearts when she was gone
her words took roots, and her voice lived on
The soft voice of the ocean shell
to counsel her sons and the sons of her sons as well."

The Plaque to my immediate right will be unveiled by George Herbert Walker, the Third, and the further one by John M. Walker, Jr.

N. W.

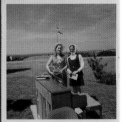

Dedication of gates
by Nancy Walker. July 4, 1971

Bush had an ambiguous, somewhat wary relationship with Henry Kissinger (as did most people). "Henry Kissinger, I don't think fundamentally he believed in personal diplomacy," Bush recalled—a kind of diplomacy Bush cherished. "Actually, he was pretty good at it, but I don't think he fundamentally believed in it. And his point to me and to others was 'You're not going to get somebody to change their vote, change their political philosophy, because they like you.' The United Nations is a political forum. One day there's a vote on one question; another day there's a vote on another question. One day there's one alignment of nations voting one way; the other day some of those same nations may be voting another." Getting along with diplomats, then, could bend them, however slightly, toward the American point of view.

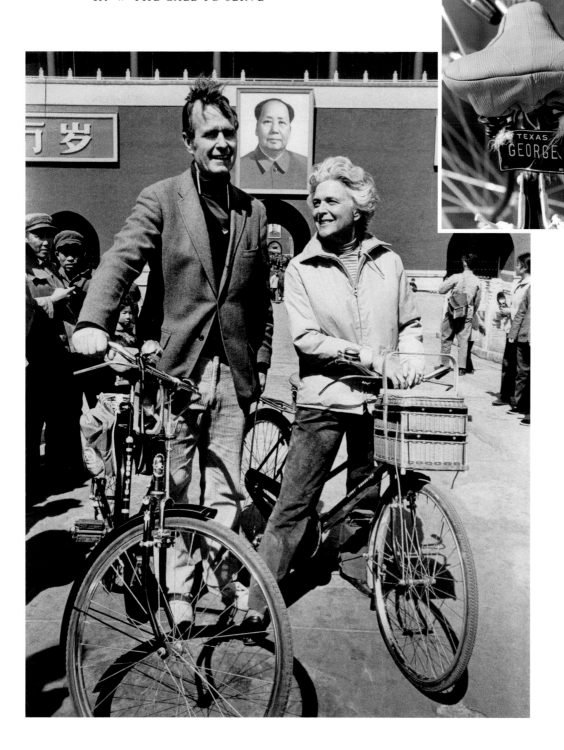

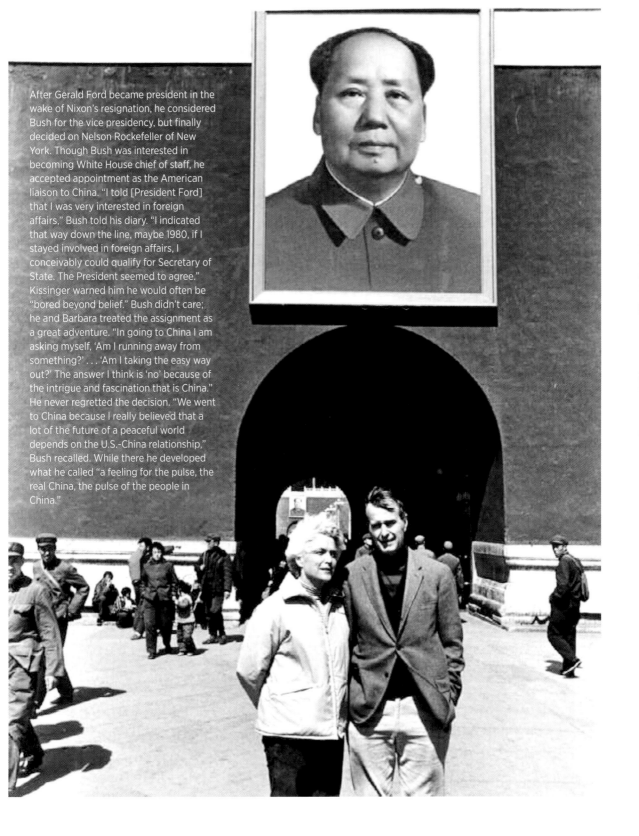

After Gerald Ford became president in the wake of Nixon's resignation, he considered Bush for the vice presidency, but finally decided on Nelson Rockefeller of New York. Though Bush was interested in becoming White House chief of staff, he accepted appointment as the American liaison to China. "I told [President Ford] that I was very interested in foreign affairs," Bush told his diary. "I indicated that way down the line, maybe 1980, if I stayed involved in foreign affairs, I conceivably could qualify for Secretary of State. The President seemed to agree." Kissinger warned him he would often be "bored beyond belief." Bush didn't care; he and Barbara treated the assignment as a great adventure. "In going to China I am asking myself, 'Am I running away from something?' . . . 'Am I taking the easy way out?' The answer I think is 'no' because of the intrigue and fascination that is China." He never regretted the decision. "We went to China because I really believed that a lot of the future of a peaceful world depends on the U.S.-China relationship," Bush recalled. While there he developed what he called "a feeling for the pulse, the real China, the pulse of the people in China."

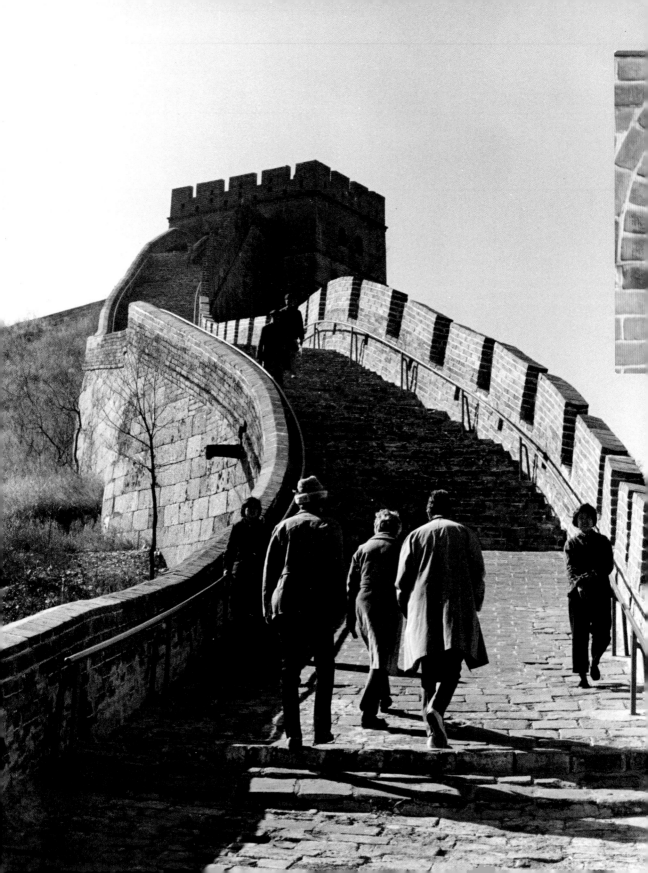

The Bushes attacked life in China the way they had attacked life everywhere else: energetically. C. Fred Bush, the family's cocker spaniel, came along. Much of Bush's job was to seek to make sense of the legendarily opaque ethos of Chinese politics. *"Was some leader not mentioned in a news story about the dedication of a new building in his city of birth?"* Bush recalled of the questions that consumed him. *"Was a Chinese deputy minister sent to an international conference, instead of his boss? Why hasn't so-and-so been heard from in over three months? Who's up, who's down?"* Chinese diplomats, Bush noted, could turn "the cryptic phrase into an art form." There were, he said, three ways a Chinese official might reject a request—"all polite," Bush noted, but all unappealable. If a meeting was said to be "not convenient," the Chinese meant that it would not happen "until hell freezes over." If a meeting was accepted "in principle," that meant "don't hold your breath." And if a meeting was described as "possible, but it might take a while," you might wait "five to twenty years," since "a while" meant something very different to the Chinese than to the Americans. Yet Bush loved it. He rode his bicycle around the capital, becoming known as "Busher, who ride the bicycle, just as the Chinese do." Kissinger's visits were always dramatic. "His staff are scared to death of him," Bush told his diary. "The procession is almost 'regal.' People quake, 'He's coming, he's coming.'"

B. 我和你一起去参加招待会.

Wǒ hé nǐ yìqǐ qù cānjiā zhāodàihùi.

I'll go to the reception with you.

A. 太好了. 明天见.

Tài hǎo le. Míngtiān jiàn.

That's too good. See you tomorrow.

B. 明天见.

Míngtiān jiàn.

See you tomorrow.

二. 生词 (Shēngcí)

1.	去	qù	go to
2.	参观	cānguān	visit
3.	工厂	gōngchǎng	factory
4.	出发	chūfā	set out start out
5.	到	dào	arrive
6.	左右	zuǒ yòu	left and right —— around, about)
7.	回	huí	return, go back
8.	或者	huòzhě	or (in declarative sentence)
9.	还是	háishì	or (in interrogative sentence)
10.	看	kàn	see
11.	电影	diànyǐng	movie picture
12.	参加	cānjiā	to attain, to participate
13.	招待会	zhāodàihùi	reception
14.	和...一起	hé ...yìqǐ	with
15.	太	tài	too

补充生词 → Bǔchōng shēngcí — supplementary words

1.	宴会	yànhùi	banquet
2.	酒会	jiǔhùi	cocktail party
3.	茶会	chá hùi	tea party

(handwritten margin notes:)

shuǐ = water

shuì = sleep

biéde = other

zo = make

měi = every

měi ge rén = every person

cānguān – visit

zou houchē = train

zou feichang =

ting shou = hear tell

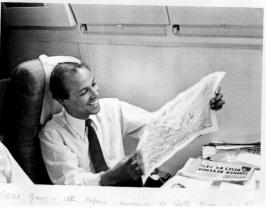

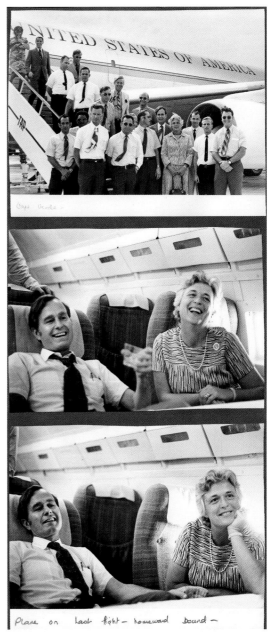

Bush returned to Washington in 1975. There was perennial interest in his political future, a sign of his standing within the party. Kissinger had explicitly raised the question with him on the ground in Beijing toward the end of 1974. "He asked how long I planned to stay," Bush told his diary. "I had in my mind that he was probing to see what my political plans were." Bush was uncertain and said so. "I told him I had no political plans, that I thought the ticket for '76 was locked in with the appointment of Rockefeller, which I do, and that I had no plans at all." The wily secretary of state did not let the matter drop. "Kissinger made some reference to my running for President in 1980," Bush noted. This much was clear: Those at the highest levels in Washington believed Bush, at age fifty, had much before him.

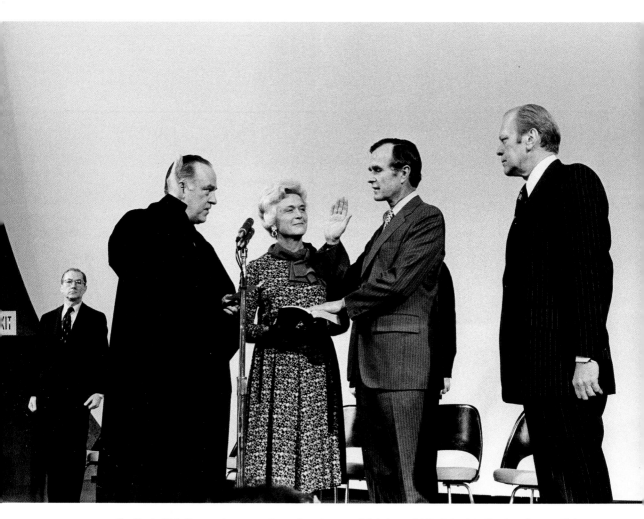

The Central Intelligence Agency and a profound sense of duty brought Bush back to the American capital. Facing a difficult primary challenge from Ronald Reagan, President Ford made a series of moves that included Nelson Rockefeller's announcement that he would not run on the 1976 ticket with Ford. Bush was asked to come home to run a scandal-plagued CIA. If he accepted, Bush knew that he would be taking himself out of the running to be the GOP's vice-presidential nominee. (The agency needed to be seen as removed from partisan politics.) Bush hated foreclosing that possibility, but he had been raised to do what a president asked him to do. And so he said yes to Langley.

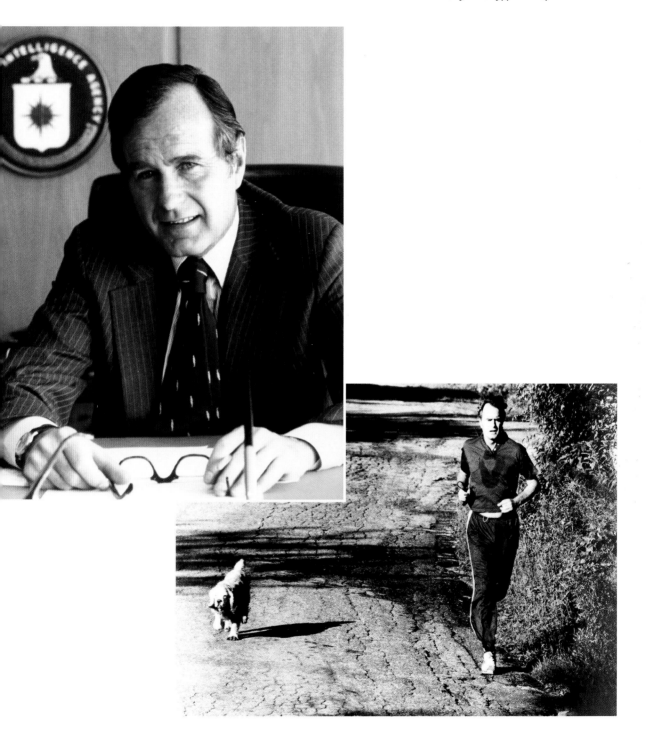

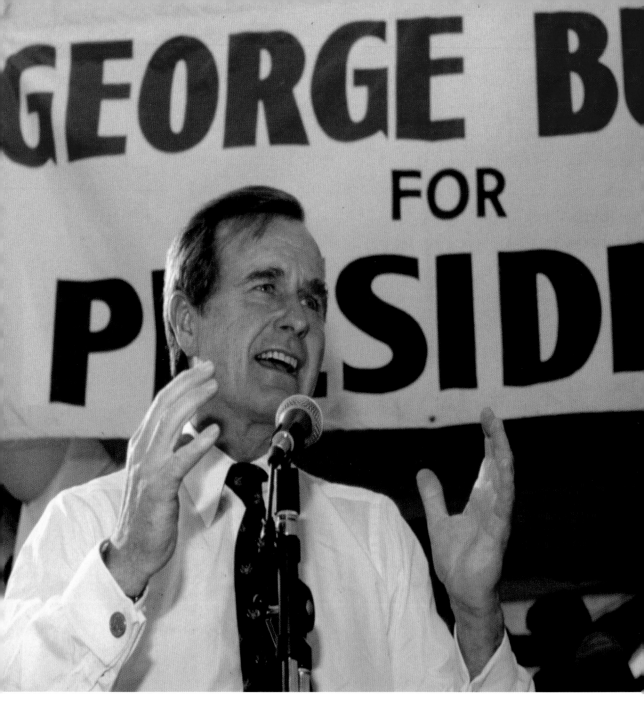

Arguing that he was "Up for the Eighties," Bush announced his presidential campaign in May 1979. "I am a candidate for President of the United States," he told an audience at the National Press Club in Washington. "I seek this nomination as a lifelong Republican who has worked throughout his career, in business and in public office, on behalf of the principles of Lincoln, Theodore Roosevelt and Dwight Eisenhower." In *The New York Times,* James Reston wrote, "This was the first time in memory that Ike had ever been nominated for equality and immortality with Teddy Roosevelt and Lincoln, and it told something about George Bush's ideals."

Bush ran the scrappiest of primary campaigns. He threw himself into Iowa—Jimmy Carter had made the state's caucuses a key test of presidential viability in 1976—and outlasted his old Texas nemesis John Connally and leading senators Howard Baker and Bob Dole. Bush upset Reagan in Iowa, but the Gipper regathered his forces and prevailed in New Hampshire, holding on to his lead though Bush carried primaries in Pennsylvania and Michigan. But it would not be enough: The race was Reagan's.

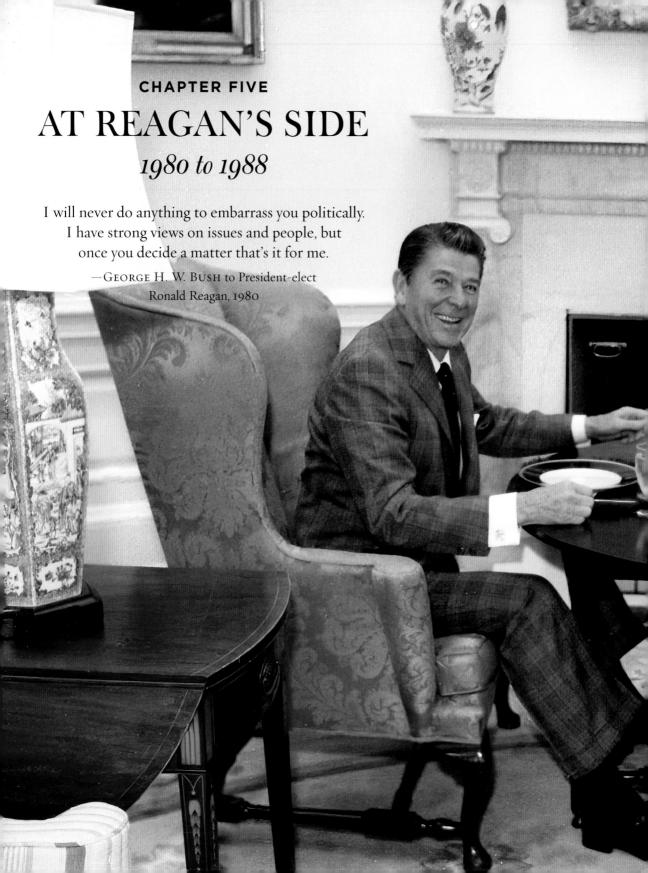

CHAPTER FIVE

AT REAGAN'S SIDE

1980 to 1988

I will never do anything to embarrass you politically.
I have strong views on issues and people, but
once you decide a matter that's it for me.

—GEORGE H. W. BUSH to President-elect
Ronald Reagan, 1980

THE BUSHES RETURNED to Houston after the Carter inaugural. They loved Texas—always had—but now it seemed rather as the East Coast had after the war: a place that was too comfortable, too staid, too far from the action that Bush loved. "I think I want to run or at least be in a position to run in '80—but it seems so overwhelmingly presumptuous and egotistical," Bush wrote a friend in March 1977. The observation about presumption and ego is interesting, for it illuminates an enduring tension in the Bush psyche. He wanted, as he once put it, to be "Number One," but he found it more than a bit awkward to acknowledge his own ambition. Part of this must have come from his mother's admonitions not to focus on oneself; part from Andover's motto, "Not for Self." And yet there it was, from year to year, decade to decade: a drive to rise not only to the highest levels but to *the* highest level.

"My motivation's always been *goal*—you know, to be captain," he once said. "Are you going to make the team in your freshman year? Going to go out and be in the fraternity you want to be in? Going to be . . . tapped for Skull and Bones? Whatever it is. That's not good in a way, but in a way it is; it's what motivated me all my life. I'm a goal kind of guy. . . . Whatever you're in. Be Number One."

In remarks at the National Press Club in Washington on Tuesday, May 1, 1979, Bush announced his bid for president. "Ladies and gentlemen," Bush began, "I am a candidate for President of the United States. . . . I seek this nomination as a lifelong Republican who has worked throughout his career, in business and in public office, on behalf of the principles of Lincoln, Theodore Roosevelt and Dwight Eisenhower."

His mission, he made clear, was more about stewardship than revolution. "As a candidate for President," Bush said, "I am not promising" a New Deal, a New Frontier, or a Great Society. "But I do pledge a new candor. To be effective, leadership in the eighties must be based on a politics of substance, not symbols; of reason, not

Chapter-opening spread: Reagan and Bush lunched by themselves most weeks of the two Reagan terms. "No agenda. No paper. 'Please, sir, this is a good opportunity to see my view on whatever it is'—none of that," Bush recalled. "It was more, I hope, for him a relaxing meeting that he would look forward to and not dread. We'd tell jokes. If there was something going on in a big way in the world, or on domestic policy, we'd talk about that. But it was totally relaxed. . . . I think he knew I wouldn't blindside him."

bombast; of frankness, not false promise. . . . As a candidate, and as President, I will speak not in terms of simple solutions but of hard choices."

Eisenhower, unsurprisingly, was his lodestar. "More than a quarter century ago," Bush concluded, "in his first State of the Union message to the Congress, one of the wisest and strongest of this century's Presidents said: 'There is in world affairs a steady course to be followed between an assertion of strength that is truculent and a confession of helplessness that is cowardly. There is in our affairs at home, a middle way between the untrammeled freedom of the individual and the demands for the welfare of the whole nation. . . .' President Dwight Eisenhower then went on: 'In this spirit we must live and labor: confident of our strength, compassionate in our heart, clear in our mind. In this spirit, let us turn to the great tasks before us.'"

Bush summed up: "In this spirit, too, I from this day will go forward to seek the Presidential nomination of my Party and the support of Americans everywhere who believe that in the decade of the eighties, America must have a new leadership—a leadership confident of our strength, compassionate of heart, and clear in mind, as we turn to the great tasks before us."

The vice-presidential residence on the grounds of the Naval Observatory off Massachusetts Avenue in northwest Washington. This would be the Bushes' home for eight years—the longest they had lived in a single house in their married lives, which had begun in the distant winter of 1945. Bush's predecessor in the office, Walter F. Mondale, had been the first vice president to make the house at Number One Observatory Circle his full-time residence after Congress agreed to designate the house as the vice-presidential home in 1974.

He worked Iowa hard; Jimmy Carter had shown the way four years earlier, when the former Georgia governor had won the caucus there and catapulted himself to the Democratic nomination and then the White House. It was a state where hand-to-hand politics mattered, and Bush, along with the extended family, worked, worked, worked. On caucus night in Iowa, the news was staggering. Bush defeated Reagan, 31.5 percent to 29.4 percent. Victory night, Barbara recalled, turned the Bushes' suite into a "madhouse." In exuberant shorthand, Bush declared that he now had the "Big Mo."

But it didn't last. The struggle between Bush and Reagan in New Hampshire was intense, personal, and long: In 1980, there were five weeks between the Iowa caucus and the New Hampshire voting. Bush insinuated, subtly and not so subtly, that Reagan was too old and too extreme; Reagan argued, subtly and not so subtly, that Bush was too effete and too eastern. The result was a blowout for Reagan, who carried the primary 50 percent to 23 percent for Bush.

"Congratulations, sir, you beat the hell out of us," Bush told Reagan in a concession call.

Though Bush would win in Massachusetts, Michigan, and Pennsylvania, he could not withstand the Reagan forces. "I'd wanted to be president, no apologies for that," Bush recalled. "But 'Big Mo' didn't turn out to be so big after all."

The vice presidency was once again in play, and Reagan's campaign was convinced it needed a moderate to balance the ticket. Bush was an obvious option, as was Howard Baker of Tennessee. There was, however, another, more dramatic possibility: bringing former president Ford out of retirement to run again, this time in

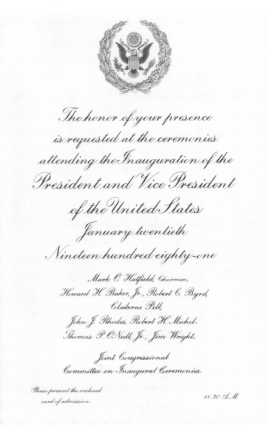

The honor of your presence is requested at the ceremonies attending the Inauguration of the President and Vice President of the United States January twentieth Nineteen hundred eighty-one

Mark O. Hatfield, Chairman,
Howard H. Baker, Jr., Robert C. Byrd,
Claiborne Pell,
John J. Rhodes, Robert H. Michel,
Thomas P. O'Neill, Jr., Jim Wright,

Joint Congressional
Committee on Inaugural Ceremonies.

Please present the enclosed
card of admission.

11:30 A.M.

An official invitation to the Reagan-Bush inaugural in 1981. Bush had first been mentioned as a possibility for the vice presidency as early as 1968, at the Republican National Convention that nominated Richard Nixon for president. He had missed the prize then and again in the complicated politics of the 1970s. Now the office of understudy was his.

the second spot. For a harried three days at the Republican National Convention in Detroit, the Reagan and Ford teams talked things over—talks that leaked out to the press—but the negotiations finally fell apart.

The call was brief but momentous. At 11:37 P.M. on the third day of the four-day convention, Reagan called Bush. "Hello, George," Reagan said, "this is Ron Reagan. I'd like to go over to the convention and announce that you're my choice for Vice President . . . if that's all right with you."

"I'd be honored, Governor," Bush said.

"Out of a clear blue sky, the phone rang," Bush recalled. "Out of a clear blue sky. I thought we were done, out of it, just gone."

Now he was back in. "It was a cliffhanger," Richard Nixon wrote Bush of the vice-presidential selection, "but you won and I am convinced it was best for November."

The last-minute ticket prevailed on Election Day, defeating President Carter and Vice President Walter Mondale. To Mondale, Bush wrote: "I'd love to sit down with you. Thank you for your wire, your call, your just plain decency. I've lost—plenty—and I know it's no fun."

Bush made certain the president-elect knew that loyalty would be total. "Please know that we both want to help you in every way possible," Bush wrote the week after the 1980 election. "I will never do anything to embarrass you politically. I have strong views on issues and people, but once you decide a matter that's it for me, and you'll see no leaks in Evans and Novak bitching about life—at least you'll see none out of me. . . . Call me if I can lighten the burden. If you need someone to meet people on your behalf, or to turn off overly-eager office seekers, or simply someone to bounce ideas off of—please holler."

The formal details of a Reagan-Bush White House were settled early on: "1) You and the President will have a scheduled weekly luncheon—no staff, no agenda; 2) You will automatically be invited to all presidential meetings; 3) You will receive a copy of all memo-

randa going to the President; 4) You will have the present Vice President's [West Wing] office."

Bush recalled his own understanding of the vice presidency:

First, don't play the political opportunist's game by putting distance between yourself and the President when some White House decision or policy becomes unpopular. . . .

Second, don't play the Washington news-leaking game. . . .

This leads directly to the third rule . . . conduct all interviews on the record—even interviews with friends, especially if you want to keep them as friends. That way you're less likely to be surprised when you later read or hear yourself quoted in the press.

Bush proved himself a figure of order and of reassurance on the long and tragic day of Monday, March 30, 1981, when President Reagan and three others—Press Secretary James Brady, Secret Service agent Timothy McCarthy, and D.C. police officer Thomas Delahanty—were wounded in an assassination attempt outside the Washington Hilton on Connecticut Avenue. Bush was on a routine political trip to Texas, flying between Fort Worth and Austin, when the news came. "Sir, we've just received word about a shooting in Washington," Ed Pollard, the head of the Bush Secret Service detail, told the vice president just before 2:30 P.M. eastern.

"It's hard to describe my emotions," Bush dictated in flight back to Washington.

They're cumulative. A funny thing: the way Reagan's and my relationship has developed—not presidential-vice presidential but more like a friend. [There's] a concern for someone who's your friend. Because I see it that way—seeing him [on videotape] getting into that car, waving—I see it on a personal plane. . . . My every inclination is to be calm, not churning around. I would have thought it would have been much more

complicated about the responsibilities, but my innermost thoughts are [that] this guy is a friend. . . . I think about Nancy Reagan: Is anybody holding her hand? I have a great feeling that all will work out. The President is very strong.

In Washington, meanwhile, chaos reigned. Reagan was in surgery, and the top officers of the government, including Secretary of State Alexander Haig, were making something of a mess of things at the White House. After a shaky briefing by a deputy press secretary in the briefing room, Haig, the former Nixon White House chief of staff and NATO commander, hurried from the Situation Room to speak to reporters. In his rush to reassure, Haig misstated the line of presidential succession and appeared to be grabbing power. "As of now," Haig told the world, "I am in control here, in the White House, pending return of the vice president and in close touch with him. If something came up I would check with him, of course."

As Air Force Two hurtled toward the capital, the Secret Service suggested that Bush land at Andrews Air Force Base and then helicopter straight to the White House, landing on the South Lawn. "By going straight to the White House, we'd get there in time for the 7 P.M. network news," Bush recalled. "What better way was there to reassure the country and tell the world the executive branch was still operating than to show the Vice President, on live TV, arriving at the White House?" Yet the prospect troubled Bush. *The President in the hospital. . . . Marine Two dropping out of the sky, blades whirring, the Vice President stepping off the helicopter to take charge,"* Bush mused. "Good television, yes—but not the message I thought we needed to send to the country and the world." Bush refused the helicopter. The drama of it was too much, the showmanship off-key. Instead, he would go by car.

Arriving discreetly at the White House, Bush walked into the Situation Room, bringing calm to the storm. "I can reassure this nation and the watching world that the American government is functioning fully and effectively," Bush told the country at eight P.M. Bush's character was particularly suited to a crisis of this kind. His

sense of propriety and his understated public persona at once met and managed the moment. Note, too, that without the other side of this coin—his ambition to be in the arena—he would not have been in a position to rise to this occasion. His handling of the assassination attempt was an example of how his dignity and his drive came together to serve the nation well.

"Did it help me with President Reagan?" Bush recalled. "Sure, I think so. He saw—and Nancy saw, I might add—that I'd meant what I'd said all along, since he called me up in Detroit. He was the president, I wasn't. A president has enough to worry about without having to worry that his vice president is undercutting him, or trying to make himself look good at the president's expense. I'd decided that he deserved my total loyalty, and he got it."

A s VICE PRESIDENT, Bush would take the lead on reducing federal regulations and, in 1983, successfully lobbied European governments to accept the deployment of Pershing II missiles. Reagan remained friendly and supportive, making it clear from the beginning that Bush would be part of the 1984 ticket. In the spring of the reelection campaign, Reagan and Bush went to speak to the Conservative Political Action Conference together. "I hated it," Barbara wrote. "All of these people have been against George Bush.... It was OK. They clapped. The President spoke and then he led the standing ovation for George, bless his heart. I would have died if he hadn't! They were polite, but it is just not comfortable."

The Reagan-Bush ticket would crush Walter Mondale and Geraldine Ferraro, carry-

In 1980, Bush's nomination as vice president was an acknowledgment of the relative strength of the old Eisenhower wing of the Republican Party. By 1984, when Reagan and Bush were renominated at the GOP convention in Dallas, even Bush had moved Reagan-ward, which is to say, rightward. True believer conservatives would never fully trust Bush—they had not fully trusted President Ford, either, in the politics of the 1970s—but Bush was unswervingly loyal to Reagan throughout their eight years together.

Dallas Times Herald

FRIDAY, AUGUST 24, 1984 8 Sections 25 Cents

THE RACE IS ON

Vice President George Bush and wife, Barbara, and President and Nancy Reagan salute the crowd after Reagan accepted the party's nomination

ing forty-nine states, but the political class and the press tended to portray the incumbent vice president as rich, privileged, and, in a word that *Newsweek* would use on its cover in 1987, a "wimp." "It's funny how those who have real breaks early in life" get put in one of two categories, Bush told his diary. "If you're a Republican, that's bad; but if you're a Democrat, a la Kennedy or Harriman or Roosevelt or whoever, why, it's no problem. I've always been annoyed that the journalists are determined to fit me in a mold in spite of Texas, in spite of the Navy, in spite of [working in the oil business], in spite of running in Texas, and in spite of a lot of different things, but this journalism has a way of neatly fitting you where they think you [should] be."

In 1985, as vice president, Bush met Mikhail Gorbachev, the new leader of the Soviet Union. In a memorandum to Reagan, Bush was insightful, candid, and balanced:

March 13, 1985
For the President:

I have had about 8 hours to think about our 1 hour and 25 minute meeting with Gorbachev. . . .

Gorbachev will package the Soviet line for Western consumption much more effectively than any (I repeat any) of his predecessors. He has a disarming smile, warm eyes, and an engaging way of making an unpleasant point and then bouncing back to establish real communication with his interlocutors.

He can be very firm. Example: When I raised the human rights question with specificity, he interrupted my presentation to come back with the same rhetorical excess we have heard before. Quote: "Within the borders of the US you don't respect human rights" or "you brutally suppress their rights." But along with this the following, "We will be prepared to think it over" and "Let's appoint rapporteurs and discuss it." The gist being as follows—"don't lecture us on human rights, don't attack socialism but let's each take our case to discussion!" . . .

George Shultz made a superb presentation at the very end of our meeting in which he told Gorbachev that you wanted to be personally engaged etc. He

did it with great sincerity and warmth and even though it went through translation, I had the feeling Gorbachev responded with the same kind of man to man sincerity. . . .

In his conclusion, though, he came back to human rights but in a way that made his summation positive. The following is almost an exact quote. "It is a good thing we have spoken not in diplomatic but political language. If what I heard from the V.P. and Secretary of State quoting the President reflects wanting a 'normal road' and if all this reflects a 'serious side' we cannot but welcome this!!" . . .

I didn't get the feeling he had to prove how tough he is.

He seemed self confident turning to [Foreign Minister] Gromyko and chatting from time to time but not being worried that Gromyko might differ or not afraid to show lack of total knowledge in front of Gromyko.

This Gucci Comrade brings the General Secretariat a quantum leap forward in overall appearance. . . . He beats the hell out of the Penney's basement look that some of his predecessors projected.

He has a large very prominent birth mark across his balding head, but because of his attractive manner of presentation it is not something you notice all the time.

I feel he will want to meet you. He will handle his end well—so well I'd predict that it will help him at home and show the West a much more reasonable face. Having said that the big question will be—will this "new look man" merely be a more effective spokesman for tired, failed policies or will he have enough self assurance and foresight to "start anew"—a term he himself used in expressing hope for U.S.-Soviet relations.

I don't know the answer to this question but I strongly urge that we try to find out.

I personally would like to see you set up a true back channel totally apart from the wide array of experts upon whom we must depend, but the channel should have a tiny handful of key players whom Gorbachev knew were truly your personal confidants and in whom he would gradually get confidence as he saw there were no leaks.

If one of these key players had to go public in a rhetorical way, Gorbachev should be told as in the early days of our Chinese relationship when one side or the other publicly attacked: "These are empty cannons of rhetoric."

*All normal channels would remain open, but this would be something
very special that you could use, in confidence, to establish a truly personal
rapport with this new and different leader. . . .*

*Warm regards,
George*

In seeking the presidency in 1988, Bush relied heavily on the capital he had stored up as Reagan's vice president. He would joke about his long odds; journalists loved to point out that no sitting vice president had won election to succeed a sitting president since Martin Van Buren had done so under Andrew Jackson in 1836. Bush privately called this the "Old Marty problem."

As 1988 APPROACHED, Bush knew he had a fight on his hands if he wished to win the biggest prize of all. He hired Lee Atwater and Roger Ailes, both bare-knuckled operatives, and asked his son George W. Bush, who had long worked in politics, to come to Washington to keep an eye on things at headquarters. The elder Bush was unsentimental about what had to be done, and as the campaign unfolded he found himself facing first Bob Dole and then Michael Dukakis.

Wintry and witty, Dole of Kansas had been a mainstay of the Senate since 1968, and Ford's running mate in 1976. "He's what they call a tough guy, and yet I wonder how really tough he is," Bush told his diary. "I don't like to equate meanness with toughness, ugliness with toughness. They accuse me of being too nice—not tough enough. But I believe I've got more inner fiber and more strength than Bob Dole will ever have. Time will tell."

Time surely told this: Dole was a threat, winning the Iowa caucuses Bush had carried eight years before. The news out of the Midwest was particularly bad: The vice president came in third, behind Dole and the televangelist Pat Robertson, who placed second. The result, *The New York Times* reported, amounted to a "humiliation for Mr. Bush, who until now has led the Republican Presidential field in virtually all national polls."

"This is the beginning," Bush told reporters that night. "I can't say that I'm not disappointed, but I'm not down, I will guarantee you that." Cornered, Bush unleashed a tough ad against Dole on taxes, found his footing, and won the nomination. He had summoned all his formidable energies and plunged on. "If I don't make it, I have no excuses," Bush had dictated to his diary just before the

New Hampshire voting. "Just go on about my life, which will be an exciting one. I would have no politics, no head table, no Republican Party, a total hiatus, shifting direction of my life. And if I win, and I still think I will, my hands will be full. The biggest job in the world."

He worried that the extremes were growing ever louder. Bush was a party man—to a point. He believed—though he probably wouldn't have put it this way—that the parties played an important intermediary role in American politics by bringing more unifying nominees to the country for the ultimate choice in November. Harry Truman had seen this, observing that it was good for the country to have both liberals and conservatives in both parties: That way, the eventual candidates who were presented to the country had already been vetted by voters of different philosophical dispositions. At one point, Bush's campaign manager, Lee Atwater, raised the possibility that the New York real-estate developer Donald Trump be considered for the vice-presidential nomination. "Strange and unbelievable," Bush said of the idea.

For Bush in 1988, the hard right was largely embodied by hardcore evangelicals who believed they had found their messenger in Pat Robertson. Once on the campaign trail in Kingsport, Tennessee, a Robertson true believer refused to shake Bush's hand. He did not give up, telling her that once the primaries were over the party would come together. To his diary, Bush dictated:

> Still this staring, glaring ugly—there's something terrible about those who carry it to extremes. They're scary. They're there for spooky, extraordinary right-winged reasons. They don't care about party. They don't care about anything. They're the excesses. They could be Nazis, they could be Communists, they could be whatever. In this case, they're religious fanatics and they're spooky. They will destroy this party if they're permitted. There is not enough of them, in my opinion, but this woman reminded me of my John Birch days in Houston. The lights go out and they pass out the ugly literature. Guilt by association. Nastiness. Ugliness. Believing the Trilateral Commission, the

After eight years in Reagan's formidable shadow, Bush defeated rivals that included Bob Dole and the Reverend Pat Robertson to win the GOP nomination in 1988. Facing Massachusetts governor Michael Dukakis in the general election, Bush ran a tough campaign—Dukakis would recall it as the work of "the Bush attack machine"—that emphasized patriotic tropes and argued Dukakis was too far to the left of American politics and culture. It worked—and the day after the election, Bush called for cooperation now that the competition was over.

conspiratorial theories. And I couldn't tell—it may not be fair to that one woman, but that's the problem that Robertson brings to bear on the agenda.

The general election campaign was brutal. Early on, Bush had sensed that the Democratic nominee, Michael Dukakis, would be vulnerable because of the Massachusetts governor's purportedly out-of-the-mainstream liberalism. Bush ran a red, white, and blue campaign that made much of Dukakis's veto of a bill requiring public school teachers to lead the Pledge of Allegiance and a furlough program for first-degree murderers that had released an inmate who went on to commit grievous crimes in Maryland. It was an ugly season in American politics, leavened a bit by Bush's argument, made most explicitly at the Republican National Convention in New Orleans, that his biography was perhaps his greatest qualification for the presidency.

"I may not be the most eloquent, but I learned early on that eloquence won't draw oil from the ground," Bush told the convention and the nation. "And I may sometimes be a little awkward, but there's nothing self-conscious in my love of country. And I am a quiet man, but I hear the quiet people others don't. The ones who raise the family, pay the taxes, meet the mortgage. And I hear them, and I am moved and their concerns are mine." He argued that Democrats saw "'community' as a limited cluster of interest groups, locked in odd conformity."

Bush continued:

And in this view, the country waits passive while Washington sets the rules. But that's not what community means—not to me. For we're a nation of community; of

thousands and tens of thousands of ethnic, religious, social, business, labor union, neighborhood, regional and other organizations, all of them varied, voluntary and unique. This is America: the Knights of Columbus, the Grange, Hadassah, the Disabled American Veterans, the Order of Ahepa, the Business and Professional Women of America, the union hall, the Bible study group, LULAC, "Holy Name"—a brilliant diversity spread like stars, like a thousand points of light in a broad and peaceful sky.

The key section brought attention back to his own story:

> For seven and a half years, I've worked with a great president. I've seen what crosses that big desk. I've seen the unexpected crises that arrive in a cable in a young aide's hand. And I've seen problems that simmer on for decades and suddenly demand resolution. And I've seen modest decisions made with anguish and crucial decisions made with dispatch.
>
> And so I know that what it all comes down to, this election— what it all comes down to, after all the shouting and the cheers—is the man at the desk. And who should sit at that desk?
>
> My friends, I am that man.

On Election Day 1988, George H. W. Bush carried forty states with 53.4 percent of the popular vote. According to exit polls, he won a majority of votes among men and among women and in each age group, from the young (eighteen to twenty-four) to the old (sixty plus). He took 60 percent of the white vote; 30 percent of the Hispanic; 11 percent of the African American, and carried a majority in each geographic region—East, West, Midwest, and South.

The moment the campaign was over, Bush wanted to change the subject. He had caricatured Dukakis, attacked Dukakis, tried to humiliate Dukakis. But once the votes were cast, the president-elect longed to move on—quickly. "The American people," Bush said the

day after the election, "are wonderful when it comes to understanding when a campaign ends and the work of business begins." The campaign, however brutal, was one thing—a means to an end. And the end was governing, not engaging in endless partisan conflict. It is easy to dismiss this Bushian understanding of politics as cynical—he would, it is true, stoop to conquer—but it was in fact his understanding, and so we should judge him not only on his tactics to win power but also on the results of his service once *in* power.

Four decades on, Bush's vision of politics not as sport but as serious business may seem antiquated. So might the tone he took when speaking of his defeated rivals, Dukakis and the vice-presidential nominee, Lloyd Bentsen, who had won the Senate seat that Bush had wanted in 1970. "To our opponents, I offer my congratulations for a hard-fought campaign," Bush said. "Both the Governor and Senator Bentsen have given a major portion of their own lives to public service, and I have the greatest respect for that commitment. And I know that each one is going to serve the public interest as they see it, with the same energy and conviction that they demonstrated so well in this campaign. The very real differences between us have been highlighted by the glare of the television lights, but for my part I've never had any doubt that we share a common interest in building a better America. And that's fundamentally what the American election is all about."

One way of thinking about George H. W. Bush and presidential politics is a little crude, but largely accurate: On the campaign trail he'd cut your throat—and then do all he could to save your life until the ambulance got there.

On the day after the election, the Bushes flew back to Washington to be greeted at the White House by the Reagans. "With George Bush and Dan Quayle, I feel our achievements are secure, our change now a permanent feature of American government," Reagan told reporters in the Rose Garden. "But I also believe your mandate will make it possible not just to continue but to build upon the achievements of the past eight years. This is not the end of an era

but a time to refresh and strengthen our new beginning. In fact, to those who sometimes flatter me with talk of a Reagan revolution, today my hope is this: You ain't seen nothin' yet."

Bush was grateful. "I can hardly believe it, but it's sinking in now, the enormity of what has taken place—peaceful election, eventually a peaceful transfer of power," Bush said in the Rose Garden. Addressing Reagan, Bush continued: "I really believe that the results would have been entirely different . . . if I hadn't learned from a giant the good things about the United States of America. Thank you, sir."

The Reagan era was ending, and the Bush years were beginning.

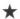

Gerald Ford was an intriguing factor in the politics of 1980. The thirty-eighth president had only narrowly lost to Jimmy Carter and was more than notionally interested in avenging that defeat. He kept his options about entering the contest himself open until well into the primary season; the thinking then was that Reagan was too conservative to win a general election. When Reagan appeared the inevitable nominee, however, Ford acknowledged his old rival's victory and, at Reagan's direct request, allowed negotiations over his own potential nomination as vice president to go forward at the convention in Detroit in July. It was a near-run thing, and the talks ran into the third night of the four-day meeting. At last, not long before midnight on the penultimate evening, Reagan called Bush and asked him to join the ticket.

Scenes from the 1981 inaugural.

The 1981 inaugural was the first in American history to be held on the West Front of the Capitol. Previous generations had held the ceremonies on the East Front, but Reagan, with his masterly visual imagination, wanted to be looking west, down the Mall and toward the vast fields of the Republic. On that cold, largely clear day, Tuesday, January 20, 1981, Bush was sworn into office by his old friend Potter Stewart, an associate justice of the Supreme Court appointed by President Eisenhower. And Reagan took the oath from Chief Justice Warren E. Burger. "To a few of us here today this is a solemn and most momentous occasion, and yet in the history of our nation it is a commonplace occurrence," Reagan said. "The orderly transfer of authority as called for in the Constitution routinely takes place, as it has for almost two centuries, and few of us stop to think how unique we really are. In the eyes of many in the world, this every-four-year ceremony we accept as normal is nothing less than a miracle." Afterward, during the inaugural parade, Bush was ebullient, seeming to risk hurling himself out of the car with his waves to the crowds. One line from Reagan's speech that day was especially Bushian: "How can we love our country and not love our countrymen; and loving them, reach out a hand when they fall, heal them when they're sick, and provide opportunity to make them self-sufficient so they will be equal in fact and not just in theory?"

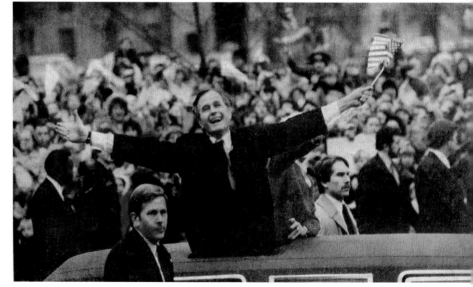

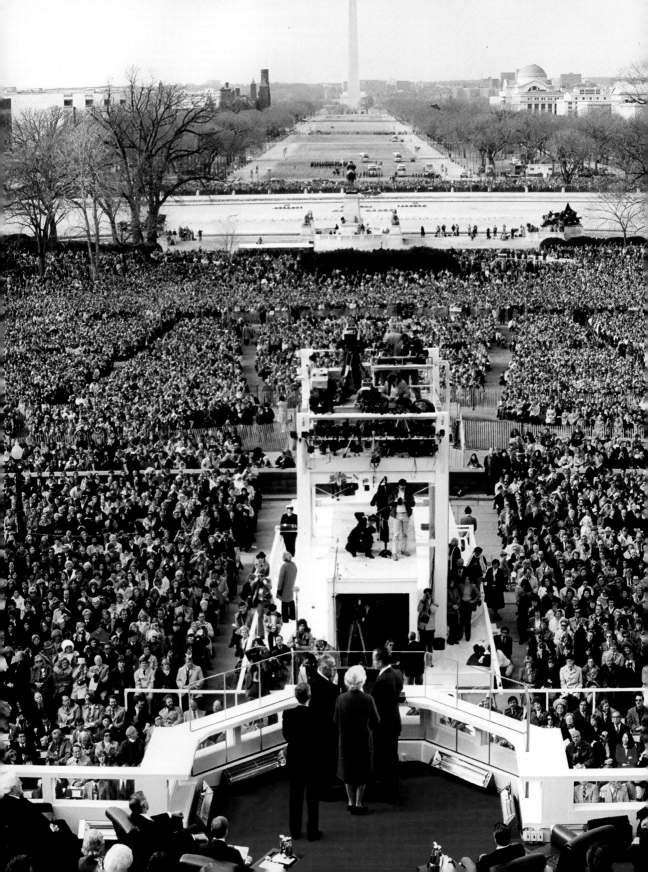

In the middle of the afternoon of Monday, March 30, 1981, President Reagan was wounded by a would-be assassin while leaving the Washington Hilton hotel on Connecticut Avenue in northwest Washington. At first the president, who was coughing up bright red blood, thought his ribs had been injured when Secret Service agent Jerry Parr had hurled him into the back of his limousine. Parr then realized that Reagan had been struck by one of the assailant's bullets and ordered the car to divert to the George Washington University Hospital. Three others were also injured in the shooting: White House press secretary James Brady, Secret Service agent Timothy McCarthy, and D.C. police officer Thomas Delahanty. Reagan insisted on walking unassisted into the hospital; he then collapsed once he was inside the doors of the emergency room. For an America shaped by Dallas in 1963, Memphis and Los Angeles in 1968, and two separate attempts on President Gerald R. Ford, the shooting was a grim sequential chapter in political violence.

Vice President Bush was in Texas on a speaking tour on that dark Monday. His first stop had been in Fort Worth, and he was due to speak to the Texas legislature in Austin when it became clear that he needed to return to the capital. Bush's arrival in the capital that evening brought a measure of order and stability to what had been a chaotic day in the White House. Below: Mrs. Bush greets a recovering president as Reagan returned home from the hospital on Saturday, April 11, 1981.

U.S. Air Force Academy graduation Colorado Springs, Co. June 2nd 1982

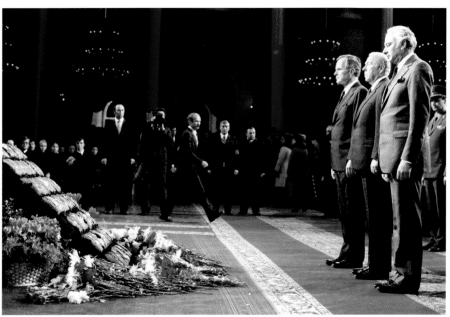

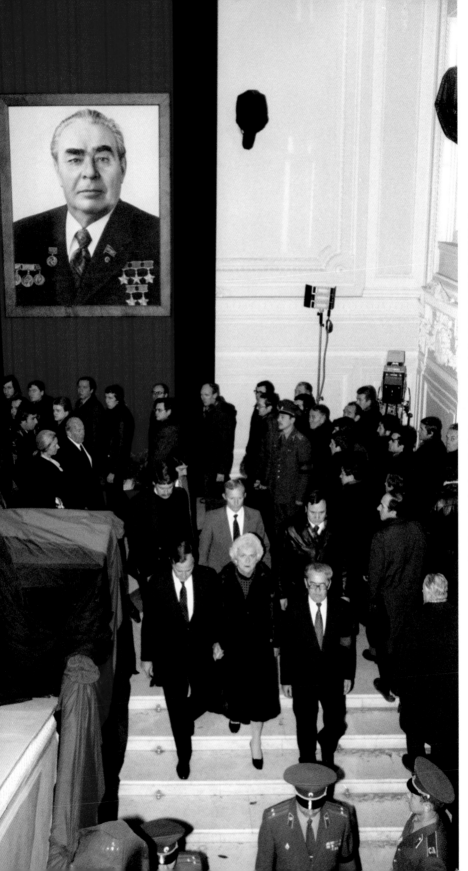

"You'll die, I'll fly" was James Baker's irreverent motto for the Bush vice presidency. Bush did spend a great deal of time attending the funerals of foreign leaders. There was more to this than immediate ceremonial protocol: As he had at the United Nations, Bush believed gestures of individual effort and of respect were beneficial elements of American diplomacy even if the payoff was not immediately evident. He saw off three Soviet leaders, and it was at the funeral of Konstantin Chernenko in 1985 that Bush first met Mikhail Gorbachev. "I get sick of Vice Presidential jokes," Bush noted in 1984, "but everyone really does want this job if they can't have the number #1 slot; and, yet, the political satirists and commentators continue to downgrade the job even though it's taken on vast new dimensions. . . . [W]hat they overlook is the substance of attending funerals and inaugurations, and the diplomacy that goes with it, the showing of the flag, and the meetings with Chiefs of State."

Bush had a curiously complicated public image in his years on the largest national stage. Many thought him elitist and somehow soft; those who encountered him in person were more like Warren Beatty, who told a mutual friend that Bush was powerfully impressive. "You have a Gary Cooper there," Beatty said. "They can't beat him." Bush's charisma was understated but real, and there were those who recognized it—including, as shown here, *Playgirl* magazine, which named him one of its "Ten Sexiest Men" of 1983, an unusual honor, to say the least, for George Herbert Walker Bush. (Barbara kept the clip in her family scrapbooks.) Bush would spend the rest of his vice presidency, and even part of the presidency, asserting authority and command in a media environment that often felt hostile and even contemptuous. "Tensions are very very high," he wrote his sister, Nancy Bush Ellis, late in the 1984 campaign. "I am totally convinced (I hope not conspiratorially so) that we are up against many in the press who hate to see the demise of Ferraro and the defeat of [Mondale]. In any event it has been very rough going."

news from **DOUBLEDAY**

FOR IMMEDIATE RELEASE July 15, 1983 Contact: Elizabeth St. John
 (212) 953-4485

Doubleday and Co., Inc., is pleased to announce the forthcoming publication of
C. FRED'S STORY: A Dog's Life by C. Fred Bush, the golden cocker spaniel of
Vice-President George Bush and Mrs. Barbara Bush. The text, though almost en-
tirely the words of C. Fred, has received some slight editing by Mrs. Bush,
and is, as one might expect from a personage so well-travelled, an exciting
chronicle of the many places, people, and events C. Fred has encountered
throughout his lifetime. His trip to China, the parties at the Vice-President's
house in Washington, D.C., the many confidences intended "for his ears only,"
all are recounted in C. Fred's inimitable style, and are accompanied by 62
black-and-white photographs.

C. FRED'S STORY: A Dog's Life will be published on April 2, 1984 to coincide
with C. Fred's 12th birthday. All of the authors' proceeds will be donated to
the following charities: The Laubach Literary Action and The Literacy Volunteers
of America, Inc.

C. FRED'S STORY: A Dog's Life
by C. Fred Bush and Mrs. Barbara Bush
Publication date: April 2, 1984
Illustrated with 62 black-and-white photographs

C. Fred and Mrs. George Bush. Photo by: Cynthia Johnson.

Personal mention

From Mrs. Bush's scrapbook, a collection of images of C. Fred Bush. Barbara used the cocker spaniel as a literary device in *C. Fred's Story,* a book published to help raise funds for literacy, a favorite Bush cause. The vice president acknowledged the elevation of C. Fred in the household with grace, writing a friend: "As for me, my ego has accepted my new status, but I don't like Ken-L-Ration twice a day." Mrs. Bush drafted her first manuscript by hand; the publisher asked if she might manage to have it typed. "I wanted people to know that we had a literacy problem and to urge them to be part of the answer," Barbara recalled, "whether they donated money to local programs that worked, volunteered their time, or just made darn sure that they were reading to their children and grandchildren."

Bush faced an unusual challenge in 1984: He was running against the first female major-party nominee for vice president in American history. Walter Mondale (below, watching the 1984 vice-presidential debate) had chosen New York Representative Geraldine Ferraro as his running mate.

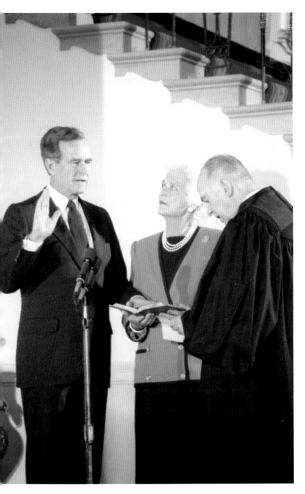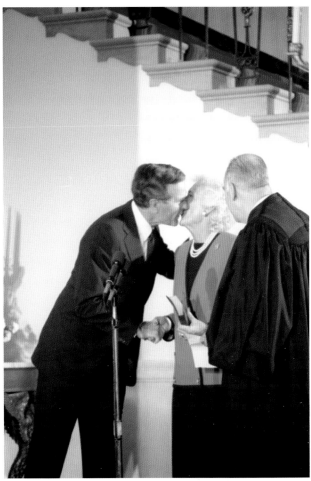

Reagan and Bush were renominated at the 1984 Republican National Convention in Dallas. In his remarks, Bush cited Eisenhower: "Three decades ago, a great American President stood on the Capitol steps and made his second inaugural address. 'May we pursue the right without self-righteousness,' said Dwight Eisenhower. [And] 'May the light of freedom flame brightly, until at last the darkness is no more.' Now, as in President Eisenhower's day, these words reflect the true spirit and aspirations of the American people." The Reagan-Bush ticket would go on to carry forty-nine states. The second inaugural took place indoors at the White House on Sunday, January 20, 1985.

BUSH'S RETREAT

John R. VanBeekum photographs
the vice president's haven
in Kennebunkport, Maine

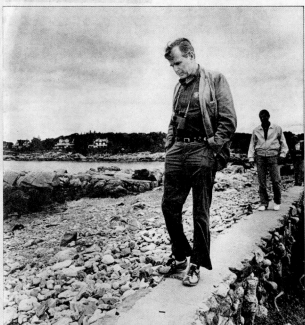

When Vice President George Bush wants to really relax, he wings up to his house on Walker's Point in the Maine village of Kennebunkport. Perched above the coastal rocks, the summer home was damaged in a 1977 winter storm but is almost restored. It has five bedrooms and a dormitory that sleeps six. Solar panels on the large gable heat water. Above, Bush and his wife use binoculars to watch seals and birds.

Baker Family and President & B.P.B.

Frank Sinatra produced two galas for the 1985 inaugural, the first in Bush's honor on Friday, January 18. Merv Griffin was master of ceremonies; the Gatlin Brothers sang; and Rich Little performed. "Besides Gatlin's country-western singing group, other stars celebrating Bush included singers Pearl Bailey, Lou Rawls, [and] Dean Martin," *The Washington Post* reported. "Yale's Whiffenpoofs proved to be classic gentlemen songsters, with Yalie Bush singing along poignantly to 'The Whiffenpoof Song.' And the Naval Academy Glee Club also presented a medley of justifiably neglected campaign songs dating back to George Washington." Bottom right: A photo of the family of James A. Baker III, the incoming secretary of the Treasury, with President Reagan and Mrs. Bush.

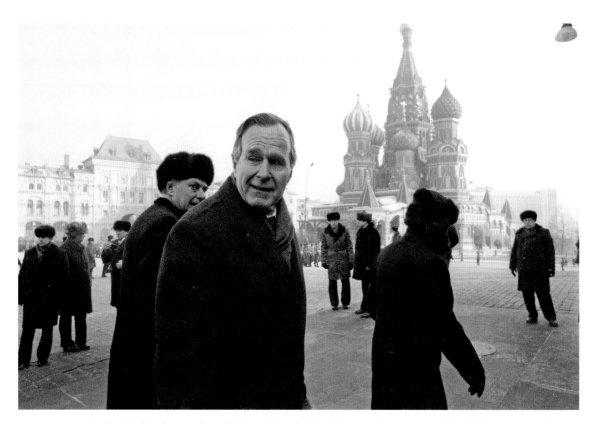

Bush at Yuri Andropov's funeral in the winter of 1984. Andropov, a former head of the KGB, had succeeded Leonid Brezhnev on the occasion of Brezhnev's death in late 1982. When asked in his first term as president why he had not met with the Soviet premier, Ronald Reagan joked that they kept dying on him. More seriously, the Reagan strategy in the Cold War was summed up simply: "We win, you lose." Bush came from a less hawkish sphere of the Republican Party but was a loyal supporter of the president's policies and a skilled diplomat in selling that strategy to often skeptical European allies. In a report to Reagan on the Brezhnev funeral in 1982, Bush was philosophical: "I saw a funeral without tears, save for the immediate family, I saw a funeral without God and thought 'How sad—how lonely.'" Never as publicly eloquent as President Reagan, in private Bush was an articulate defender of the Western values under siege in what President Kennedy had called "the long twilight struggle."

The vice president was always a man of hope, but he was also realistic about the Soviet Union's aspirations and ambitions. On a trip to Berlin not long after Brezhnev's funeral, Bush told his diary: "The starkest memory . . . is seeing the wall in Berlin with the dogs and the watch tower and the human component of all of that. What an impact it makes to stand up and see the tanks, the guards and the wire and the soldiers looking at you. I wonder how in God's name anybody could think the Soviet Union wanted normal relations or share any values on human rights when you see the barbed wire, and the stark brutality of it all." As the eighties unfolded, and leaders came and leaders went, Bush maintained confidence that the combination of the Reagan military buildup and a steady case in favor of human rights might, just might, hasten a thaw in the Cold War.

Moments with the 1980s military.

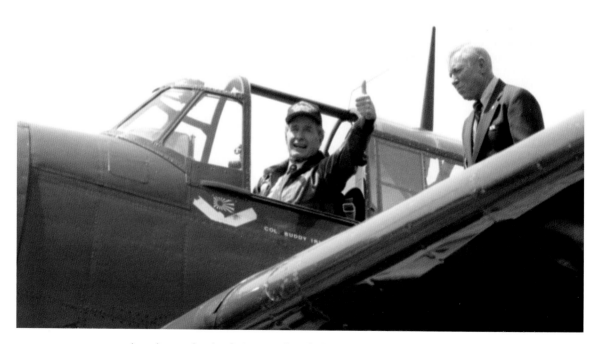

In an Avenger bomber forty years after Chichi-Jima.

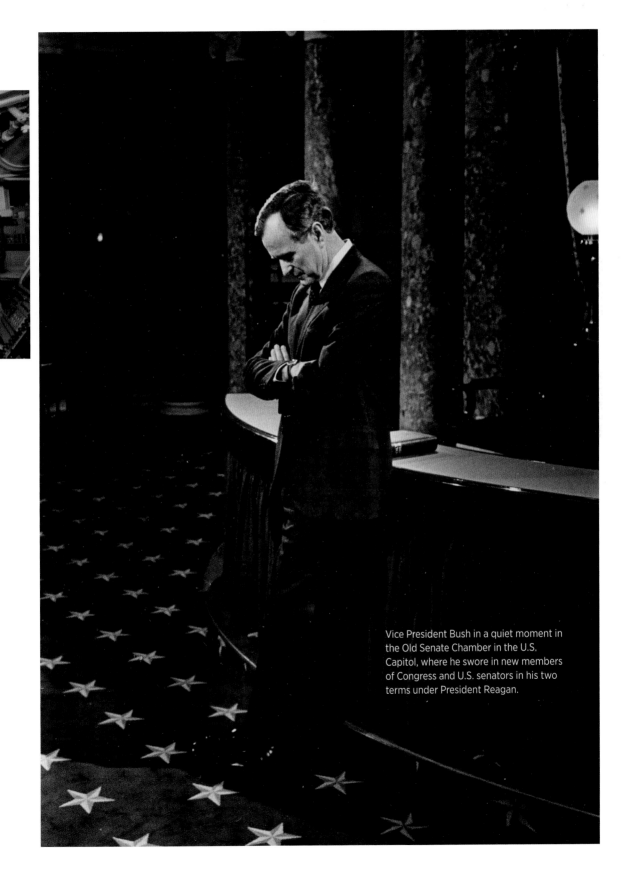

Vice President Bush in a quiet moment in the Old Senate Chamber in the U.S. Capitol, where he swore in new members of Congress and U.S. senators in his two terms under President Reagan.

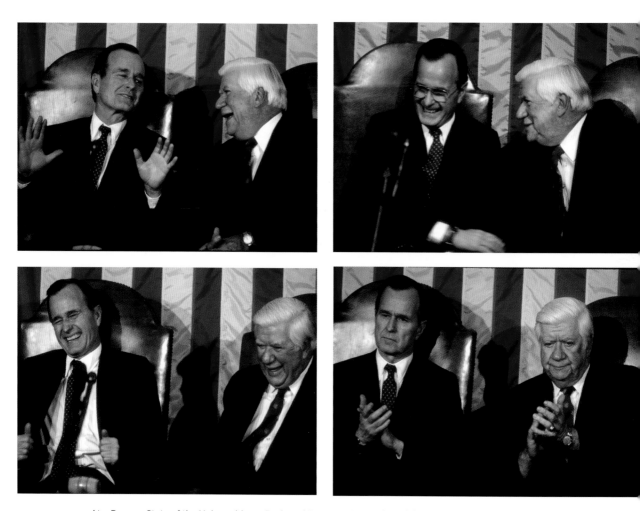

At a Reagan State of the Union address, Bush and Democratic speaker of the House Thomas P. "Tip" O'Neill, Jr., chat, laugh, and then strike dignified poses as the speech unfolds. The two men had served together in the House during Bush's two terms from Texas's Seventh District (O'Neill held President Kennedy's old seat in the House). "I've always known that Tip was behind me," Reagan later said at a tribute to the speaker, "even if it was only at the State of the Union Address. As I made each proposal, I could hear Tip whispering to George Bush, 'Forget it. No way. Fat chance.'"

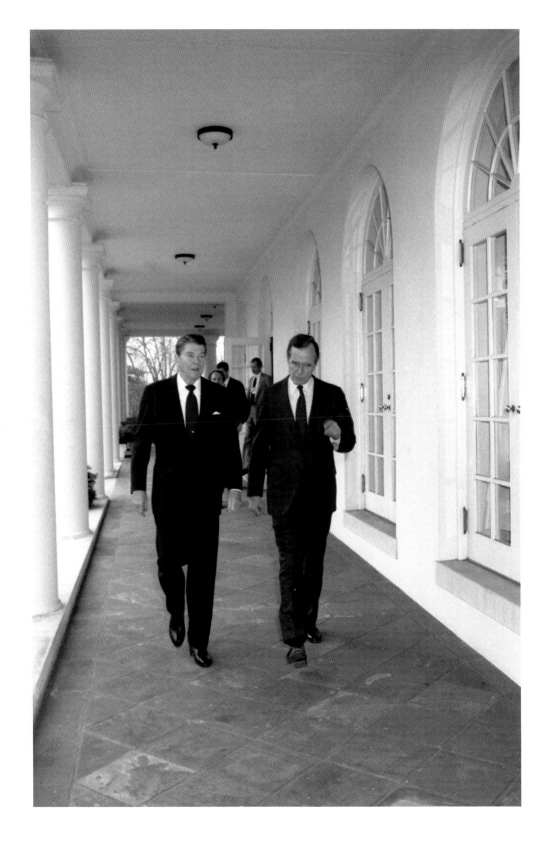

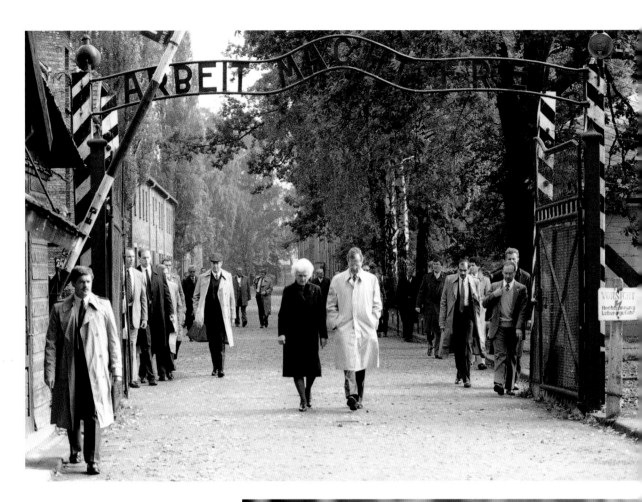

In 1987 the Bushes toured Auschwitz and Birkenau in Poland, the Nazi death camps where four million Jews and Poles were murdered. "It is so moving that it is very hard to describe it for me," Bush said. "There is no way to express it." According to the *Los Angeles Times*, "The Bushes seemed particularly horrified at an exhibition in the Jewish Pavilion. They stopped in front of a large photograph of a woman inmate wearing a cardboard sign that said in German, 'I Had Relations With a Jew.' Mrs. Bush was visibly upset at a photograph of naked women inmates being marched to their death." As the vice president said at the end of the tour, "It's a horrible reminder of a part of civilization's past. It's a reminder that everybody should work to see that we could never have such brutality in the future."

Visiting a children's leukemia ward in Krakow, Poland, Bush was inevitably reminded of Robin and her suffering in the 1950s. One patient, a seven- or eight-year-old boy, wanted to greet the American vice president. Learning that the child was sick with the disease that had killed Robin, Bush began to cry. "My eyes flooded with tears, and behind me was a bank of television cameras," Bush told his diary. "And I thought to myself, 'I can't turn around . . . I can't dissolve because of personal tragedy in the face of a host of reporters and our hosts and the nurses that give of themselves every day.' So I stood there looking at this little guy, tears running down my cheek, but able to talk to him pleasantly . . . hoping he didn't see but, if he did, hoping he'd feel that I loved him."

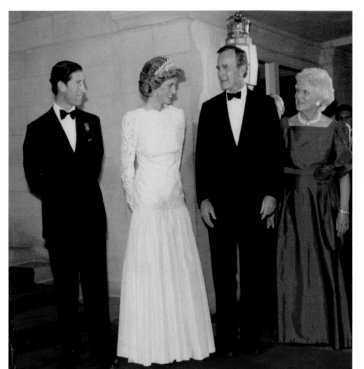

July 16= 1986
White House

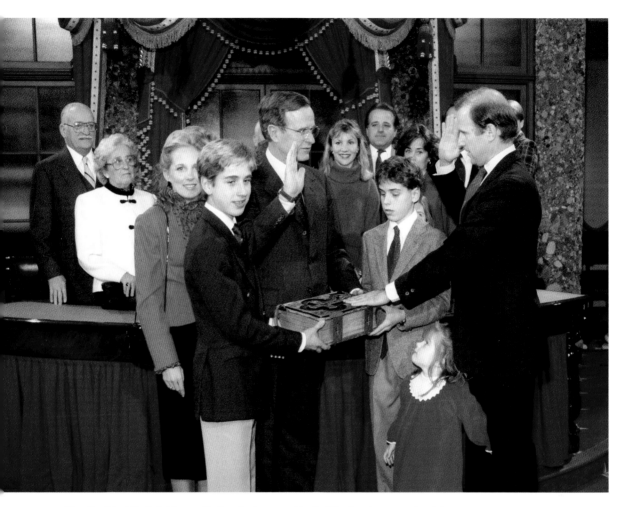

Vice President Bush, in his constitutional role as president of the Senate, swears in a future successor: Joseph R. Biden, Jr., Democrat of Delaware, for the longtime senator's third term in 1985. Though political opponents, Biden always admired Bush, and Bush was privately supportive of his old Senate antagonist when Biden became vice president under President Barack Obama in 2009. Early in the administration, Obama fell into the habit of poking fun at Biden's fabled loquaciousness, and the former president let it be known in Washington circles that a president should not joke about his vice president.

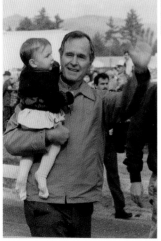

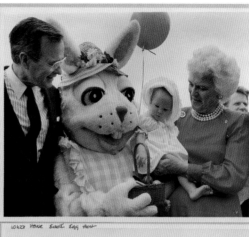

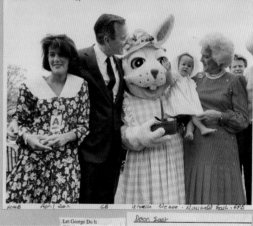

Sundry images from Mrs. Bush's scrapbook (above). Opposite:
A print advertisement for Bush's pre-1988 campaign autobiog-
raphy, *Looking Forward.*

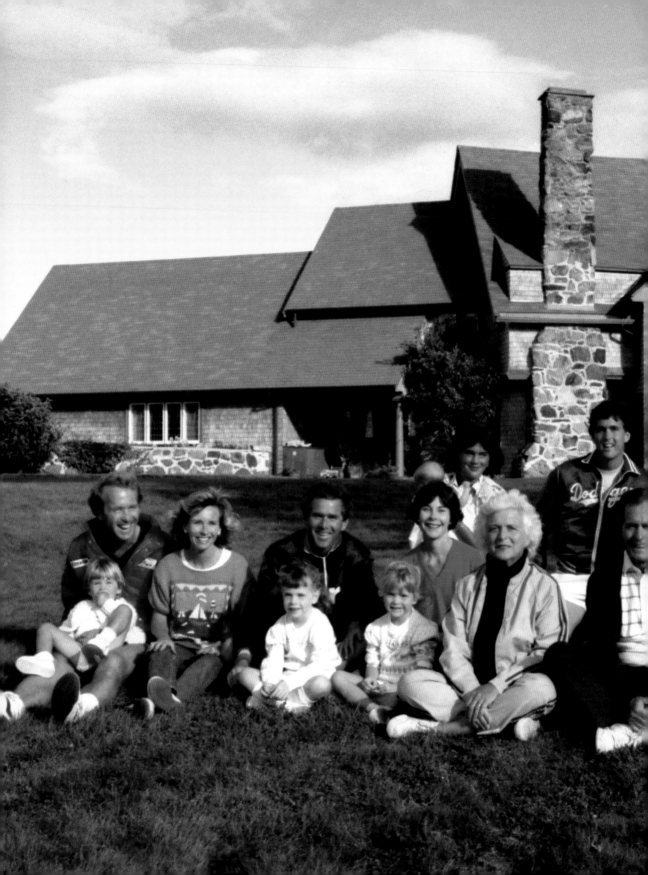

Images from 1980s Christmases.

Bush

George, Laura
Barbara & Jenna
Texas

Neil, Sharon
Pierce & Lauren
Colorado

Mar
&

C. Fred
Washington, D.C.

New Arrival
Nancy Ellis LeBlond
November 19, 1986

Jeb, Columba
...lie, Jebby & George
Florida

Bill, Doro
& Sam LeBlond
Maine

The Bush Family
wishes you a
Merry Christmas
and a
Peaceful New Year

Barbara Bush

Vice President George Bush

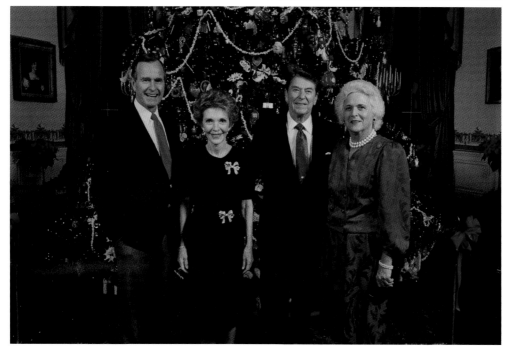

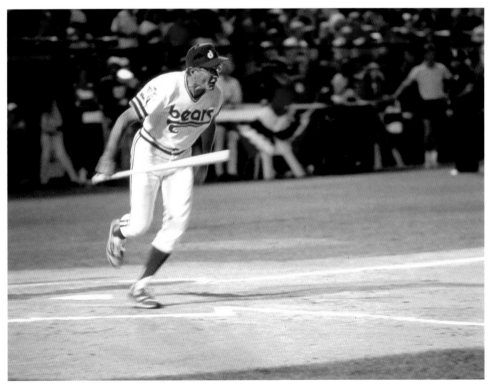

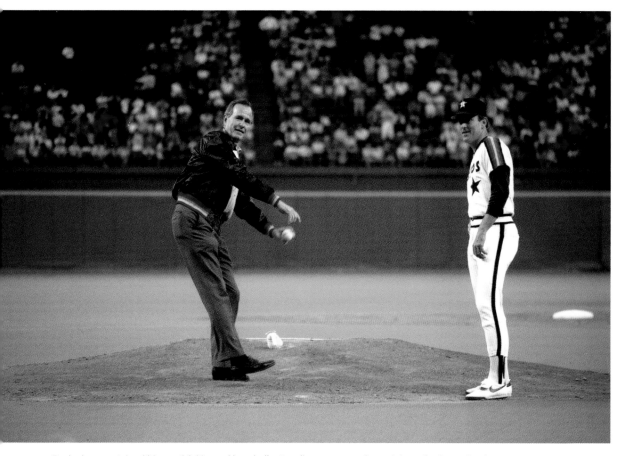

Bush always retained his youthful love of baseball, attending games and remaining a fan long after he hung up his Yale uniform. In the Astrodome with the great Nolan Ryan, he threw out a ceremonial first pitch, and as president he sought to use the game to further diplomatic ends, taking Egyptian president Hosni Mubarak and Queen Elizabeth II (along with Prince Philip) to Baltimore Orioles games. He was thrilled, too, when his son George W. Bush became an owner of the Texas Rangers while the elder Bush was in the White House. The grace of the game had a perennial appeal, as did its emphasis on steady performance over a long season rather than on singular heroic moments. As a metaphor for the elder Bush's life, it would be hard to find a better one.

A morning at Kennebunkport.

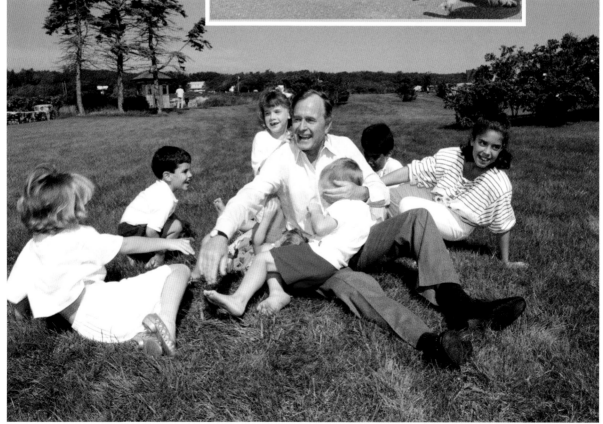

The personal relationships among the Reagans and the Bushes were not without their nuances. While President Reagan was genial and charming, Mrs. Reagan never warmed to either Bush. The tension was possibly rooted in the 1980 campaign, when Bush, challenging Reagan, had alluded to what was known as "the age issue." (Reagan was sixty-nine, then thought to be on the elderly side of the ledger.) Mrs. Reagan also had what might be called a "Hollywood view" that only the leading man and woman should receive attention. For his part, Bush quickly formed an affectionate view of Reagan, which, given Bush's nature, was not surprising. "I spent sixteen years fighting the man and what he stood for," Bush told Congressman Mickey Leland, a Texas Democrat, in February 1981. "But I didn't know him." Reagan, Bush said, was "unthreatened by people or events, a superb person." Between the election and the inauguration, William Wilson, a member of Reagan's kitchen cabinet from California, reached out to Bush. "Right after Reagan had been elected—and I had been elected, vice president—we got a message from this guy Wilson," Bush recalled. "It turned out he was carrying water for Nancy on this. The message was, 'Stay out of the paper, get a lower profile, back down. Tell the "Shrubs" to keep a lower profile.' We weren't taking a high profile, not doing the Washington thing of saying this or that, and it burned me up, and it burned Barbara up. She was very unhappy about it, deservedly so. We couldn't back down if we hadn't backed forward. We hadn't done anything. Hadn't done a damn thing. And I was very careful about that, always. Still don't know what drove that. But Nancy and Barbara just did not have a pleasant personal relationship."

April 29= 1987

April 29= 1987
The Presidential Dinner

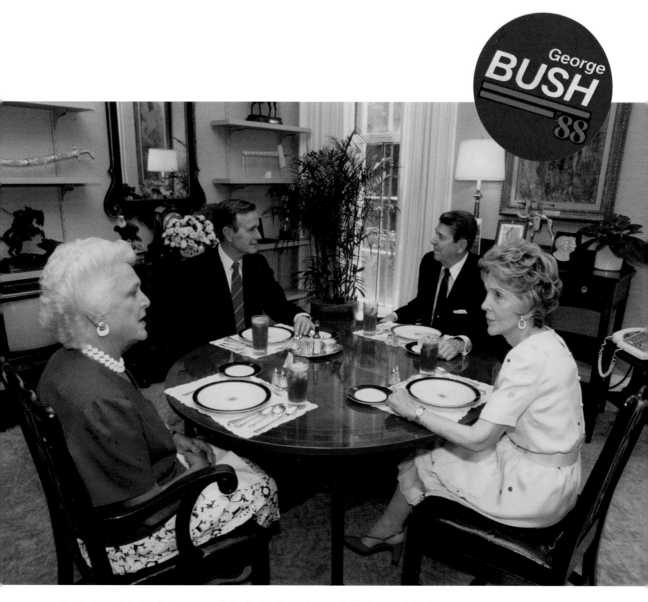

A private lunch in the dining room off the Oval Office in August 1988, the month Bush accepted the presidential nomination.

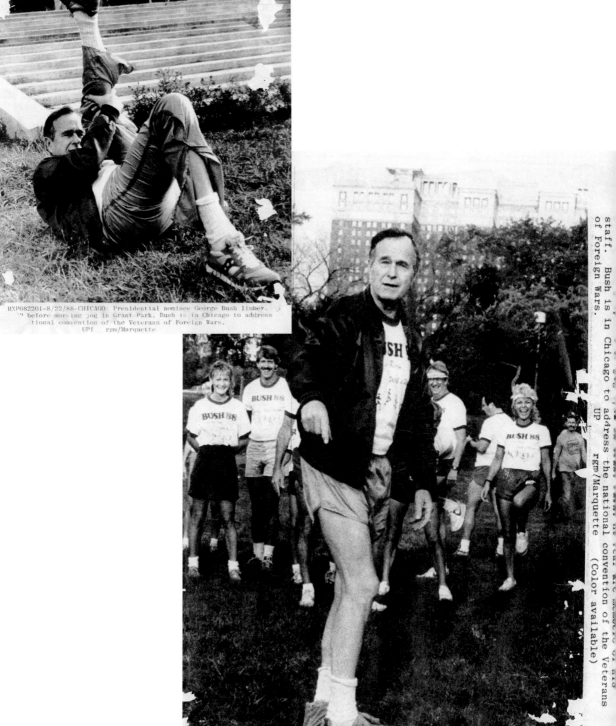

HXP082201-8/22/88-CHICAGO: Presidential nominee George Bush limber..
?? before morning jog in Grant Park. Bush is in Chicago to address
.tional convention of the Veterans of Foreign Wars.
UPI rgm/Marquette

staff. Bush is in Chicago to address the national convention of the Veterans of Foreign Wars.
UP rgm/Marquette
(Color available)

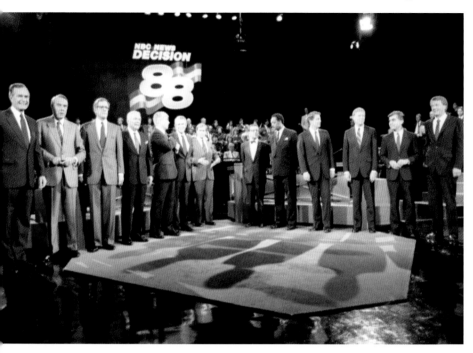

The 1988 field on both sides included: George H. W. Bush, Bob Dole, Pete du Pont, Alexander Haig, Jack Kemp, Pat Robertson, Paul Simon, Jesse Jackson, Al Gore, Dick Gephardt, Michael Dukakis, and Bruce Babbitt. Bush and Dukakis would emerge victorious.

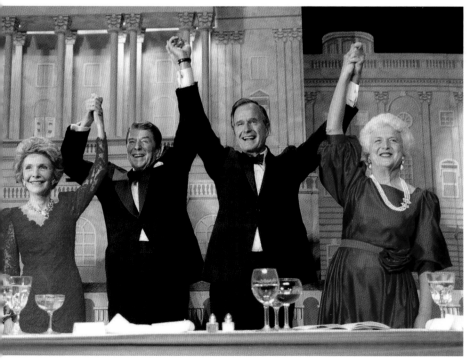

President Reagan endorsed no candidate in the Republican primary to succeed him; he declared his support for Bush at a dinner in Washington in May 1988. "Eight years ago, George Bush and I said to the American people, 'The time is now.' And it still is," Reagan said. "If I may, I'd like to take a moment to say just a word about my future plans. In doing so, I'll break a silence I've maintained for some time with regard to the Presidential candidates. I intend to campaign as hard as I can. My candidate is a former Member of Congress, Ambassador to China, Ambassador to the United Nations, Director of the CIA, and National Chairman of the Republican Party. I'm going to work as hard as I can to make Vice President George Bush the next President of the United States."

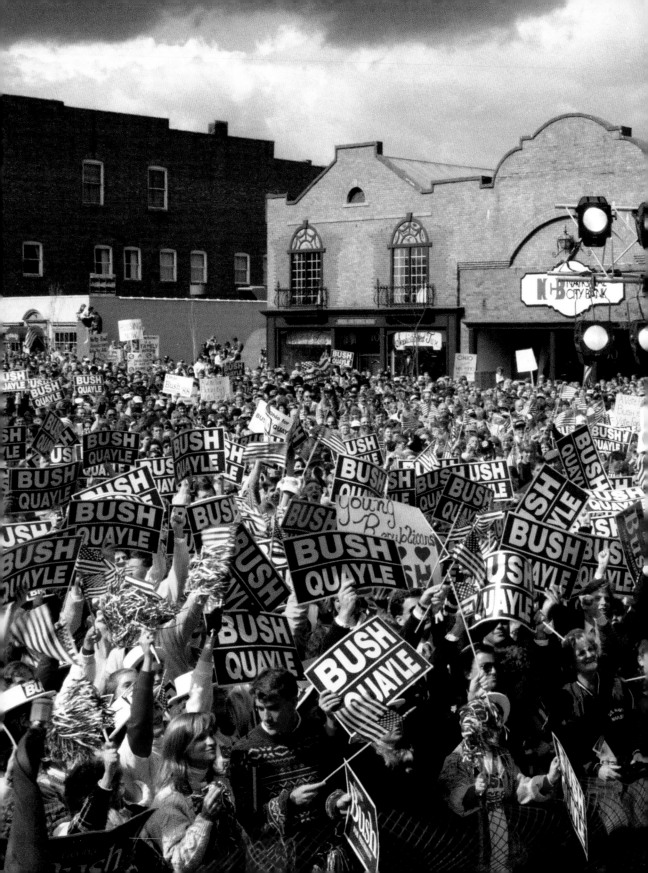

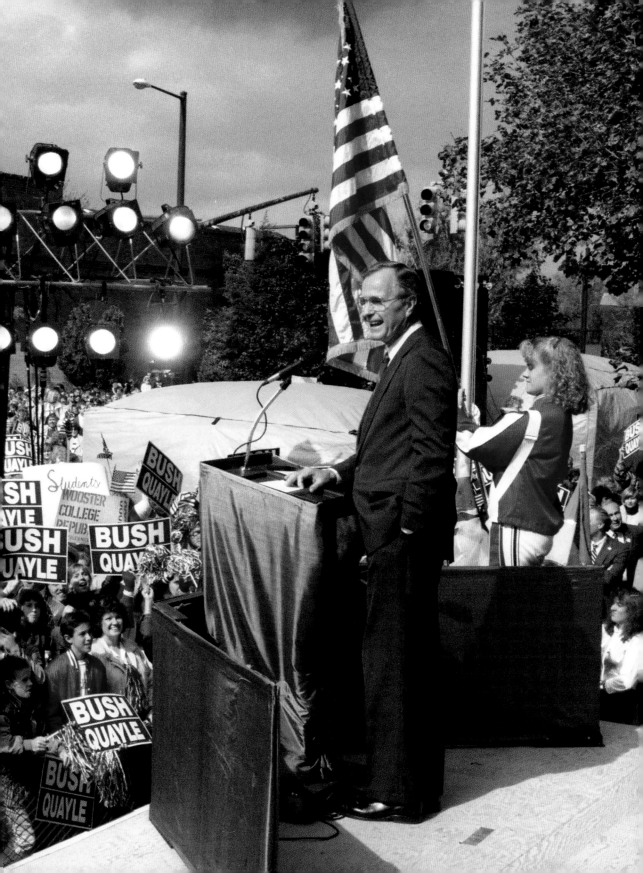

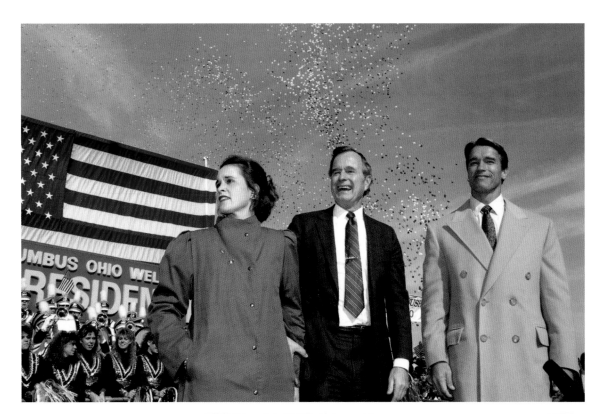

Arnold Schwarzenegger referred to his friend the vice president as "Conan the Republican," and Bush raced to the finish in 1988 with a series of tough attacks on Dukakis and an assurance that he would lead a "kinder, gentler" America. The voters' verdict was decisive: On Election Day 1988, Bush carried 53.4 percent of the popular vote, 40 states, and 426 electoral votes to Dukakis's 111. The Bushes watched the returns in their suite at the Houstonian Hotel. It was the vindication of a lifetime, an hour to savor. "To those who supported me," Bush said that night, "I will try to be worthy of your trust, and to those that did not, I will try to earn it."

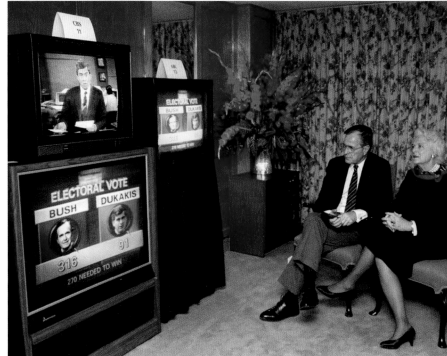

With Baker, Barbara, and adviser Robert Teeter in the Houstonian. Below: Home to the vice-presidential residence off Massachusetts Avenue in Washington. "A campaign is a disagreement," Bush said after the election, "and disagreements divide, but an election is a decision, and decisions clear the way for harmony and peace, and I mean to be a president of all the people."

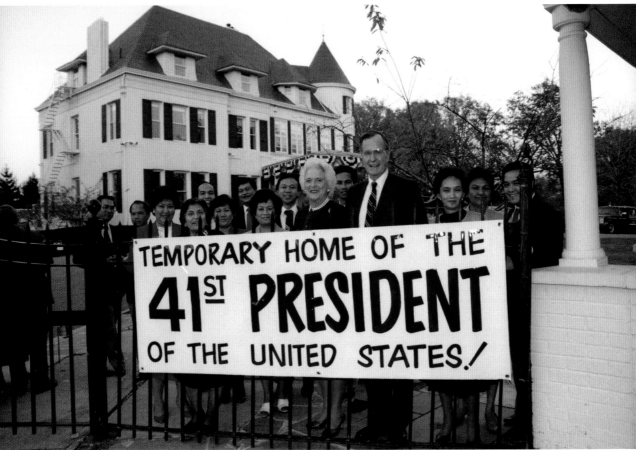

TEMPORARY HOME OF THE 41ST PRESIDENT OF THE UNITED STATES!

With Reagan and Gorbachev on Governors Island in New York Harbor, Wednesday, December 7, 1988. Later that day, the Soviet leader would speak at the United Nations; his words there signaled the end of the Cold War. "Relations between the Soviet Union and the United States of America span five-and-a-half decades," Gorbachev said. "The world has changed, and so have the nature, role, and place of these relations in world politics. For too long they were built under the banner of confrontation, and sometimes of hostility, either open or concealed. But in the last few years, throughout the world people were able to heave a sigh of relief, thanks to the changes for the better in the substance and atmosphere of the relations between Moscow and Washington. . . . The future U.S. administration headed by newly elected President George Bush will find in us a partner, ready—without long pauses and backward movements—to continue the dialogue in a spirit of realism, openness, and good will, and with a striving for concrete results, over an agenda encompassing the key issues of Soviet-U.S. relations and international politics." Afterward, *The New York Times* wrote: "Perhaps not since Woodrow Wilson presented his Fourteen Points in 1918 or since Franklin Roosevelt and Winston Churchill promulgated the Atlantic Charter in 1941 has a world figure demonstrated the vision Mikhail Gorbachev displayed yesterday at the United Nations."

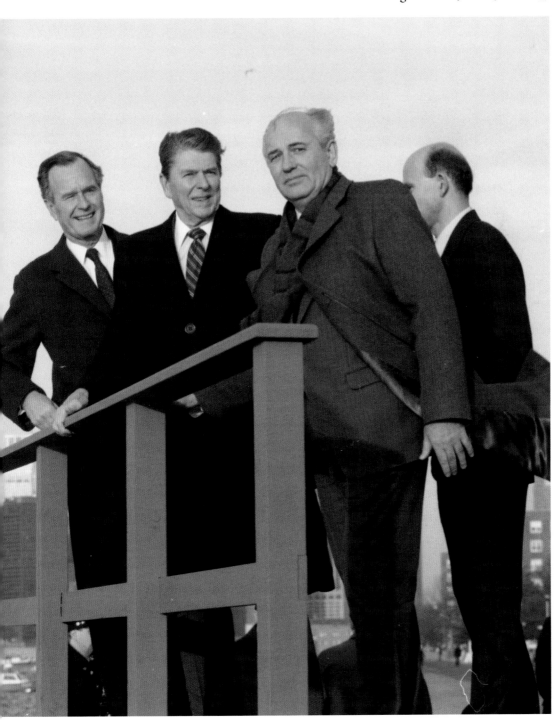

THE BIGGEST JOB IN THE WORLD

1989 to 1993

I've tried to serve here with no taint of dishonor; no conflict of interest; nothing to sully this beautiful place and this job I've been privileged to hold. . . . Maybe misjudgment on this issue or that, but never misconduct, never doing anything that would tarnish and hurt the Presidency.

—GEORGE H. W. BUSH, on his last day in office, 1993

Don't let the turkeys get you down.

Dear George

You'll have moments when you want to use this particular stationary. We'll get to it.

George I treasure the memorys we share and wish you all the very best. You'll be in my prayers. God Bless you & Barbara. I'll miss our Thursday lunches.

Ron

Boynton

RECALLING THE NIGHT he became prime minister of Great Britain on Friday, May 10, 1940, Winston Churchill later wrote that he believed all his "life had been but a preparation for this hour and for this trial." George H. W. Bush was coming to the American presidency at a less dire hour—it would fall to Churchill to stand alone against Nazi tyranny in democracy's hour of maximum danger—but Churchill's point about the past as prelude to the present was true for Bush. Though no one could know it on the cold, sunny January day when Bush rose to take the oath of office as the forty-first president of the United States, Bush's life experience was a good match to deal with the issues to come—of war and peace, of fiscal responsibility, and of the tone and tenor of politics in a changing partisan and media environment.

The man who stood before the nation and the world on Friday, January 20, 1989—a moment Bush called "a fascinating time of change in the world itself"—was a diplomat by inclination and a conciliator by temperament. He was succeeding a president who was rhetorically revolutionary; Bush was of a different mold. He disliked grand speechmaking, preferring to think of himself as a steady steward, a safe pair of hands, a judicious leader. He was a figure in the Eisenhower tradition—a point he himself understood. "You know, every President admires other Presidents," Bush remarked in 1990, commemorating Eisenhower's centennial. "Harry Truman was fond of Andrew Jackson. Gerald Ford studied Abraham Lincoln. And so, today I say it loudly and very proudly: I have always liked Ike." With an unsubtle allusion to his own public image, Bush added: "He was decisive, acting on instincts that were invariably wise. You know, some critics can't figure out how Eisenhower was so successful as a President without that vision thing. Well, his vision was etched on a plaque, sitting on his desk, that many of you around here remember because you were there: 'Gently in manner, strong in deed.' And he used that vision not to demagogue but deliver."

The handwritten letter President Reagan left for President Bush in the Oval Office on Friday, January 20, 1989. Bush's election was historically notable; the last incumbent vice president to win popular election to succeed the president with whom he served had been Andrew Jackson's vice president, Martin Van Buren, who prevailed in the 1836 election.

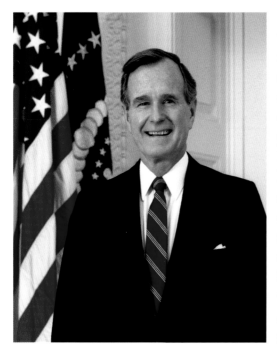

President Bush's official White House portrait.

Which is precisely what President Bush sought to do. In the domestic realm he governed largely from the center, struggling to tame deficit spending—at the time widely understood as a central challenge—and deciding, in the summer of 1990, to abandon a high-profile campaign pledge not to raise taxes. Confronted with a Democratic-controlled Congress, he agreed to legislation that increased some tax rates in exchange for provisions that required any new spending to be paid for by corresponding restraints. It was a classic Bushian deal: wise, but difficult to explain in simple terms. Yet the politically costly agreement contributed mightily to the balanced budgets of the later 1990s—a short-term sacrifice that became a substantive success. Bush also supported and signed the Americans with Disabilities Act and important environmental legislation, banned the import of assault weapons, spoke out against the gubernatorial campaign of Ku Klux Klan leader David Duke in Louisiana, and tried to stem the rising tide of hard-right partisanship led by the Republican congressman Newt Gingrich.

THROUGH IT ALL, in good times and in bad, there was Barbara Pierce Bush. Blunt and tireless, her husband's fiercest defender, Mrs. Bush was known as "the Enforcer" in the family—the one who spoke the hard truths. She was never an important policy voice in her husband's orbit; she was, rather, a shrewd judge of people, and a constant source of support for the man she still sometimes called, in private, "Pop" or "Poppy." In the spring of 1990, the administration of Wellesley College invited the First Lady to speak at commencement and receive an honorary degree. Students at the women's college protested, declaring in a petition that Mrs. Bush had "gained recognition through the achievements of her husband," and adding

that Wellesley "teaches us that we will be rewarded on the basis of our own merit, not on that of a spouse."

Mrs. Bush was being attacked, the president told his diary, "because she hasn't made it on her own—she's where she is because she's her husband's wife." He added: "What's wrong with the fact that she's a good mother, a good wife, great volunteer, great leader for literacy and other fine causes? Nothing, but to listen to these elitist kids there is."

Mrs. Bush marched on, accepted the invitation, and delivered the commencement speech. There was no single path, she told the graduates; one followed one's heart and did the best one could. "Maybe we should adjust faster, maybe we should adjust slower," she said. "But whatever the era, whatever the times, one thing will never change: Fathers and mothers, if you have children—they must come first. You must read to your children, hug your children, and you must love your children. Your success as a family, our success as a society, depends not on what happens in the White House, but on what happens inside your house."

The loudest applause came when she remarked that perhaps there was someone in the audience who would, like her, one day preside over the White House as the president's spouse. "And," Mrs. Bush said, her timing perfect, "I wish him well." It was classic Barbara Bush: politically skillful, balanced—and good for her husband, for she presented herself as at once reasonable and reasonably conservative.

In 1989, at a time when AIDS was still shrouded in mystery and misunderstanding, Mrs. Bush visited a home for HIV-infected infants in Washington and hugged the children there, as well as an infected adult man. Her popularity as First Lady was such that, in 1992, some voters sported buttons with a last-gasp plea for the World War II generation: "Re-Elect Barbara's Husband."

Asked once if he had known, in the beginning, how resilient Mrs. Bush would be, George H. W. Bush said no—and tears came to his eyes. "She's the rock of the family, the leader of the family. I kind of float above it all, but she's always there, for me and for the kids. Deb-

utante from Rye, willing to make our own way, have adventures. Wasn't always easy for her, but never a word of complaint—just love, and strength. Opinions too, of course. Lots of those." And Bush once recalled his wife's remarkable memory for the slings and arrows of political life. "I told Barbara once, I said, 'Guess who I saw?' I'll make up a name here, but, 'I just saw Phil Smith the other day.' And she said, 'Don't you remember what he said about you in 1960?' I mean, she was a loyal fighter."

Barbara was in fact strength itself—and if her tongue was sometimes sharp, she was as honest with herself as she was with others. When she once unwisely described a female political opponent of her husband's as a word that rhymes with "rich," she reported that her family now referred to her as the "poet laureate." Later in life, she loved the story of how, when her eldest son, the forty-third president of the United States, took up painting, his instructor asked

The fall of the Berlin Wall in November 1989 was a signal moment in the long history of the Cold War. Long a superpower flashpoint, the divided German capital had been a source of global tension since World War II. And peace at last came on Bush's watch as president.

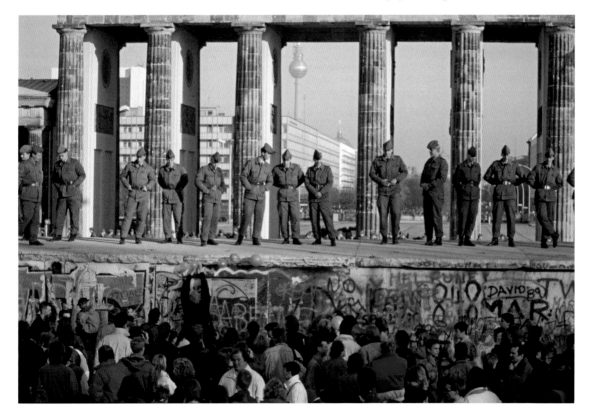

him if he'd ever used the color "burnt umber." No, Bush 43 replied, but he *did* remember that from his mother's cooking. "Brings down the house," she would say, approvingly. Mother and son needled each other to the end. In her final days in the spring of 2018, while the forty-third president was visiting, Mrs. Bush asked one of her doctors if she'd like to know why George W. was the way he was. Her humorous verdict: "I smoked and drank while I was pregnant with him."

Mrs. Bush believed literacy a civil and human right. At a televised event commemorating the bicentennial of the Constitution, a sixty-three-year-old son of a former sharecropper, a man named J. T. Pace, who had only recently become literate, was scheduled to read the Constitution's preamble aloud. Backstage, Mr. Pace was nervous. Mrs. Bush asked if it would help if they read it together on the broadcast. He agreed. Soon the two of them stood onstage, reading in unison. As Mr. Pace grew comfortable, Mrs. Bush lowered her voice—and lowered it again—and then again—until at last Mr. Pace was reading wholly on his own. He wept as he read—supported by Barbara Bush, who stood to the side, now silent as his voice spoke of the unending search for a more perfect Union. J. T. Pace had found his voice in part because Barbara Bush had lent him her heart.

In August 1990, Saddam Hussein of Iraq launched an invasion of neighboring Kuwait, an aggressive action that threatened to alter the delicate balance of power in the Middle East. Once the shock of the news sunk in, President Bush, together with advisers such as Secretary of Defense Dick Cheney and General Colin Powell, chairman of the Joint Chiefs of Staff, built a multinational coalition to reverse the invasion and restore the status quo ante. Bush's carefully defined mission was fulfilled in the early months of 1991, propelling the president to dizzyingly high approval ratings.

Abroad, President Bush presided over the reunification of Germany after the fall of the Berlin Wall in November 1989, and worked closely with Mikhail Gorbachev as the Soviet Union came to an end on Christmas Day 1991. In the Middle East, Bush assembled a massive coalition of nations to reverse Saddam Hussein's invasion of Kuwait in 1990–91. He took total responsibility for his actions. Bush passed no buck; he ducked no blame. "The face of war," he told his diary on the eve of Desert Storm, "looks at me."

In a letter to his children written from Camp David on New Year's Eve 1990, Bush was clear about his view of what was about to happen in the Gulf.

Dear George, Jeb, Neil, Marvin, Doro,

When I came into this job I vowed that I would never wring my hands and talk about "the loneliest job in the world" or wring my hands about the "pressures or the trials."

Having said that I have been concerned about what lies ahead. There is no "loneliness" though because I am backed by a first rate team of knowledgeable and committed people. No President has been more blessed in this regard.

I have thought long and hard about what might have to be done. As I write this letter at Year's end, there is still some hope that Iraq's dictator will pull out of Kuwait. I vary on this. Sometimes I think he might, at others I think he simply is too unrealistic—too ignorant of what he might face. I have the peace of mind that comes from knowing that we have tried hard for peace. We have gone to the UN; we have formed an historic coalition; there have been diplomatic initiatives from country after country.

And so here we are a scant 16 days from a very important date—the date set by the UN for his total compliance with all UN resolutions including getting out of Kuwait—totally.

I guess what I want you to know as a father is this: Every human life is precious. When the question is asked "How many lives are you willing to sacrifice"—it tears at my heart. The answer, of course, is none—none at all.

We have waited to give sanctions a chance, we have moved a tremendous force so as to reduce the risk to every American soldier if force has to be used; but the question of loss of life still lingers and plagues the heart.

My mind goes back to history:

How many lives might have been saved if appeasement had given way to force earlier on in the late '30's or earliest '40's? How many Jews might have

President Bush meets with British prime minister Margaret Thatcher in Aspen, Colorado, in the days after Saddam's invasion in August 1990. Long an intimate of President Reagan's—whom she preferred—the "Iron Lady" would be a steadfast ally of Bush's in the unfolding crisis in the Gulf.

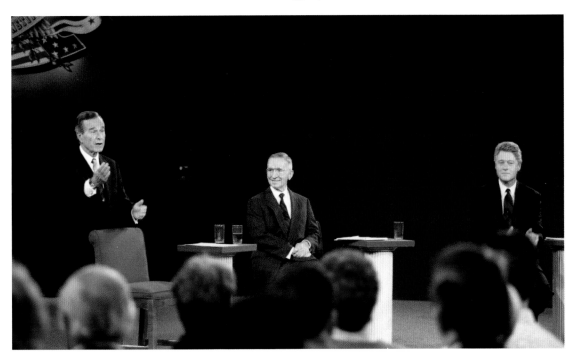

been spared the gas chambers, or how many Polish patriots might be alive today? I look at today's crisis as "good" vs. "evil"—Yes, it is that clear.

I know my stance must cause you a little grief from time to time and this hurts me; but here at "years-end" I just wanted you to know that I feel:

—every human life is precious— the little Iraqi kids' too.

—Principle must be adhered to—Saddam cannot profit in any way at all from his aggression and from his brutalizing the people of Kuwait.

—and sometimes in life you have to act as you think best—you can't compromise, you can't give in—even if your critics are loud and numerous.

So, dear kids—batten down the hatches.

Senator Inouye of Hawaii told me "Mr. President, do what you have to do. If it is quick and successful everyone can take the credit. If it is drawn out, then be prepared for some in Congress to file impeachment papers against you"—that's what he said, and he's 100% correct.

And so I shall say a few more prayers, mainly for our kids in the Gulf. And I shall do what must be done, and I shall be strengthened every day by our family love which lifts me up; every single day of my life.

For Bush, the 1992 campaign would prove grim and seemingly interminable. Challenged both by a young Democratic governor, Bill Clinton of Arkansas, and by Texas billionaire businessman H. Ross Perot, Bush never managed to make a compelling case for a second term. "God," he would recall, "it was ghastly." The year had begun badly, with a strong primary attack from right-wing commentator Patrick J. Buchanan. With rising polarization, partisan talk radio, and the new power of cable news shows such as *Larry King Live*, the 1992 race foreshadowed much of how American politics would develop in the ensuing decades.

I am the luckiest Dad in the whole wide world.

I love you, Happy New Year and May God Bless every one of you and all those in your family.

Devotedly,
Dad

Though he governed with skill, Bush was less sure-footed as the political ground in America shifted in his White House years. Rush Limbaugh's daily radio show was growing in popularity on the right. CNN, which had been on the air since 1980, featured programming that could treat politics more as sport than substance. "The more controversial your statement is, and the more you yell it with the guy on talk shows, the better the showbiz," Bush lamented. "The result is, they all have to come in with 'zingers.' It's a sorry performance for the most part, and serious journalism gives way to a lot of yelling, shouting, and posturing." Gingrich, meanwhile, was working toward building a Republican House majority for the first time in four decades, and his strategy depended on casting Democrats as, in Gingrich's terms, "sick."

In 1992, amid a mild recession, the right-wing commentator and former Nixon and Reagan adviser Patrick J. Buchanan mounted a primary challenge to President Bush, coming perilously close to defeating Bush in the New Hampshire primary with a campaign based heavily on isolationist and nativist traditions. By the time of the Republican National Convention in August 1992, Buchanan would articulate an understanding of American politics as total warfare. "My friends, this election is about more than who gets what," Buchanan said. "It is about who we are. It is about what we believe, and what we stand for as Americans. There is a religious war going on in this country. It is a cultural war, as critical to the kind of nation we shall be as was the Cold War itself, for this war is for the soul of America. And in that struggle for the soul of America, Clinton and Clinton are on the other side, and George Bush is on our side."

In the chaos of 1992, Bill Clinton of Arkansas prevailed in the contest for the Democratic nomination, and the Texas billionaire Ross Perot offered himself as a straight-talking, antiestablishment independent candidate. After a dozen years of Republican control of the White House—with the exception of the FDR-Truman years, the longest consecutive streak since Martin Van Buren succeeded Andrew Jackson in 1836—the country seemed ready for a change. For all his virtues, George Herbert Walker Bush was what a significant number of American voters wanted to change *from*.

The assets that had made him appealing only four years before were now seen as liabilities. His dignity was mistaken for emotional distance; his prudence for lassitude; his caution for disengagement. Bush ran a poor campaign, flitting from attacks on Clinton's character to amorphous promises that he would now, in a second term, actually turn his attention to domestic affairs—hardly a confidence-inspiring message for a man who was supposed to have been in charge of those domestic affairs for four years.

Even then, however, the race was close, with Clinton winning 43 percent to Bush's 37.5 and Perot's 18.9. At a dinner on Capitol Hill after the election, Bush had a few quiet words with Ann Simpson, the wife of his old friend Senator Alan Simpson of Wyoming. Bush said he "had let people down, that there was a generational disconnect and the thing that discouraged me was my failure to click with the American people on values, duty, and country, service, honor, decency. All the things that I really believe; they never came through—never ever. The media missed it, and the Clinton generation didn't understand it, and I told her I felt a little out of it and that I had not been able to communicate better what I really believe."

He was grace itself to the man who had defeated him. "Bill, I want to tell you something," Bush told the president-elect during a White House meeting. "When I leave here, you're going to have no trouble from me. The campaign is over, it was tough but I'm out of here. I will do nothing to complicate your work and I just want you to know

that." Tip O'Neill, the longtime Democratic Speaker of the House, was blunt and kind. "You ran the worst campaign I ever saw," O'Neill told the president, "but you're going out a beloved figure and everybody will tell you that."

O'Neill had it right. Bush hoped so, but couldn't know for sure. On his last day in office, in his final hours in power, the forty-first president sat in the Oval Office, the sun shining in the room he loved so much, and dictated his thoughts to his diary. "As I told Bill Clinton, I feel the same sense of wonder and majesty about this office today as I did when I first walked in here." He continued:

> I've tried to keep it; I've tried to serve here with no taint of dishonor; no conflict of interest; nothing to sully this beautiful place and this job I've been privileged to hold. . . . Maybe misjudgment on this issue or that, but never misconduct, never doing anything that would tarnish and hurt the Presidency. And yet no one seems to know that, no one seems to care. They say, "What motivates you?" And I used to be teased about service for the sake of service. Well, it does motivate me and people should give; but it's service with honor, service with a flair for decency and hopefully kindness. I know the latter never came through because the press won that one—"cold hearted," "disconnected," and "not caring about people." But I don't think they can lay a glove on me in the final analysis on serving without conflict; never for personal gain; always bearing in mind the respect for the office that I've been privileged to hold; the house that I've been privileged to live in; the office in which I've tried to serve.

And then it was over. His hour had passed. His mission was complete.

On Inauguration Day—Friday, January 20, 1989—the president-elect of the United States reviews his inaugural address in the courtyard of Blair House, the presidential guest house across from the White House on Pennsylvania Avenue. "People say, 'What does it feel like? Are you ready, can you handle it? What do you do?'" he told his diary shortly before the inauguration. "The answer, 'Family, faith, friends, do your best, try your hardest, rely on your innate good sense, kindness, and understanding of the American people.' That is where a President gets his strength, I'm sure of it. No one can have instant success, no one can make this nation kinder and gentler overnight, but we can try." He and Mrs. Bush would meet the Reagans for coffee at the White House later that morning before riding to the Capitol for the ceremonies.

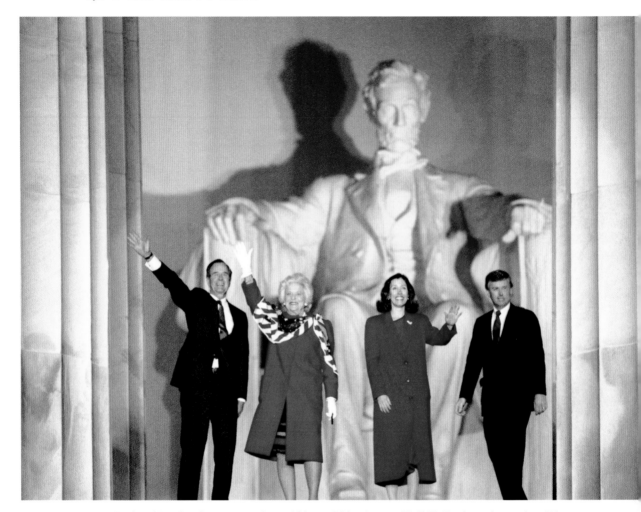

Bush and Dan Quayle were sworn in at midday on Friday, January 20, 1989. "As the oath was given," Mrs. Bush recalled, "I felt as if we were standing still in time. In one awesome moment George Bush became President of the United States." She held two Bibles: "the one George Washington had held two hundred years ago when he was sworn in, and the one the House and Senate prayer group had given George, opened at the Beatitudes. I have used a different Bible at each of George's swearing-ins—one for the United Nations, one for the CIA, two for vice president, and one for president—so each of the children may have one."

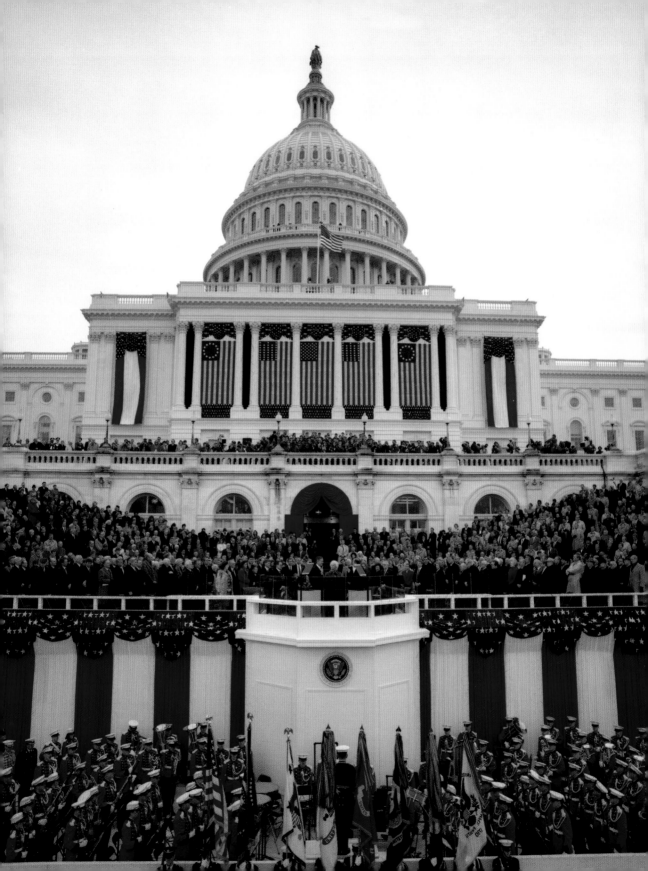

To his diary, President Bush confided: "The balls: going around to 14 different events, and I think 10 or 11 hotels. It was too much. We were just exhausted when we got home. When we got back, I had that almost so-tired-you-couldn't-sleep feeling; and I knew that at 8:00 this morning we would have to greet the first group of people who stayed out all night to get to be one of several thousand people to go through the White House. I love that part. Young people and old, so grateful that they had a chance to go through the White House. Even though they had to stay out all night to get to do it. It's interesting in that regard how people view their country. It's a wonderful thing indeed. . . . We toured the grounds with all the kids, and the press had a field day with the photos. The football was out, the tennis courts . . . and on and on it went—activity. So far it's only show business. I feel comfortable in the job. I am not quite used to being called 'Mr. President.' Beautiful winter day, January 21st—clear, sunny, cold. The People's House, the Family's House. It was great."

Facing page: "The whole day has been one of emotion," Bush recalled. "I went to the Oval Office and every-thing was changed overnight, quick. Reagan was gone, and Bush was in. The papers were the way I wanted them. . . . The CIA briefing started. I made clear that I wanted to continue the briefing by the briefing team. . . . We went over the world, talked about how we are going to meet next week with the Congressional leaders; talked about how we're going to discuss with another group of bipartisan Senators and Congressmen how we approach a bipartisan foreign policy."

The Bushes' English springer spaniel, Millie, gave birth to six puppies during the first hundred days of the administration. "We stood watching our little Millie deliver and got quite teary," Mrs. Bush recalled. The president told his diary that Millie quickly became "a caring, loving, and experienced Mother. If one goes too far away, she nudges him over; she rolls him over; and cleans him up. . . . She looks at us with soulful eyes. When she goes out to run, she does just like the old Millie—though not quite as fast—but then gets restless and wants to be back next to her puppies."

In 1990, Mrs. Bush published *Millie's Book,* an account of White House life from Millie's perspective. A successful bestseller, the book was in the tradition of *C. Fred's Story.* "Our life at the White House is pretty heavily scheduled," Millie told her readers. "The alarm goes off at 6 A.M. The Prez says that I go off a few minutes earlier by shaking my ears pretty hard in their faces. In any case, Bar jumps up, throws on her clothes, and races down three flights of stairs, or takes the elevator if she feels a little tired. (She usually feels tired.) She walks me around the South Lawn drive, brings me back in, feeds me, and climbs back into bed to read the papers with The Prez and drink coffee and juice. Between 7 and 7:08, the President and I go off to the Oval Office. I often sit in on the morning briefings. . . . I overheard the Bushes talking the other night. Some discussion about me keeping a lower profile. The media were reporting that I was getting more publicity than some members of the Cabinet."

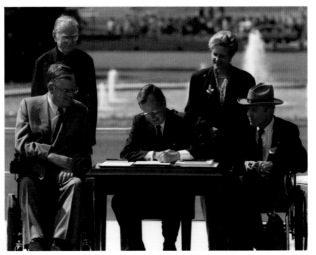

"With today's signing of the landmark Americans with Disabilities Act," Bush said on the South Lawn in July 1990, "every man, woman, and child with a disability can now pass through once-closed doors into a bright new era of equality, independence, and freedom." The legislation was sweeping. "Together, we must remove the physical barriers we have created and the social barriers that we have accepted," Bush said. "For ours will never be a truly prosperous nation until all within it prosper."

In 1992, with the King family in attendance at the Freedom Hall auditorium in Atlanta, Bush signs the Dr. Martin Luther King, Jr., Federal Holiday Proclamation. The original bill marking this holiday was signed into law by President Reagan in 1983.

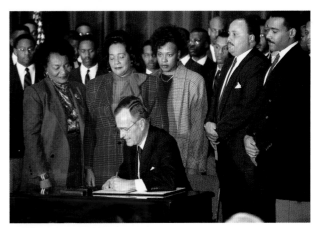

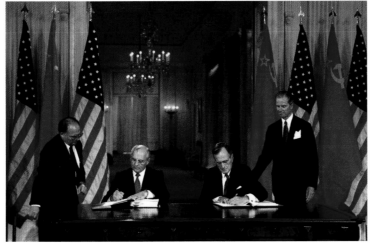

In June 1990, Mikhail Gorbachev and Bush signed what *The New York Times* described as "the broadest Soviet-American understandings in two decades, including commitments to cut stockpiles of long-range nuclear arms and to eliminate most of their chemical weapons." It was one of a series of momentous summits as the Soviet Union moved toward disintegration in late 1991.

Dec. 31, 1990

Dear George, Jeb, Neil, Marvin, Doro.

I am writing this letter on the last day of 1991./

First, I can't begin to tell you how great it was to have you here
at Camp David. I loved the games (the Marines are still smarting
over their 1 and 2 record), I loved Christams Day, marred only by the absence
of Sam and Ellie. I loved the movies- some of 'em- I loved
the laughs. Most of all, I loved seeing you together. We are family blessed; and this
Christmas simply reinforced all that.

I hope I didn't seem moody. I tried not to.

When I came into this job I vowed that I wouuld never ring my hands
and talk about "the loneliest job in the world"
or ring my hands about the pressures or the trials".

Having said that I have been concerned about what lies ahead.
There is no 'loneliness' though because I am backed by a first rate
team of knowledgeable and committed people. No President has been more
blessed in this regards..

I have thought long and hard about what might have to be done.
As I write this letter at Year's end, there is still some hope
that Iraq's dictator will pull out of Kuwait. I vary on this . Sometimes
I think he might, at others I think he simply is too unrealistic- too
ignorant of what he might face. I have the peace of mind that comes from knowing
that we have tried hard for peace. We have gone to the uN ;we have formed an historic
coalition, there have been diplomatic initiatives from country after country.
And so here we are a scant 16 days from a very important

date- the date set by the uN for his total compliance with all UN resolutions

including getting out of Kuwait- totally.

I guess what I want you to know as a father is this:

Every Human life is precious. When the question is asked "How many lives

are you willing to sacrifice"- it tears at my heart. The answer ,of course, is

none- none at all. We have waited to give sanctions a chance, we have moved

a tremendous force so as to reduce the risk to every American soldier

if force has to be used; but the question of loss of life still lingers and plagues the heart.

My mind goes back to history:

How many lives might have been saved if appeasement had given way to force

earlier on in the late '30's or earliest '40's? How many Jews might have been

sapred the gas chambers, or how many Polih patriots might be alive today?

I look at todays crisis as "good vs. "evil".... yes, it is that clear.

I know my stance must cause you a little grief from time to time;and this

hurts me; but here at 'years end' I just wanted you to know that I feel:

 - every human life is precious.. the little Iraqi kids' too.

 - Principle must be adhered to- Saddam cannot profit in any

way at all from his aggression and from his brutalizing the people of Kuwait.

 - and sometimes in life you have to act as you think best-you

can't compromise, you can't give in....even if your critics are loud and numerous.

With John Sununu and reporters on Air Force One.

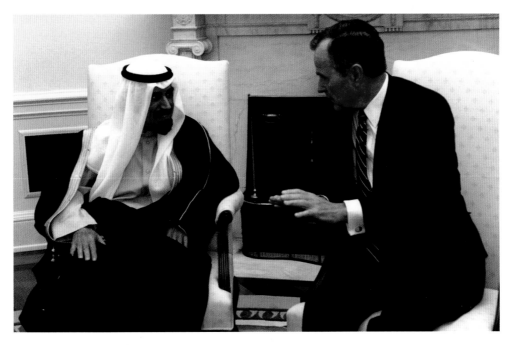

Diplomacy in the Oval Office.

Joint Chiefs chairman General Colin Powell briefs the president and key advisers in the Treaty Room in the White House Residence. (Bush used this room as a study.) The crisis had begun on August 2, 1990; by August 5, Bush told his diary that "the enormity of Iraq is upon me now. I have been on the phone incessantly. . . . The bottom line is that the West is together." One fear was that the invasion of Kuwait was but a prelude to a strike against Saudi Arabia, which the president privately believed could lead to a world war.

At work with National Security Advisor Brent Scowcroft in the president's small study off the Oval Office, and on the phone in the Oval itself. Bush was masterly at personal diplomacy, calling leaders of nations large and small to build support for the coalition to oppose Saddam. "I feel tension in the stomach and the neck," the president told his diary early in the crisis. "I feel great pressure, but I also feel a certain calmness when we talk about these matters. I know I am doing the right thing." At right: Bush walks alone on the first day of combat operations in the Gulf in January 1991. "I simply can't sleep," he told his diary. "I think of what other Presidents went through. The agony of war. I think of our able pilots, their training, their gung-ho spirit. And also what it is they are being asked to do."

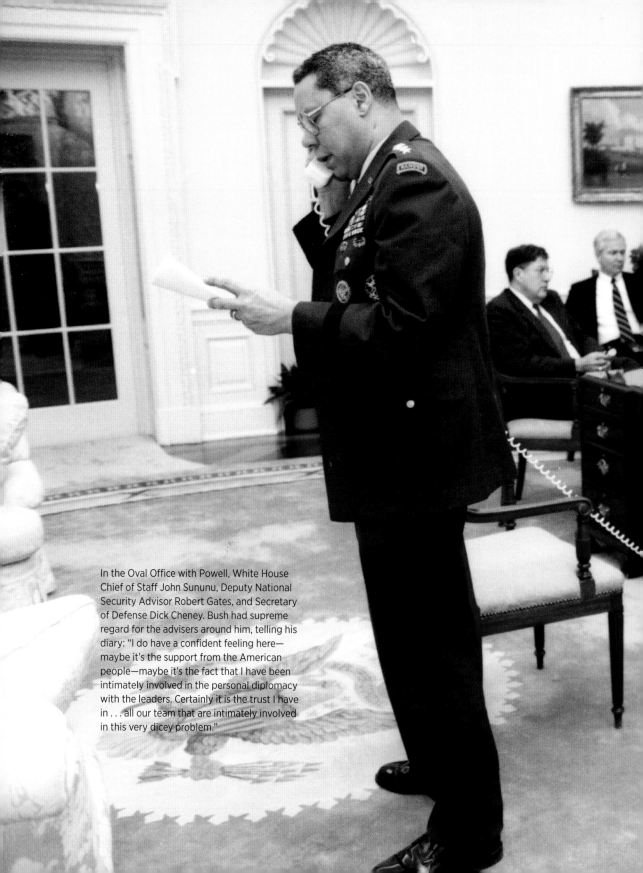

In the Oval Office with Powell, White House Chief of Staff John Sununu, Deputy National Security Advisor Robert Gates, and Secretary of Defense Dick Cheney. Bush had supreme regard for the advisers around him, telling his diary: "I do have a confident feeling here—maybe it's the support from the American people—maybe it's the fact that I have been intimately involved in the personal diplomacy with the leaders. Certainly it is the trust I have in . . . all our team that are intimately involved in this very dicey problem."

Walker's Point was an impromptu command post for the crisis in the Gulf. Upper right: Richard Haass, James Baker, Robert Gates, and John Sununu meet with the president and Prince Bandar, the longtime Saudi ambassador to the United States. Riyadh's cooperation was essential, and the Saudi agreement to allow U.S. forces to deploy there had far-reaching consequences—Osama Bin Laden would cite the decision in his later declaration of war on the West. In 1990–1991, however, with the end of Communism and the apparent triumph of liberal democracy, Bush hoped, with Baker and Scowcroft, to build a "new world order" based on the rule of law and respect for borders.

Maine, Bush recalled, "is where my family comes home. . . . It has great meaning in terms of family. And we are blessed; the Bush family is blessed. The children come home, and they look forward to it." Below: The presence of his children and grandchildren—one has a word with the president and Scowcroft—were constant reminders to Bush of why he was doing what he was doing. "I guess what I want you to know as a father is this: Every human life is precious," Bush wrote his children on New Year's Eve 1990. "When the question is asked 'How many lives are you willing to sacrifice'—it tears at my heart. The answer, of course, is none—none at all. . . . And so I shall say a few more prayers, mainly for our kids in the Gulf. And I shall do what must be done, and I shall be strengthened every day by our family love which lifts me up; every single day of my life."

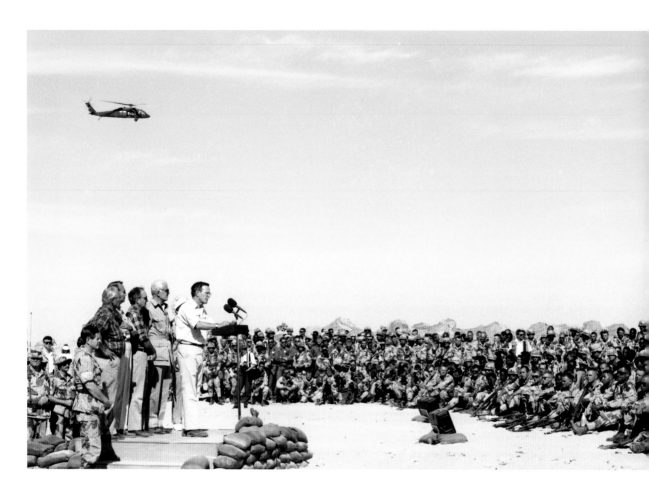

The president and the First Lady traveled to the Gulf over Thanksgiving 1990 to meet with the troops of Operation Desert Shield. It was, Mrs. Bush recalled, the best Thanksgiving the Bushes ever had. "Our day in the desert with our men and women in the military was a highlight of George's presidency," she recalled. There were several stops, including a command base in Dhahran. "George spoke, and then we plunged out into the crowd while somebody tried to keep order," Mrs. Bush recalled. "Every single serviceman and servicewoman seemed to have a camera. . . . We posed for as many pictures as possible and hugged and clasped hands."

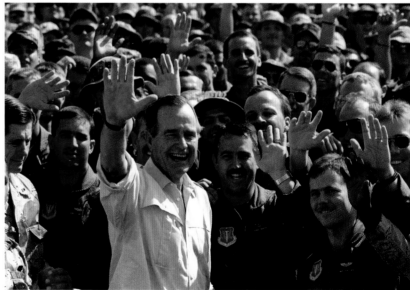

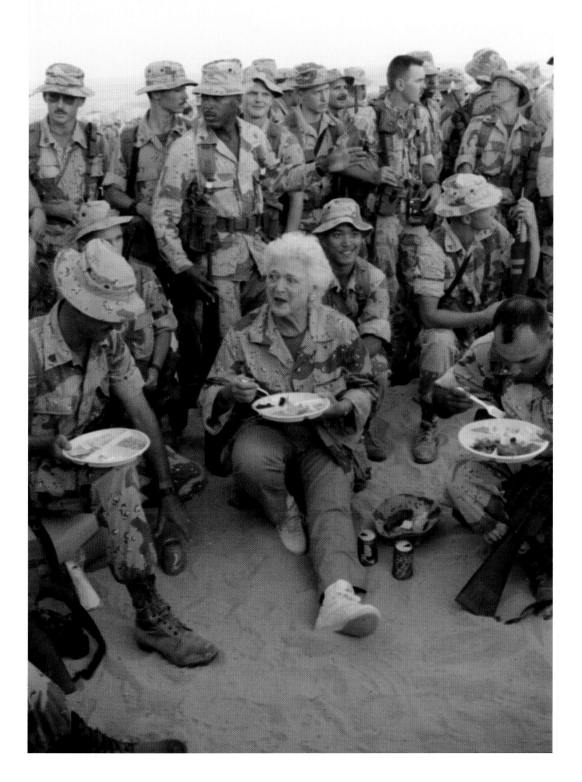

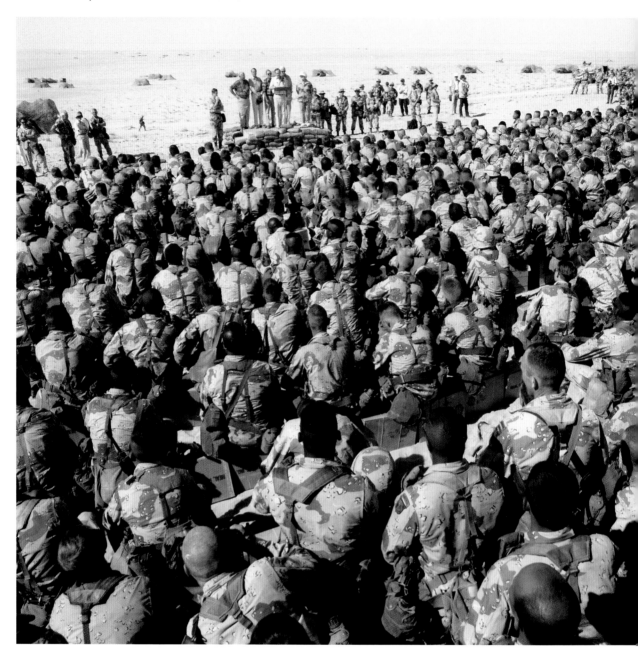

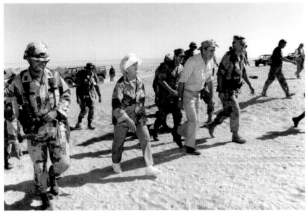

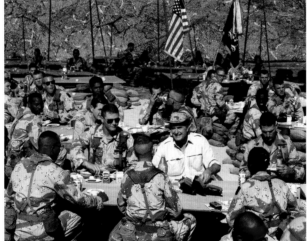

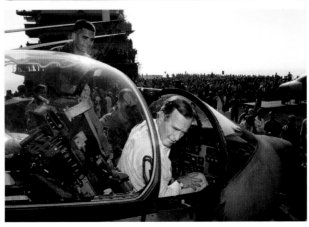

After the day with the troops in Saudi Arabia, Bush told his diary, "There is no way to adequately describe the moving time in the desert. We went first to greet the Air Force, then up to an Army base in the sand, then over by chopper to the USS *Nassau* in international waters where we had a nice prayer service for Thanksgiving on the deck: and finishing with the Marines back in the desert. . . . The kids were fantastic; it was an emotional day. I wasn't sure I could get through the speeches, and I did choke up in the hangar, on the flight deck of *Nassau* at the Church service. The kids look so young and yet they are gung-ho. I had a long briefing on [Air Force One] with [General Norman] Schwarzkopf, and I am convinced more than ever that we can knock out Saddam Hussein early. I'm worried that the American people might think this will be another Vietnam and it isn't and it won't be." Three days later, in a memo to Scowcroft, Bush asked a few key questions: "1. Exact status of Iraqi Nuclear Capability. 2. Best estimate now from Cheney and Powell as to how long it will take, once all forces there, to conquer Saddam."

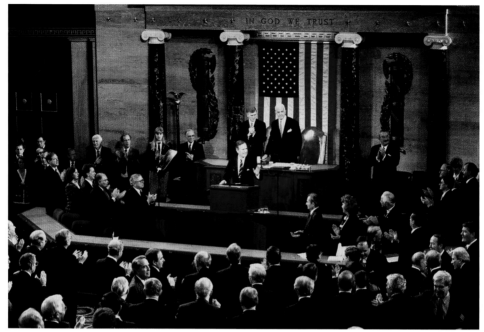

In the end, the ground campaign against Iraq took only a hundred hours, and Kuwait was liberated. Bush's popularity as president soared to historic levels, but he knew that such enthusiasm was fleeting. "From the moment Operation Desert Storm commenced on Jan. 16 until the time the guns fell silent at midnight one week ago," Bush told the Congress in March 1991, "this nation has watched its sons and daughters with pride—watched over them with prayer. As Commander in Chief, I can report to you: Our armed forces fought with honor and valor. . . . The war is over."

The national victory celebration in Washington, D.C., held on Saturday, June 8, 1991. As Bush had said to Congress, "The consequences of the conflict in the Gulf reach far beyond the confines of the Middle East. Twice before in this century, an entire world was convulsed by war. Twice this century, out of the horrors of war hope emerged for enduring peace. Twice before, those hopes proved to be a distant dream, beyond the grasp of man. Until now, the world we've known has been a world divided, a world of barbed wire and concrete block, conflict and cold war. And now, we can see a new world coming into view . . . a world in which freedom and respect for human rights find a home among all nations. The Gulf War put this new world to its first test. And my fellow Americans, we passed that test."

Bush and James Baker were great friends from Houston, brought even closer together by the death of Baker's first wife, Mary Stuart, from cancer in 1970. Theirs was a complicated and essential relationship with elements of love, respect, and, on occasion, rivalry. "Jimmy," Bush would say if Baker was pressing him too hard on an issue, "if you're so smart, why am I President of the United States?" Baker would serve as Reagan's White House chief of staff and Treasury secretary before becoming Bush's 1988 campaign chief and then secretary of state.

Newt Gingrich's brand of ferocious partisanship was out of sync with Bush's inclination to use compromise to pursue what the president called "sound governance." The budget deal of 1990, which included some tax increases, gave Gingrich the wedge with which to break with the president. "Don't want a terrible deal to take place," Bush told his diary, "but don't want to be off in some ideological corner falling on my sword and keeping the country from moving forward."

The president with his bank of televisions in the Treaty Room, his study in the White House Residence. He worked in this room in the evenings, often dictating diary entries into a small portable cassette recorder.

Below: President Bush visits the Emily Harris Head Start Center in Catonsville, Maryland, in January 1992. Right: Bush and Quayle with students Russell Frisby, Rachel Heckmann, and Conner Sabatino of the Young Astronauts Council participate in a conversation with astronauts on the space shuttle *Discovery* via a January 1992 video hookup.

Bush loved throwing horseshoes and installed pits at the White House, Camp David, and Walker's Point. Clockwise from top left: He is shown playing with Brian Mulroney, Queen Elizabeth II, Mikhail Gorbachev, John Major, and Boris Yeltsin.

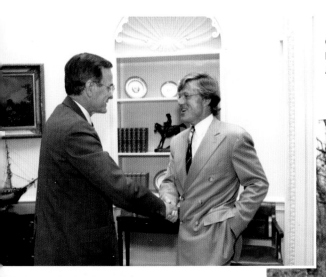

Clockwise from top left: The president with Robert Redford, Chuck Norris, James Earl Jones, and Arnold Schwarzenegger.

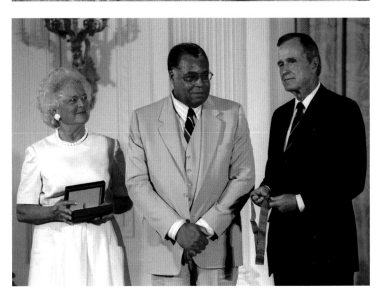

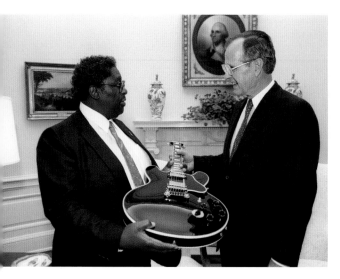
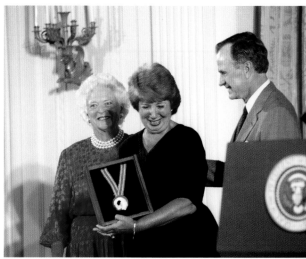

Clockwise from top left: B. B. King, Beverly Sills, Larry Gatlin, and Maya Angelou.

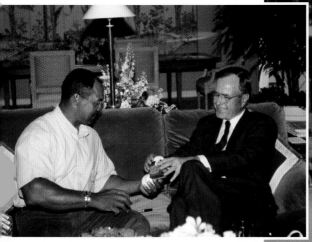

Clockwise from top left: Joe DiMaggio; Bush throws out a first pitch in Arlington, Texas; with Tommy Lasorda; with Reggie Jackson.

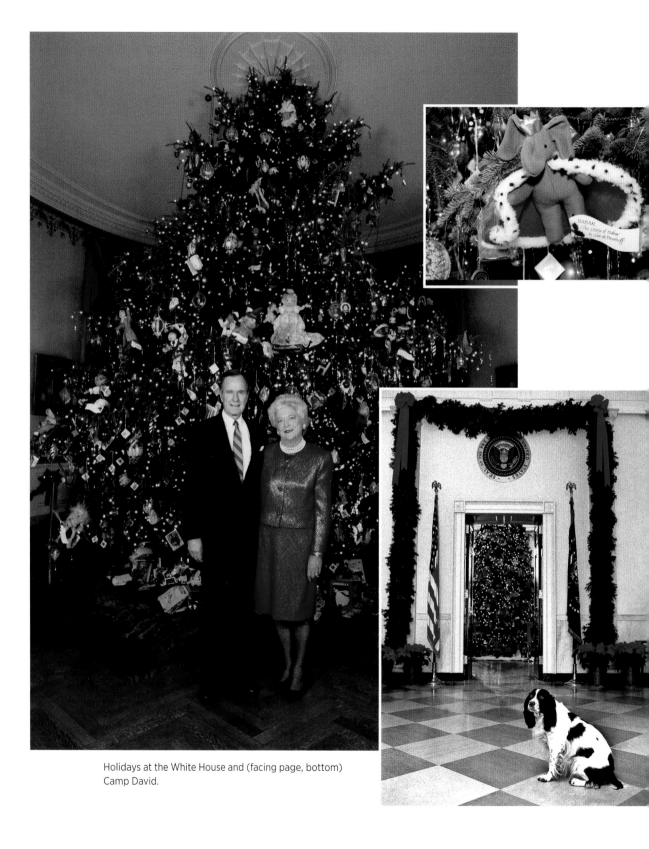

Holidays at the White House and (facing page, bottom)
Camp David.

The Bush years were a momentous time in the world; Henry Kissinger observed that the single Bush term compressed eight years of history into four. In February 1990, Nelson Mandela was released from prison in South Africa after twenty-seven years. "Change—amazing change," Bush told his diary. Middle right: In late November 1989, West German foreign minister Hans-Dietrich Genscher gives the American president a piece of the now-fallen Berlin Wall. And it was a new day for figures such as Lech Walesa of Poland, the heroic leader of the anticommunist Solidarity movement, as what Winston Churchill had called the Iron Curtain was torn asunder after decades. "The task before us is to consolidate the fruits of this peaceful revolution and provide the architecture for continued peaceful change," Bush remarked of the loosening of the Soviet grip on neighboring countries. "The people of every nation have the right to determine their own way of life in freedom."

In a toast to Queen Elizabeth II during her May 1991 state visit to Washington, the president said: "Most of all, what links our countries is less a place than an idea—the idea that for nearly 400 years has been America's inheritance and England's bequest. The legacy of democracy, the rule of law, and basic human rights. Recently, this legacy helped our nations join forces to liberate Kuwait. All Americans involved in the crisis will remember as long as they live the resolve of Prime Minister Margaret Thatcher and Prime Minister John Major, the gritty resolution, ma'am, of Your Majesty's services, and through it all, the steadfast support of the British people. We believed that the human will could outlast the bayonets and the barbed wire, and so we told the world aggression will not stand. Our military cooperation in the Gulf harkened back to our joint military endeavors of two World Wars, and four decades of peacetime alliance." The Queen replied: "The free world has to thank you, Mr. President, for your clarity of vision and firmness of purpose. You have led not with bombast and rhetoric but with steadiness and quiet courage. . . . And you made the decisions that had to be made."

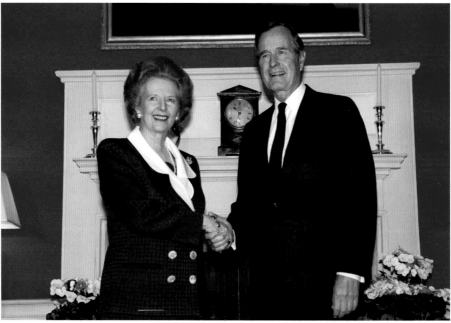

In a 1989 visit to the United Kingdom amid important discussions about the future of NATO, the Bushes called on Queen Elizabeth II and Prince Philip at Buckingham Palace. The real business of the season, however, was conducted with Prime Minister Margaret Thatcher, whom Bush found complicated. "My first impression: Margaret [is] principled, very difficult, [and] most people are far more down on her than I would have thought possible." He was puzzled when the prime minister gave him and Turgut Ozal, the leader of Turkey, "a lecture on freedom." Ozal, Bush added, "was like I was—'Why does she have any doubt that we feel this way on this issue?'"

In Budapest, Hungary, during a 1989 state visit to Poland, Hungary, and the Netherlands.

In May 1989, the Bushes met with Pope John Paul II at the Vatican. "In [your] inaugural address, Mr. President, you made reference to power as existing to help people, to serve people," the pope said. "This is true at different levels, including power at the political and economic level. We see this, too, at the level of each community, with its power of fraternal love and concern. In all these areas, an immense challenge opens up before the United States in this third century of her nationhood. Her mission as a people engaged in good works and committed to serving others has horizons the length of your nation and far beyond—as far as humanity extends."

Bush considered the reunification of Germany, undertaken with West German leader Helmut Kohl, to be his greatest achievement as president. Margaret Thatcher and France's François Mitterrand were skeptical about reunification; as Thatcher said, if "we are not careful, the Germans will get in peace what Hitler couldn't get in the war." Bush was more measured about a strong Germany, telling his diary that "there is a certain insult to the Germans suggesting that they will give up democracy and give way to some new Hitler once they're unified, or that they will immediately want to expand their borders."

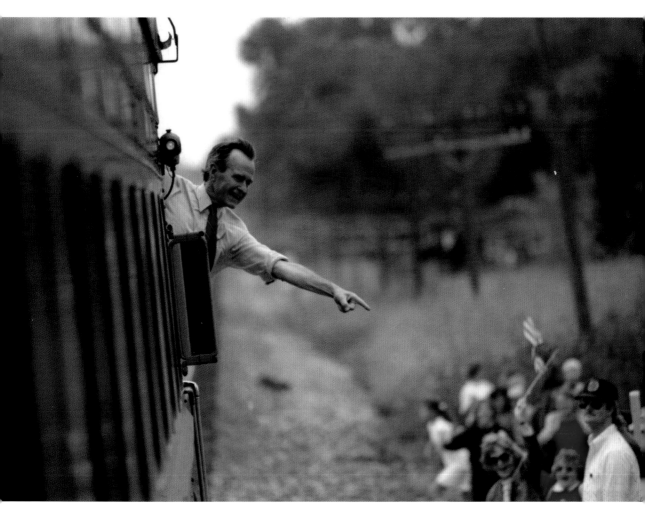

The 1992 campaign, Bush recalled, was "ghastly." He tried everything, including a Truman-style whistle-stop train journey. In the end, it was time to go. Late in the campaign he became philosophical. "I care very deeply about our nation," he told a crowd in Houston. "And I believe that we must treat this precious treasure with great care. America is something that has been passed on to us. And we must shape it. We must improve it. We must help people and be kind to people. And then we must pass that on to our kids and grandkids." Once the votes were in and Clinton's victory was clear, Bush told his diary: "I have this strange feeling deep inside. I guess I'm hurt, but a strange feeling of relief. I think it's the ugliness of the hour, the ugliness of the year." Two decades later, the forty-first president recalled: "It hurt a lot. My problem was the feeling of letting people down. . . . That was the sad part for me, and I felt very strongly about that. I still do."

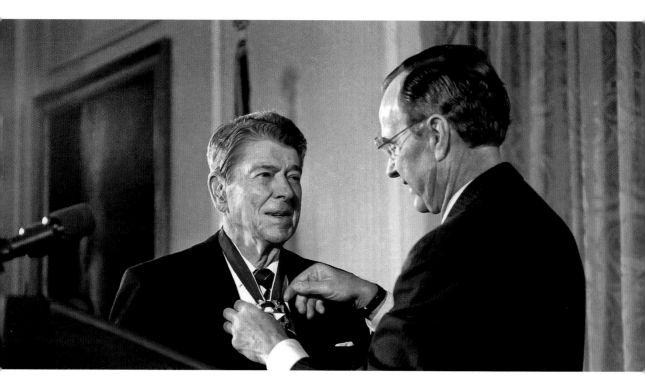

In one of his last acts as president, Bush awarded Ronald Reagan the Presidential Medal of Freedom. "Today we honor the American life of an American original," Bush said in the East Room on Wednesday, January 13, 1993. "We all remember the movie in which he once said, 'Win one for the Gipper.' Well, as President, Ronald Reagan helped win one for freedom, both at home and abroad. And I consider him my friend and mentor, and so he is. And he's also a true American hero. . . . Ronald Reagan didn't just make the world believe in America; he made Americans believe in themselves. And I remember Inauguration Day in 1981 and how the clouds— maybe you remember it—of a gloomy morning gave way as he began his speech. He turned that winter of discontent into a springtime of possibility." A week later, the Reagan-Bush era would come to an end with the inauguration of Bill Clinton and Al Gore.

The Bushes were grace itself in welcoming the Clintons to the White House on Wednesday, January 20, 1993. Bush would be the last combat veteran of World War II to serve as president; Clinton was the first baby boomer. "As I told Bill Clinton, I feel the same sense of wonder and majesty about this office today as I did when I first walked in here," Bush told his diary in his final hours as president. "I used to be teased about service for the sake of service. Well, it does motivate me. . . . service with honor, service with a flair for decency and hopefully kindness." He and Mrs. Bush took a final stroll around the White House grounds. And then it was over. "This," he told his diary, "is my last day as President of the United States." In his inaugural address at midday, Clinton paid tribute to his predecessor, thanking the former president for "a half century of service to America." The Bushes then flew home to Houston.

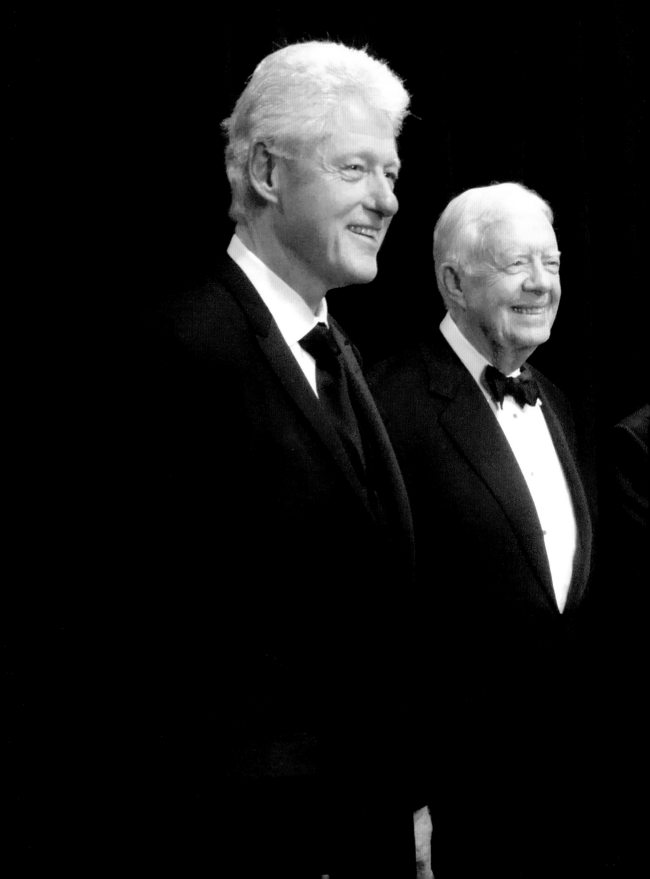

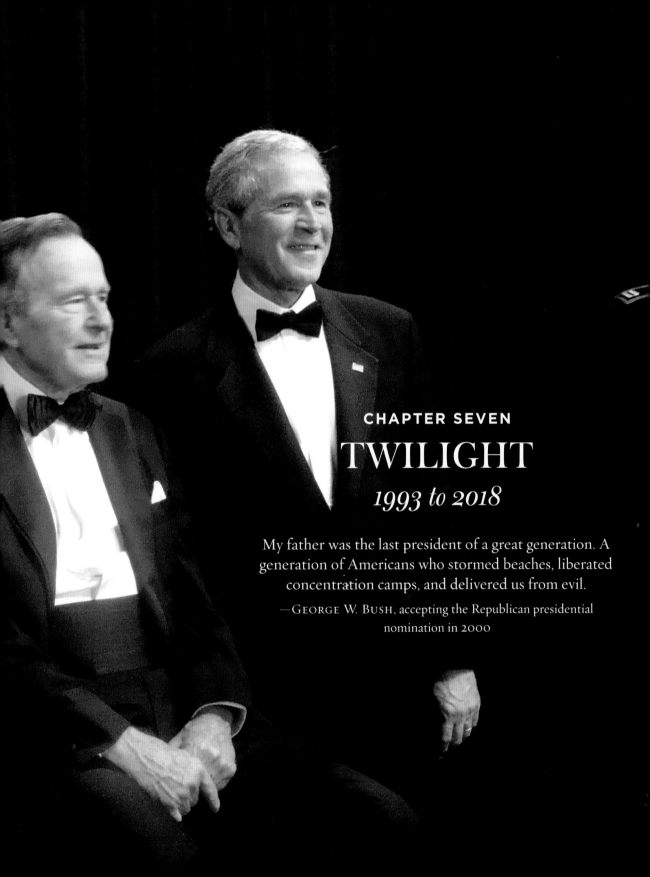

CHAPTER SEVEN

TWILIGHT

1993 to 2018

My father was the last president of a great generation. A generation of Americans who stormed beaches, liberated concentration camps, and delivered us from evil.

—GEORGE W. BUSH, accepting the Republican presidential nomination in 2000

IN RETIREMENT, THE president would become the patriarch—the father of a family whose story remained entwined with that of the nation, and of the world. George W. Bush won the governorship of Texas in 1994 at the age of forty-eight. "You have given us more than we ever could have deserved," the son wrote the father. "You have sacrificed for us. You have given us your unwavering loyalty and devotion. Now it is our turn." Jeb would prevail in a gubernatorial race in Florida four years later. Like his own father, Bush was careful not to insert himself into the lives of his children, eschewing advice giving and second-guessing. To George H. W. Bush, a new generation was a new generation, and he would not meddle. He made himself clear in a letter to both George and Jeb:

Your Mother tells me that both of you have mentioned to her your concerns about some of the political stories—the ones that seem to put me down and make me seem irrelevant—that contrast you favorably to a father who had no vision and who was but a place holder in the broader scheme of things. I have been reluctant to pass along advice. Both of you are charting your own course, spelling out what direction you want to take your State, in George's case running on a record of accomplishment. But the advice is this. Do not worry when you see the stories that compare you favorably to a Dad for whom English was a second language and for whom the word destiny meant nothing. . . . At some point both of you may want to say "Well, I don't agree with my Dad on that point" or "Frankly I think Dad was wrong on that." Do it. Chart your own course, not just on the issues but on defining yourselves. No one will ever question your love of family—your devotion to your parents. We have all lived long enough and lived in a way that demonstrates our closeness; so do not worry when the comparisons might be hurtful to your Dad for nothing can ever be written that will drive a wedge between us— nothing at all. . . . So read my lips—no more worrying.

Chapter-opening spread: Bill Clinton, Jimmy Carter, and the two Presidents Bush in 2011.

Opposite: Bush 41 chose Texas A&M University in College Station, Texas, for his presidential library. The Bushes built an apartment there as well and enjoyed, as always, hosting streams of guests. But the former president took care not to opine too much or, as he put it, to "cast myself as a big and important person. I want to be a tiny point of light, hopefully a bright point of light, but I don't crave sitting at the head table; nor do I burn with desire to see that history is kind to us." He continued: "Be quiet, stay out of and away from the press, especially the talk shows."

Still, as the years passed, the forty-first president's historical stock rose slowly but steadily. In the summer of 1995, President Clinton asked the Bushes back to the White House for the unveiling of their official portraits. "President Bush's portrait will hang out here in the Grand Foyer, across from the portrait of President Franklin Roosevelt, the Commander in Chief he served in World War II," Clinton said. "It will stand as a reminder of George Bush's basic integrity and decency and of his entire adult lifetime devoted to public service. Most of all, it will stand as a testimony to a leader who helped Americans move forward toward common ground on many fronts."

Bush avoided grand pronouncements in retirement—he hated what he called "yellow pad conferences" of former officials holding forth on the issues of the day—but on at least one occasion he could not stay silent. In the aftermath of the bombing of the federal building in Oklahoma City in 1995—a domestic terrorist attack that killed 168 people, including 19 children—the National Rifle Association, in a fundraising appeal, referred to federal law enforcement agents as "jack-booted thugs." Bush immediately resigned as a life member of the organization, writing: "Your broadside against Federal agents deeply offends my own sense of decency and honor; and it offends my concept of service to country. It indirectly slanders a wide array of government law enforcement officials, who are out there, day and night, laying their lives on the line for all of us."

As the 2000 campaign approached, George W. Bush was broadly considered to be the likeliest Republican presidential nominee. "He is good, this boy of ours," Bush wrote Hugh Sidey, a friend and columnist for *Time* magazine. "He's uptight at times, feisty at other times—but who wouldn't be after months of grueling campaigning. He includes people. He has no sharp edges on issues. He is no ideologue, no divider. He brings people together and he knows how to get things done. He has principles to which he adheres but he knows how to give a little to get a lot. He doesn't hog the credit. He's low on ego, high on drive. . . . His character will pass muster with flying colors."

The father was a symbolic force in the campaign. "My father was the last president of a great generation," George W. Bush said in accepting the Republican presidential nomination in 2000. "A generation of Americans who stormed beaches, liberated concentration camps, and delivered us from evil. Some never came home. Those who did put their medals in drawers, went to work, and built on a heroic scale . . . highways and universities, suburbs and factories, great cities and grand alliances—the strong foundations of an American Century."

The race between George W. and Al Gore was breathtakingly close, and the result came down to fewer than six hundred votes in Florida amid a disputed recount process. In early December, the United States Supreme Court stopped the recount, in a 5–4 decision, effectively declaring Bush the winner. In an hour of patriotic dignity and of enduring respect for democratic institutions, Gore conceded the race in an address to the nation from the Eisenhower Executive Office Building. "His speech was absolute perfection," George H. W. Bush wrote Sidey. "He did it with grace and dignity and a genuineness that enthralled the nation. I know how difficult it was for him to do what he did." Bush 41 watched on television as Gore left the EEOB. He reached for the telephone, ringing the White House switchboard to try to reach his son's defeated rival. He knew what it was like to lose, and he appreciated Gore's grace. The call was brief, but Gore always remembered the old man's thoughtfulness. "President Bush was very emotional, very kind," Gore recalled. Characteristically, now that the campaign was over, the elder Bush was thinking not in competitive but in collegial terms. Of that night, Bush recalled:

> The conversation was over in a flash, but I suddenly felt quite different about Al Gore. The anger was gone, the competitive juices stopped flowing. I thought of Algore as two words (Al Gore) not one. I thought of his long years of service and of his family. I thought back to my own feelings of years before when I lost, when I had to go out and accept my defeat. He did it better than I did, and his ordeal had to be tougher because the election was so close. True I had to actually give up the Presi-

dency that he was now seeking, but still he had been in public life a long time and he and his family were shattered.

The evening was not over. George W. was about to address the Texas legislature. The father was, he recalled, "literally wracked with uncontrollable sobs" as he watched his son speak to the country for the first time as president-elect. Afterward, the forty-first president called the forty-third.

"What did you think, Dad?" George W. asked.

"I told him how perfect I felt his speech was," Bush recalled. "I also told him I had lost it." His mind turned to the difficult days ahead. "May God give our son the strength he needs. May God protect the forty-third President of the United States of America." He was, Bush added, "the proudest father in the whole wide world."

George W. Bush's eight years in power were a complicated time for George H. W. Bush. He was proud of his son beyond words, offered unconditional love, and longed for the success of the forty-third president. Yet the father had been there, confronting many of the same (or similar) problems, and he could not turn off a mind trained by a lifetime of experience. "Once you've sat at that desk" in the Oval Office, the elder Bush noted, "it's complicated to see someone else there. When you've made the big calls, it's tough to be on the sidelines—but you've got to be."

The attacks of Tuesday, September 11, 2001, transformed Bush 43's presidency into a wartime endeavor. In 2003, when the United States launched its war in Iraq, seeking to topple Saddam Hussein for fear that the longtime dictator had weapons of mass destruction (fears that turned out to be unfounded), Bush 41 faxed his son:

Dear George,

You are doing the right thing. Your decision, just made, is the toughest decision you've had to make up until now. But you made it with strength and with compassion. It is right to worry about the loss of innocent life be it Iraqi or American. But you have done that which you had to do.

Maybe it helps a tiny bit as you face the toughest bunch of problems any President since Lincoln has faced: You carry the burden with strength and grace. . . .

Remember Robin's words "I love you more than tongue can tell."
Well, I do.

Devotedly,
Dad

At Bush 43's request in the first days of 2005, Bush 41 teamed up with Bill Clinton to help with tsunami relief in Southeast Asia, a mission that kindled a warm friendship between the two 1992 rivals. The younger man's volubility and chronic tardiness bemused the older former president. "He talks *all the time,*" Bush recalled of Clinton, emphasizing the last three words. "He knows every subject. You mention Nigeria, and he'll say, 'Now let me tell you about what's happening in the northern part of the country.' I don't know how much of it's bullshit and how much of it's real, factual."

The rest of Bush's days were spent doing good works, raising millions for charity and, on several occasions in great old age, jumping out of airplanes. He had never been satisfied with the way he had handled the parachute over Chichi-Jima, and one day in 1997, while giving a speech to a parachute association, he had a kind of epiphany. "For some reason, I went back to a thought I had way in the back of my mind," he recalled in a letter to his children. "It has been there, sleeping like Rip Van Winkle, alive but not alive. Now it was quite clear. I want to make one more parachute jump!" He did so in 1997 and then on his seventy-fifth, eightieth, eighty-fifth, and even his ninetieth birthdays—"reveling in the freedom," he said, and "enjoying the view."

IN THE SUMMER of 2017, on their porch in Maine on a sunny day, talk turned to World War II and that terrible Saturday, September 2, 1944, when Lieutenant George H. W. Bush was shot down over Chichi-Jima. Had young Bush been captured by the Japanese, he would have been held captive on an island that was home to horrific

"Yes, I am the George Bush that was once President of the United States of America," Bush wrote to mark his fiftieth class reunion at Yale. "Now, at times, this seems hard for me to believe. All that is history and the historians in the future will sort out the bad things I might have done from the good things. My priorities now are largely friends, family, and faith."

war crimes—including cannibalism. ("Bar, I could've been an hors d'oeuvre," he'd say in later years.) It had been the closest of calls.

"George," Mrs. Bush said that day in Maine, lost in reminiscence, "you must have been saved for a reason. I know there had to be a reason."

President Bush sat silently for the briefest of moments, then raised that big left hand and pointed his finger across the table at his wife. "*You,*" he said. "*You* were the reason."

Barbara died in April 2018 and was buried from St. Martin's Episcopal Church in Houston. President Clinton and President Obama, along with their wives, were among the mourners who gathered to pay tribute. Bush 41 made the annual trip to Maine that summer but had to spend much of it in the first-floor bedroom he had shared with Barbara for so many decades. He'd receive the occasional guest in a sitting area there, but for him the energy of Kennebunkport—the years of roaring speedboats, lightning-fast rounds of golf at Cape Arundel, ferocious family tennis—had faded.

As autumn came the former president was taken back to Houston. A few days after Thanksgiving, Barack Obama called on the ninety-four-year-old statesman. By that time Bush had difficulty speaking; he was hoarse and tired easily. Yet there the two men were, in the living room of the Bush house in Tanglewood, American presidents from radically different backgrounds who had risen to the apex of power. Bush had long appreciated Obama's gifts. Asked shortly after the 2008 election whether he had thought he would ever see a Black American become president, Bush had replied: "No. I didn't. I didn't know the guy, but once I met him I could see how *he* could do it. And I think it's a very good thing."

Obama, the son of a Kenyan father and a Kansas mother, raised in Hawaii, respected the life and work of the scion of Greenwich, Andover, and Yale. "I would argue that he helped usher in the post–Cold War era in a way that gave the world its best opportunity for stability and peace and openness," Obama said while he was in the White House. "The template he laid in a peaceful and unified Europe and in what for at least twenty-five years was a constructive relationship with Russia and the former Soviet satellites, and the trajectory away from nuclear brinksmanship at a time when things were still up in the air, was an extraordinary legacy." At home, Obama cited the Americans with Disabilities Act—something, Obama said, "that it's hard to imagine a current Republican president initiating. . . . So although President Bush was sometimes mocked for talking about 'a thousand points of light,' the fact is, even in his policies,

"George H. W. Bush was a man of the highest character and the best dad a son or daughter could ask for," George W. Bush said on Saturday, December 1, 2018. "The entire Bush family is deeply grateful for 41's life and love, for the compassion of those who have cared and prayed for Dad, and for the condolences of our friends and fellow citizens." Here Bush 43 and Laura Bush pay tribute to the late president in the Capitol Rotunda.

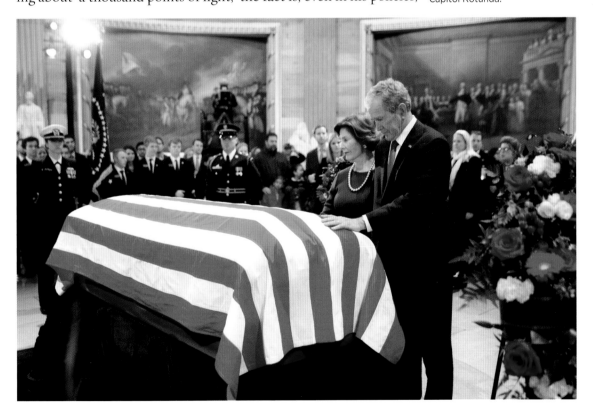

there was a genuine conservative compassion there that manifested itself in working with Republicans and Democrats on the Hill to get some big things done."

Obama's verdict: "As good a measure of a president as I know is somebody who ultimately puts the country first," he said of Bush, "and it strikes me that throughout his life he did that, both before he was president and while he was president, and ever since."

On that November afternoon in 2018 in Houston, Obama took his leave. That was a Tuesday, and it was dusk when the forty-fourth president said goodbye to the forty-first. By Friday night, George Herbert Walker Bush would be dead.

FROM THE LECTERN at the Washington National Cathedral where he had led the nation in mourning after 9/11, George W. Bush bade farewell to his father. "To us, he was close to perfect," the forty-third president said. "But, not totally perfect. His short game was lousy. He wasn't exactly Fred Astaire on the dance floor. The man couldn't stomach vegetables, especially broccoli. And by the way, he passed these genetic defects along to us."

Then the forty-third president pivoted. "He passed something else along to all of us, too," the eldest son said. "Dad taught us that public service is noble and necessary; that one can serve with integrity and hold true to the important values, like faith and family. He strongly believed that it was important to give back to the community and country in which one lived. He recognized that serving others enriched the giver's soul. To us, his was the brightest of a thousand points of light."

A towering life, a race well run, a faith kept. And however dark the age, however difficult the hour, his light can still show us a way forward.

"LET FUTURE GENERATIONS UNDERSTAND THE
BURDEN AND THE BLESSINGS OF FREEDOM.

LET THEM SAY WE STOOD WHERE DUTY REQUIRED
US TO STAND."

PRESIDENT GEORGE BUSH, JANUARY 1991

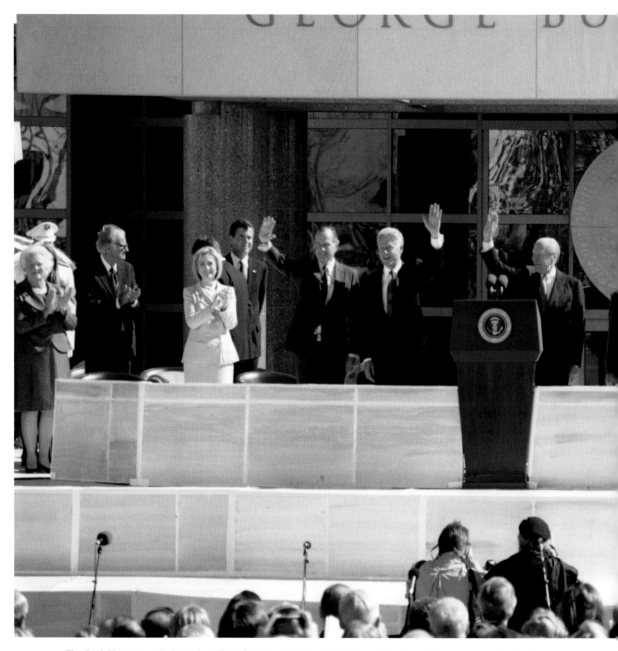

The Bush library was dedicated on Thursday, November 6, 1997. "As president and afterward, President Bush stood for American leadership for peace and prosperity, for freedom and democracy," President Clinton told the crowd—one that included Billy Graham, Nancy Reagan, the Fords, and the Carters. "He was the last president of the Cold War, but he knew that American responsibility could not end with the Cold War. And he showed us that in Desert Shield and Desert Storm. . . . For more than four and a half years now, even though our relationship began under somewhat unusual circumstances, I have been very grateful that whenever I called on President Bush, he was always there with wise counsel and, when he agreed, with public support. It's hard to express to someone who hasn't experienced it what it means in a moment of difficulty to be able to call someone who, first of all, knows exactly what you're up against and, secondly, will tell you the truth. And he has done that time and time again. I am persuaded that the country is better off because of it."

"One of the things I always remember, George, was the Thursday lunch that you and Ronnie shared, and never missed, regardless of war, peace, Congress, weather, whatever," Mrs. Reagan said at the dedication. "When we came home to California after George's inauguration, Ronnie began work in his new office the next day of the busy and exciting first week. But when Thursday came around, it just didn't seem to be the same. As Ronnie sat down to his desk to have a sandwich, the phone rang and the White House operator said President Bush was calling. And when he picked up the phone, Ronnie heard George's friendly voice saying that he, too, was about to eat lunch and it just wasn't the same without him. Ronnie was so touched."

The former president with graduates of the Bush School of Government and Public Service at Texas A&M. The school's motto was a deep Bush conviction: "Public service is a noble calling and we need men and women of character to believe that they can make a difference in their communities, in their states and in their country."

In the winter of 1997, Bush was giving a speech to a parachute association, describing his jump from the Avenger over Chichi-Jima, when he had a revelation. "For some reason, I went back to a thought I had way in the back of my mind," Bush wrote his children afterward. "It has been there, sleeping like Rip Van Winkle, alive but not alive. Now it was quite clear. I want to make one more parachute jump!" He did so later in 1997 and again to mark on his seventy-fifth, eightieth, eighty-fifth, and ninetieth birthdays.

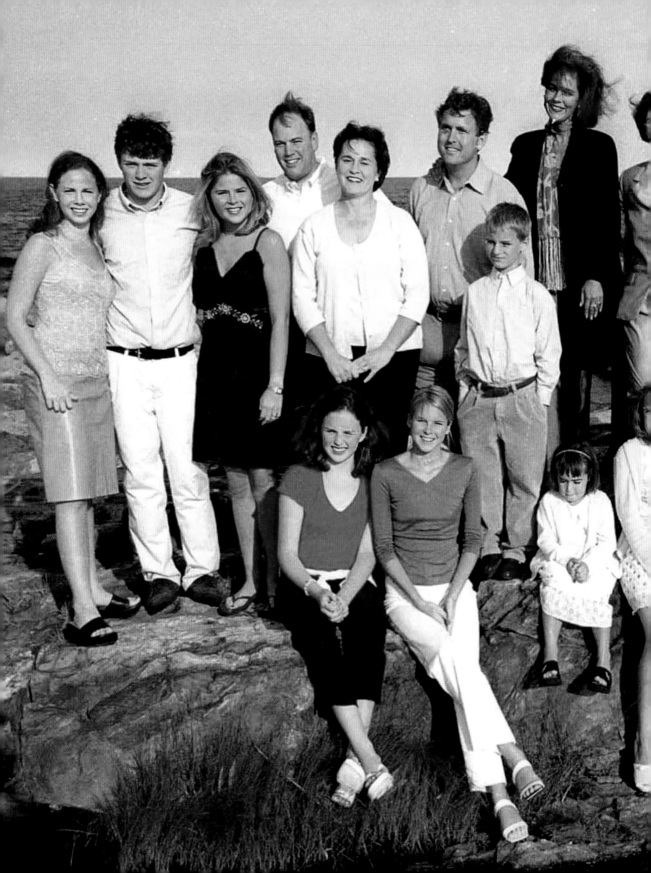

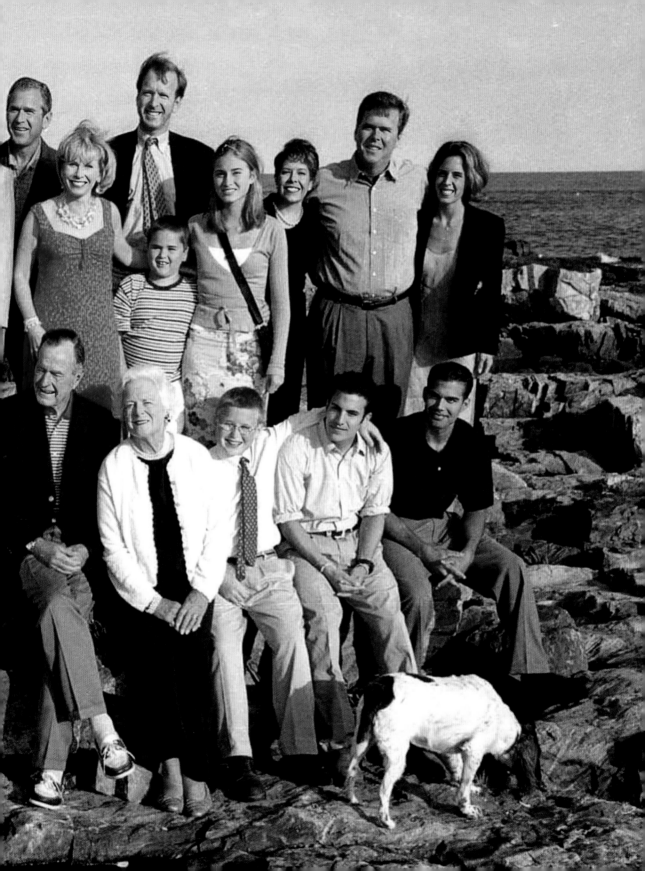

President Bush plays tennis with Pete Sampras on the White House tennis court, October 1990.

AUSTIN TEXAS

AUSTIN TEXAS

Images from a tennis life,
including from an event
featuring Spiro T. Agnew.

April 23, 2003

GEORGE BUSH

I cannot single out the one greatest challenge in my life. I have had a lot of challenges and my advice to young people might be as follows

1. Don't get down when your life takes a bad turn. Out of adversity comes challenge and often success

2. Don't blame others for your set backs

3. When things go well, always give credit to others

4. Don't talk all the time. Listen to your friends and mentors and learn from them.

5. Don't brag about yourself. Let others point out your virtues, your strong points.

6. Give someoneelse a hand. When a friend is hurting show that friend you care.

7. Nobody likes an overbearing big shot.

8. As you succeed be kind to people. Thank those who help you along the way.

9. Don't be afraid to shed a tear when your heart is broken because a friend is hurting

10. Say your prayers!!

[signature: G. Bush]

10000 MEMORIAL DRIVE · HOUSTON, TEXAS 77024
PHONE (713) 686-1188 · FAX (713) 683-0801

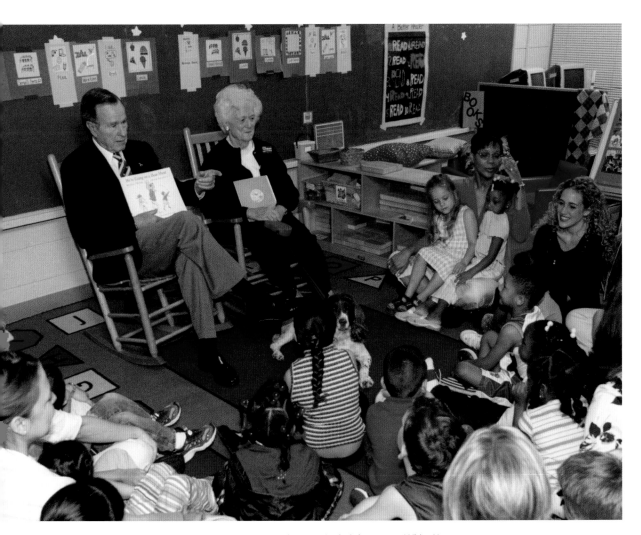

The Bushes became a kind of pair of national grandparents in their long post–White House years. Mrs. Bush remained an advocate for literacy, among other causes; both were tireless fundraisers for charities, including, in honor of Robin, cancer research.

Opposite: The former president does a bit of fishing at the pond behind his library in College Station. Above: The Bush clan gathers for the Bushes' fiftieth wedding anniversary in 1995.

At the Ford Library, 1997.

At College Station, 1997.

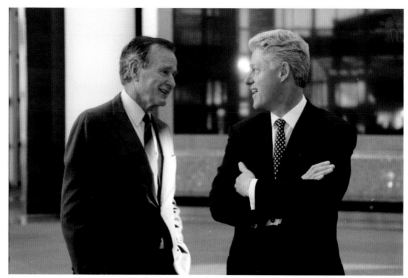

The forty-first and forty-second presidents struck up an intriguing—and genuine—friendship, a connection that grew stronger once President Clinton had given way to the second President Bush in 2001. Bush 41 and Clinton did charity work together, two men separated by generation, by party, and by personality but mutually respectful. "He talks *all the time*," Bush marveled of his onetime rival and current friend. "He knows every subject. You mention Nigeria, and he'll say, 'Now let me tell you about what's happening in the northern part of the country.' I don't know how much of it's bullshit and how much of it's real, factual. . . . I like the man." President Clinton was uncharacteristically brief in describing his feelings about his predecessor. "I love George Bush," Clinton said. "I do."

On the day after Christmas 2004, a tsunami in Southeast Asia ravaged the region, killing nearly 250,000 people. Bush 43 asked his father and former president Clinton to raise money for relief efforts, and the two former presidents went to Thailand, Indonesia, Sri Lanka, and the Maldives. "I don't think there's ever been a tragedy that affected the heartbeat of the American people as much as this tsunami has done," Bush said in Ban Nam Khem, a village in Thailand. "I don't think you can put a limit on it. It's so devastating. They're still finding wreckage, still actually some bodies being recovered." According to *The New York Times,* "Mr. Clinton's eyes watered and his voice trembled as he spoke about the trauma suffered by children in the village. 'I thought about all of our religious traditions and how they all teach us how we are not really in control—but we don't really believe it until something like this happens, and it reminds us all to be a little more humble and grateful for every day.'"

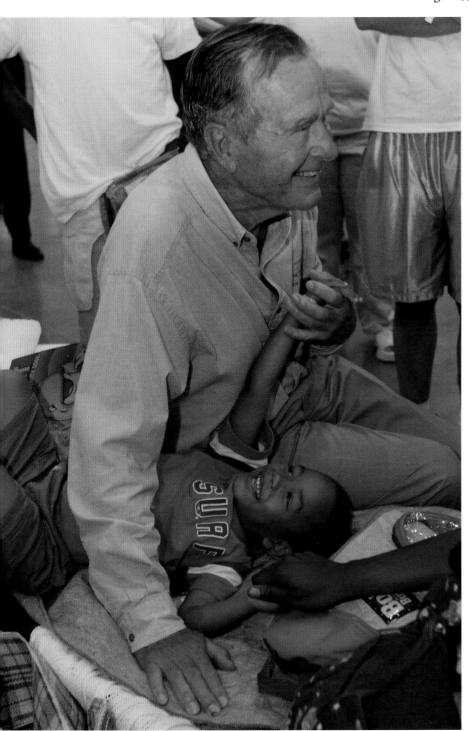

Bush and Clinton reprised their joint philanthropic roles after Hurricane Katrina struck the United States in 2005.

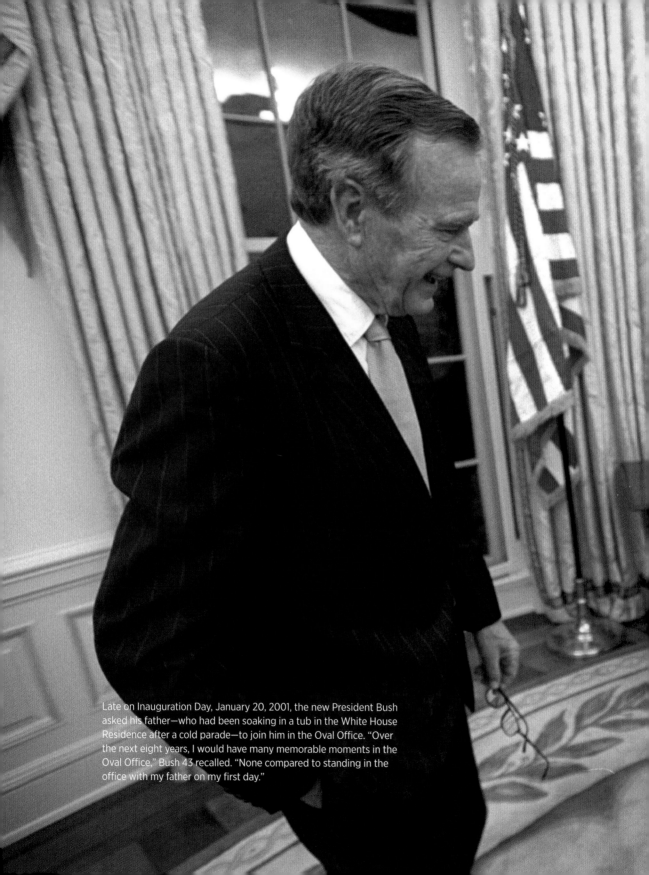

Late on Inauguration Day, January 20, 2001, the new President Bush asked his father—who had been soaking in a tub in the White House Residence after a cold parade—to join him in the Oval Office. "Over the next eight years, I would have many memorable moments in the Oval Office," Bush 43 recalled. "None compared to standing in the office with my father on my first day."

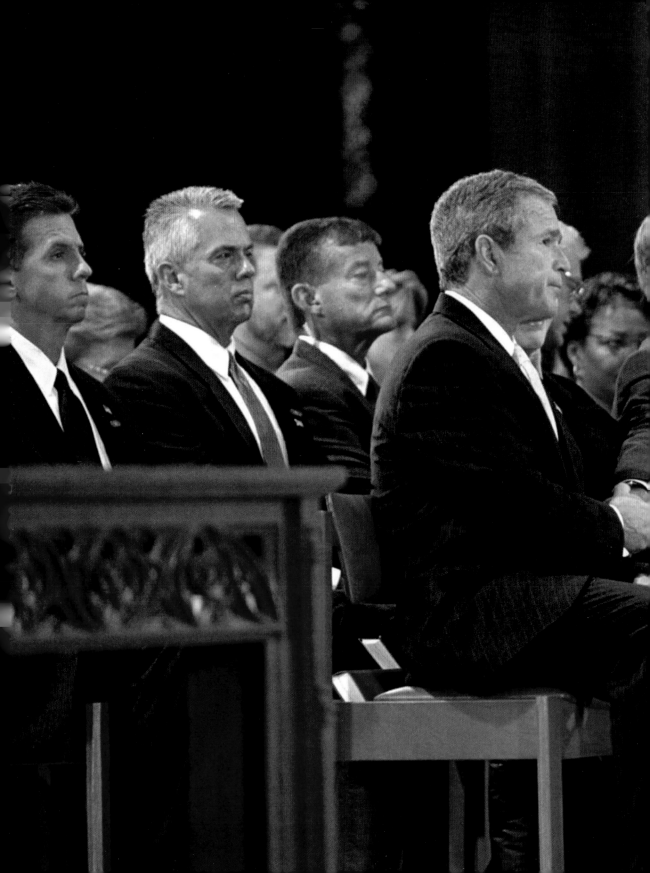

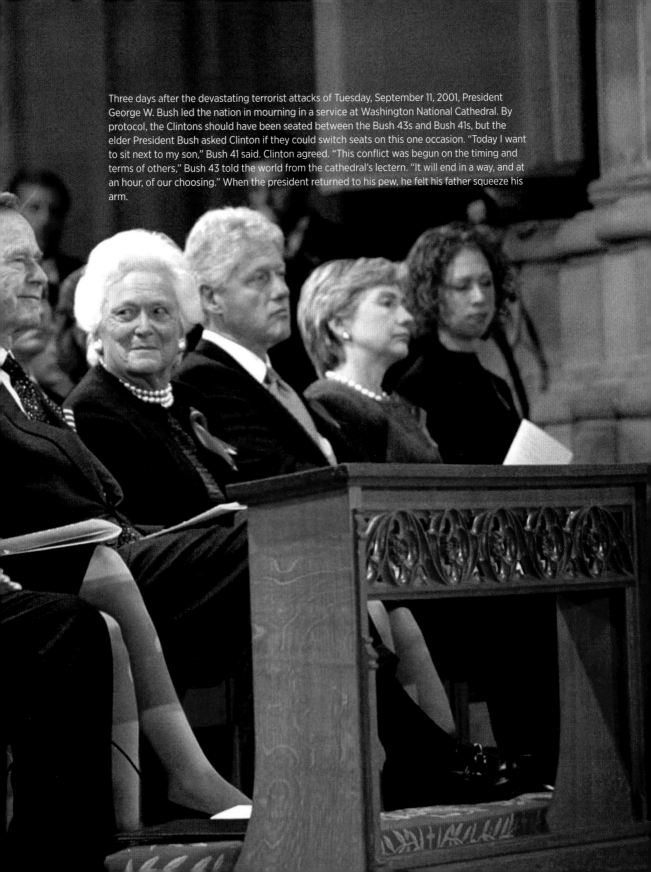

Three days after the devastating terrorist attacks of Tuesday, September 11, 2001, President George W. Bush led the nation in mourning in a service at Washington National Cathedral. By protocol, the Clintons should have been seated between the Bush 43s and Bush 41s, but the elder President Bush asked Clinton if they could switch seats on this one occasion. "Today I want to sit next to my son," Bush 41 said. Clinton agreed. "This conflict was begun on the timing and terms of others," Bush 43 told the world from the cathedral's lectern. "It will end in a way, and at an hour, of our choosing." When the president returned to his pew, he felt his father squeeze his arm.

At the dedication of the George W. Bush Presidential Library and Museum in Dallas, 2013.

In February 2011, Bush returned to the White House to receive the Presidential Medal of Freedom from President Barack Obama. "We honor George Herbert Walker Bush for service to America that spanned nearly 70 years," Obama said. "From a decorated Navy pilot who nearly gave his life in World War II to U.S. ambassador to the United Nations; from CIA director to U.S. envoy to China to the vice presidency—his life is a testament that public service is a noble calling. As President, he expanded America's promise to new immigrants and people with disabilities. He reduced nuclear weapons. He built a broad international coalition to expel a dictator from Kuwait. When democratic revolutions swept across Eastern Europe, it was the steady diplomatic hand of President Bush that made possible an achievement once thought impossible—ending the Cold War without firing a shot. Like the remarkable Barbara Bush, his humility and his decency reflects the very best of the American spirit. Those of you who know him, this is a gentleman."

In funeral rites in Houston, Washington, D.C., and College Station, the forty-first president was laid to rest in the first week of December 2018. Sully, a Labrador retriever service dog, was with the former president in the final six months. Bush's flag-draped casket was flown from Houston to Joint Base Andrews and then to the Capitol Rotunda, where the late president lay in state before services were held at Washington National Cathedral.

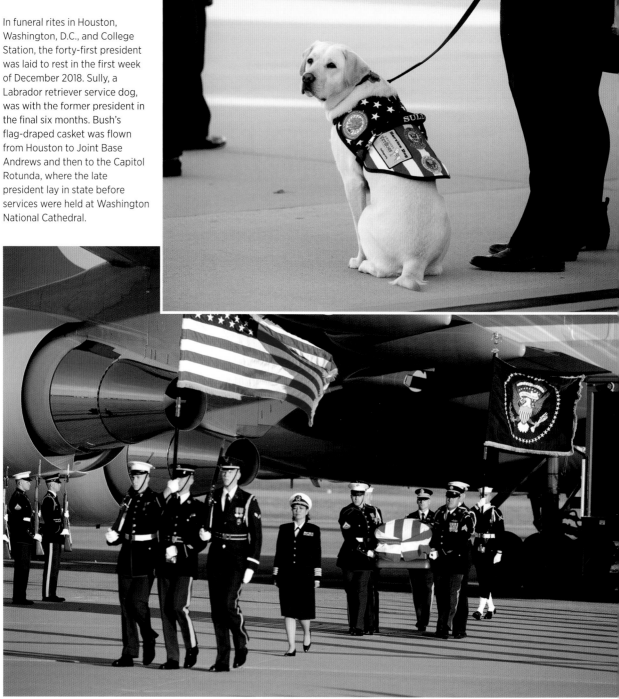

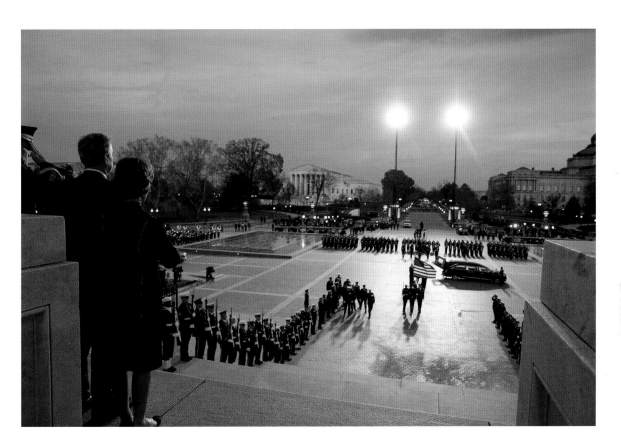

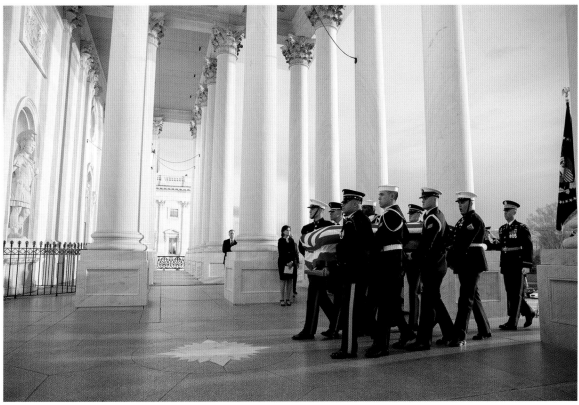

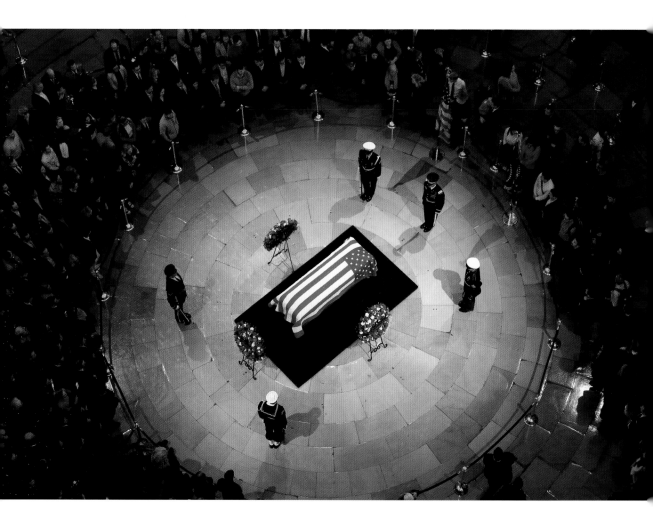

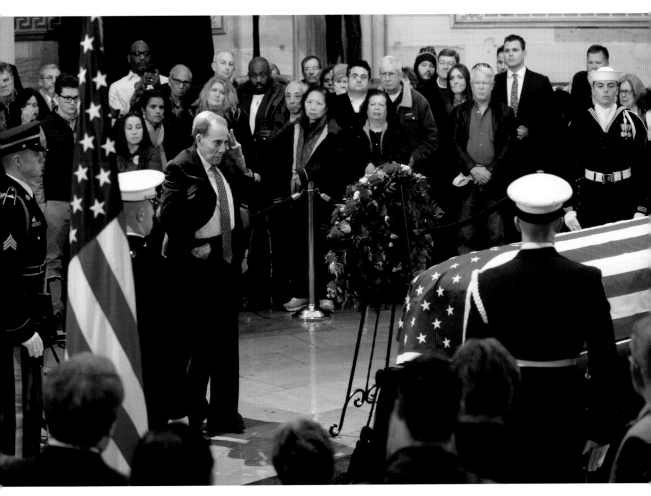

Grievously wounded in action in Italy during World War II and infirm from great old age, former senator Robert Dole insisted on rising from his wheelchair to salute the man who had been a longtime rival and became a friend. Dole and Bush had been ambitious young men in the age of Nixon, and it was Dole who had posed the greatest threat to Bush's hopes for the presidential nomination in 1988. Once Bush prevailed, however, Dole was a loyal and effective advocate for the president in the Senate from 1989 to 1993. "I was his leader in the Senate for four years," Dole recalled after the funeral. "We did what we could—too many Democrats to do as much as we wanted—but I wanted to pay my respects to a man who had been my president."

In the nave of Washington National Cathedral for Bush's funeral: The thirty-ninth, forty-second, and forty-fourth presidents in the first row; former vice president Biden, who would become the forty-sixth, is in the second row, with the Quayles, the Cheneys, and Al Gore.

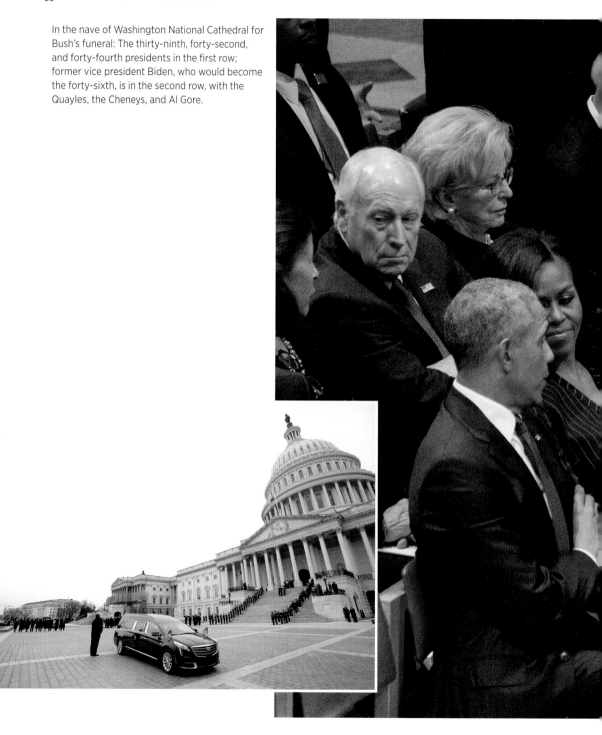

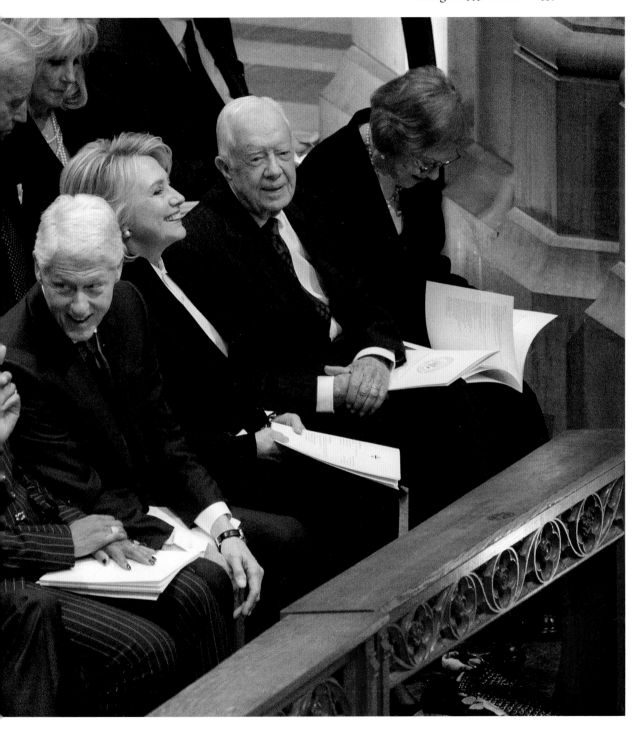

AUTHOR'S NOTE AND ACKNOWLEDGMENTS

THIS COMMEMORATION OF President Bush's life is largely drawn from text that I wrote for *Destiny and Power: The American Odyssey of George Herbert Walker Bush,* which was published in 2015, and from the visual holdings of the George H. W. Bush Presidential Library and Museum in College Station, Texas. I remain indebted to President and Mrs. Bush for their candor through long years of work on *Destiny and Power.* President Bush opened his White House diary to me; Mrs. Bush allowed me to read her decades-long diaries; and both were gracious with their time and their reminiscences of lives lived in the arena. I am also grateful to the extended Bush family, notably former president George W. Bush and Nancy Bush Ellis, the late president's sister.

At Random House, chief thanks go to Simon Sullivan, who designed the book and whose artistry has been invaluable to me and to so many other authors and editors for many years. Kate Medina guided the project with her characteristic grace. Thanks as well to the wonderful team of Dennis Ambrose, Mariah Bear, Carol Poticny, Rebecca Berlant, Porscha Burke, Benjamin Dreyer, Richard Elman, Lucas Heinrich, Joe Perez, Monica Rae Brown, and Andy Ward. Margaret Shannon provided her usual expertise, insight, and keen eye.

I am grateful to Jean Becker, the late president's chief of staff and my good friend of many years; to Michael Beschloss, who first introduced me to the forty-first president back in 1998 and whose wisdom and loyalty are great gifts; and to Gina Centrello, the longtime Random House publisher who brought *Destiny and Power* to life and who remains the soundest of advisers and the best of friends. For kindnesses large and small, I am also grateful to Amanda Urban, Evan Thomas, Ann McDaniel, Mike Hill, Thaddeus Romansky, Jim McGrath, Randy Hollerith, John Geer, and Christopher Buckley.

NOTES

Abbreviations

D&P: Jon Meacham, *Destiny and Power: The American Odyssey of George Herbert Walker Bush* (New York: Random House, 2015)

BPB: Barbara Pierce Bush (1925–2018)

GHWB: George Herbert Walker Bush (1924–2018)

GHWBPL: George H. W. Bush Presidential Library & Museum, College Station, Texas

Book epigraph "To serve and to serve well": GHWB, Remarks at Boy Scout National Jamboree, Bowling Green, Virginia, August 7, 1989, https://bush41 library.tamu.edu/archives/public-papers/802.

Introduction: Farewell to a Statesman

xvii There he was: Author observation, Rotunda, United States Capitol, Tuesday, December 4, 2018.

xviii "Use power to help people": Inaugural address of George H. W. Bush, Friday, January 20, 1989, https://avalon.law.yale.edu/20th_century/bush.asp.

xviii "Politics," Bush once privately mused: Author interview with GHWB.

xviii "If you want to be President—and I do": February 3, 1985; *D&P,* 296.

xix "The country gets over": GHWB diary, November 4, 1988; *D&P,* 330.

xx "We know what works": Inaugural address.

xxii "I take as my guide": Ibid.

xxii "Tell the truth": George Bush, *All the Best, George Bush: My Life in Letters and Other Writings,* updated ed. (New York: Scribner, 2013), 356; *D&P,* xxii.

xxiii "I'm not sure I know": Author interview with GHWB.

xxiv "Hard to believe": Ibid.

Chapter One: A Beautiful World to Grow Up In, Beginnings to 1942

3 His first memory: Author interview with GHWB.

3 "It was a beautiful world": Author interview with Nancy Bush Ellis.

3 "Grandfather Bush was quite severe": Ibid.

4 "He was a flamboyant fellow": Author interview with GHWB.

4 "He was a real son of a bitch": Author interview with G. H. Walker III.

5 "Others would climb off": Author interview with GHWB.

6 "Every mother has her own style": "GHWB Recollections of Dorothy Walker Bush on the Occasion of Mother's Day," Mrs. Prescott Bush (Senior) Materials, GHWB Collection, GHWBPL.

6 "She loved games": Ibid.

6 Mrs. Bush "also tamed": Ibid.

7 "We are interested": See, for instance, *D&P*, 28–32; Susan D. Elia, Renée F. Seblatnigg, and Val P. Storms, *Greenwich Country Day: A History, 1926–1986* (Canaan, N.H.: Phoenix Publishing, 1988).

7 "Claims More Than": Bush, *All the Best,* 53; *D&P,* 29.

7 Bush's parents filled out a questionnaire: *D&P,* 29–31; "Parents Questionnaire," undated, but most likely 1937, Bush, George, Class of 1942, Vertical Subject Files, Archives and Special Collections, Phillips Academy, Andover, Mass.

8 "Markedly a gentleman": GHWB Report Card, 1939–40, Phillips Academy Files.

8 "Not a strong boy": GHWB Report Card, 1940–41, Phillips Academy Files.

9 "Leave the kid alone": Herbert S. Parmet, *George Bush: The Life of a Lone Star Yankee* (New York: Scribner, 1997), 40–41.

CHAPTER TWO: A YOUNG MAN AT WAR, 1942 TO 1945

27 "My God": Author interview with GHWB.

27 "After Pearl Harbor": Ibid.

27 "What I wanted": Ibid.

27 "By the time": Ibid.

27 "Today our world": Claude M. Fuess, *Independent Schoolmaster* (Boston: Little, Brown, 1952), 248; *D&P,* 36–37.

29 "how the American soldier": Parmet, *George Bush,* 45.

29 "So off I went": Author interview with GHWB.

29 "a strikingly beautiful girl": Ibid.

29 "in front of the world": Barbara Bush, *Barbara Bush: A Memoir* (New York: Scribner's Sons, 1994), 17–18.

29 "I floated into my room": Ibid., 18.

29 a time of "heightened awareness": George Bush with Victor Gold, *Looking Forward: An Autobiography* (Garden City, N.Y.: Doubleday, 1987), 31.

29 "I love you, precious": Bush, *All the Best,* 38–39.

31 "Yesterday was a day": Ibid., 49–52.

34 "It worries me": Author interview with GHWB.

34 "My mother and dad": Ibid.

34 "I try to think about it": Bush, *All the Best,* 54.

34 "It was transforming": Author interview with GHWB.

34 "I didn't want to go home": Ibid.

34 "I finished the bombing run": Ibid.

35 "There were tears, laughs": Bush, *Looking Forward,* 40.

35 "I remember crying": Author interview with GHWB.

35 "We were sick": Bush, *Barbara Bush: A Memoir,* 24.

35 "Everything I'd experienced": Bush, *Looking Forward,* 41.

35 "Within minutes": Ibid.

35 "I'll always wonder, 'Why me?' ": Author interview with GHWB.

36 "I am not sure": Bush, *All the Best,* 62–63.

37 "Texas would be new": Ibid.

CHAPTER THREE: GONE WEST, 1948 TO 1962

67 that . . . "she assumed": Bush, *Barbara Bush: A Memoir,* 32.

67 "Beautiful hazel eyes": Bush, *Looking Forward,* 56.

67 "I didn't know": Author interview with GHWB.

67 "What do we do": Ibid.

67 "God, the poor little girl": Ibid.

67 "Robin does unfortunately have Leukemia": *D&P,* 98; GHWB to Harold Dorris, August 4, 1953, Jean Becker, "All the Best, George Bush." File, Post-Presidential Materials, GHWBPL.

67 "One minute she was there": Bush, *Barbara Bush: A Memoir,* 44.

67 One evening he went "out on the town": Bush, *All the Best,* 81–82.

CHAPTER FOUR: INTO THE ARENA, 1962 TO 1977

93 "Once you've had": Reminiscences of Prescott S. Bush (1966–67), 439, Oral History Archives at Columbia, Rare Book & Manuscript Library, Columbia University in the City of New York.

93 "They mentioned several possibilities": Bush, *Looking Forward,* 83–84.

94 "Privately my own political philosophy": Ibid., 80–81.

94 "I found out that jugular politics": Ibid., 86.

95 "The nuts," Barbara remarked in the fall of 1963: BPB diary, GHWBPL.

96 "I got murdered": Author interview with GHWB.

96 "The Birchers are bad news": GHWB to FitzGerald Bemiss, November 11, 1964, Correspondence Between George Bush and FitzGerald Bemiss, 1961–69, FitzGerald Bemiss Collection, Donated Materials, GHWBPL.

96 "We represent the forgotten American": *National Review,* Vol. 16, No. 48 (December 1, 1964), 1055.

97 "I'd like to be President": BPB diary and letters, January 7, 1966; *D&P,* 130.

97 "There'll be few opportunities": Joe McGinniss, *The Selling of the President 1968* (New York: Trident Press, 1969), 43–45; *D&P,* 131–32.

97 "Too long, Republicans have been": *The Galveston Daily News,* November 6, 1966.

97 "I want conservatism": *The Wall Street Journal,* September 21, 1966.

98 "There was a really rich guy": Author interview with GHWB.

98 Bush told the audience: Bush, *All the Best,* 107–10.

98–99 "is conservative on the issue of race alone": *The Galveston Daily News,* July 14, 1968.

99 "Son," Johnson said: Bush, *Looking Forward,* 100–101; BPB diary, April 9, 1969.

100 "Chairman Mills pointed out": Richard Nixon, "Remarks at the Swearing In of George Bush as United States Representative to the United Nations," February 26, 1971, American Presidency Project, https://www.presidency.ucsb.edu/node/240738.

101 "I feel battered": Bush, *All the Best,* 185.

101 "Dear Mr. President": Ibid., 193.

102 "Personalities will change": Ibid., 185.

102 "Listen to your conscience": Ibid.

103 "Your message came": Ibid., 233–34.

103 "return to Washington": Bush, *Looking Forward,* 154.

103 "In the best of times": Ibid., 155.

103 "I think this probably": Bush, *All the Best,* 238.

Chapter Five: At Reagan's Side, 1980 to 1988

177 "I think I want": Bush, *All the Best,* 271.

177 to be "Number One": Author interview with GHWB.

177 "My motivation's always been": Ibid.

177 "Ladies and gentlemen": "George Bush Announcement Speech," May 1, 1979, text in BPB diary, 1979; *Time,* May 14, 1979.

179 a "madhouse": BPB diary, January 22, 1980.

179 the "Big Mo": Parmet, *George Bush,* 226.

179 "Congratulations, sir": *Time,* March 10, 1980.

179 "I'd wanted to be president": Author interview with GHWB.

180 "Hello, George," Reagan said: Bush, *Looking Forward,* 14.

180 "Out of a clear blue sky": Author interview with GHWB.

180 "It was a cliffhanger": Richard Nixon to GHWB, July 19, 1980, Richard M. Nixon Presidential Library.

180 "I'd love to sit down": Bush, *All the Best,* 302.

180 "Please know that we both": Ibid., 303.

180 "1) You and the President will have": Dean Burch to GHWB, November 21, 1980, box 66/1, James A. Baker III Papers, Princeton University Library.

181 "First, don't play": Bush, *Looking Forward,* 227–30.

181 "Sir, we've just received word": Del Quentin Wilber, *Rawhide Down: The Near Assassination of Ronald Reagan* (New York: Henry Holt, 2011), 132.

181 "It's hard to describe": Ibid., 132–33; Chase G. Untermeyer, *When Things Went Right: The Dawn of the Reagan-Bush Administration* (College Station: Texas A & M University Press, 2013), 42–43.

182 "As of now," Haig told the world: Wilber, *Rawhide Down,* 175.

182 "By going straight to the White House": Bush, *Looking Forward,* 224.

182 "I can reassure this nation": Wilber, *Rawhide Down,* 194.

183 "Did it help me": Author interview with GHWB.

183 "I hated it": BPB diary, 1983.

184 "It's funny how": GHWB diary, July 15, 1984.

184 "For the President": Bush, *All the Best,* 342–44.

186 "He's what they call": GHWB diary, October 13, 1987.

186 "This is the beginning": *The New York Times,* February 9, 1988.

186 "If I don't make it": GHWB diary, February 11, 1988.

187 "Strange and unbelievable": Ibid., February 13–15, 1988.

187 "Still, this staring, glaring": Ibid., February 27–28, 1988.

188 "I may not be the most eloquent": George Bush, "Address Accepting the Presidential Nomination at the Republican National Convention in New Orleans," August 18, 1988, American Presidency Project, https://www .presidency.ucsb.edu/node/268235.

189 "The American people": George Bush, "The President-Elect's News Conference in Houston," November 9, 1988, American Presidency Project, https://www.presidency.ucsb.edu/node/285613.

190 "To our opponents": Ibid.

190 "With George Bush and Dan Quayle": Ronald Reagan, "Remarks and an Informal Exchange with Reporters at a White House Ceremony for President-Elect George Bush and Vice President-Elect Dan Quayle," November 9, 1988, American Presidency Project, https://www.presidency.ucsb .edu/node/252828.

191 "I can hardly believe it": Ibid.

CHAPTER SIX: THE BIGGEST JOB IN THE WORLD, 1989 TO 1993

241 all his "life": Winston S. Churchill, *The Second World War: The Gathering Storm* (Boston: Houghton Mifflin, 1948), 667.

241 "a fascinating time": GHWB diary, May 26, 1989.

241 "You know, every President": George Bush, "Remarks at a Luncheon Commemorating the Dwight D. Eisenhower Centennial," American Presidency Project, https://www.presidency.ucsb.edu/node/263731.

243 "because she hasn't": GHWB diary, April 16, 1990.

243 "Maybe we should adjust faster": Barbara Bush, Wellesley College Commencement Address, June 1, 1990, https://www.wellesley.edu/events /commencement/archives/1990commencement/commencementaddress.

243 "She's the rock": Author interview with GHWB.

245 "Brings down the house": Author interview with BPB.

245 At a televised event: See, for instance, Pamela Kilian, *Barbara Bush: Matriarch of a Dynasty* (New York: Thomas Dunne, 2002), 155–56.

245 "The face of war": GHWB diary, January 16, 1991.

246 a letter to his children: Bush, *All the Best,* 496–98.

248 "The more controversial": GHWB diary, November 8, 1989.

248 as, in Gingrich's terms, "sick": See, for instance, https://uh.edu/~englin /rephandout.html.

248 "My friends, this election": Patrick J. Buchanan, Address to the Republican National Convention, August 17, 1992, https://buchanan.org/blog/1992 -republican-national-convention-speech-148.

249 Bush said he "had let people down": GHWB diary, November 10, 1992.

249 "Bill, I want to tell you": Ibid., November 18, 1992.

250 "You ran the worst campaign": Ibid., November 30, 1992.

250 "As I told Bill Clinton": Ibid., January 20, 1993.

Chapter Seven: Twilight, 1993 to 2018

297 "You have given us": George W. Bush, *Decision Points* (New York: Crown, 2010), 55.

297 "Your Mother tells me": Bush, *All the Best,* 615–16.

298 "President Bush's portrait": William J. Clinton, "Remarks at the Unveiling Ceremony for the Official Portraits of President George Bush and Barbara Bush," July 17, 1995, American Presidency Project, https://www.presidency.ucsb.edu/node/221873.

298 "yellow pad conferences": Author interview with GHWB.

298 In the aftermath: Bush, *All the Best,* 591–92.

298 "He is good, this boy of ours": Ibid., 618.

299 "My father was": George W. Bush, "Address Accepting the Presidential Nomination at the Republican National Convention in Philadelphia," August 3, 2000, American Presidency Project, https://www.presidency.ucsb.edu/node/211699.

299 "His speech was absolute perfection": Bush, *All the Best,* 636.

299 "President Bush was very emotional": Author interview with Al Gore.

299 "The conversation was over": Bush, *All the Best,* 636.

300 "literally wracked with uncontrollable sobs": Ibid.

300 "Once you've sat at that desk": Author interview with GHWB.

300 "You are doing the right thing": Bush, *Decision Points,* 224–25.

301 "He talks *all the time*": Author interview with GHWB.

301 "For some reason": Bush, *All the Best,* 598.

301 "reveling in the freedom": Ibid., 602.

301 In the summer of 2017: Author interview with GHWB and BPB.

302 "No. I didn't.": Author interview with GHWB.

303 "I would argue": Author interview with Barack Obama.

304 "As good a measure": Ibid.

304 "To us, he was close to perfect": George W. Bush eulogy for GHWB, December 6, 2018, https://www.nytimes.com/2018/12/05/us/politics/george-w-bush-eulogy.html.

IMAGE CREDITS

All images in this book are courtesy of the George H. W. Bush Presidential Library and Museum in College Station, Texas, with the following exceptions and attributions:

xvi Photo taken by Eric Draper on December 3, 2018, for the George H. W. Bush Presidential Museum and Library.

2 (bottom) Vintage postcard from the family's personal collection, maker unknown. In the Audiovisual Archives at the George Bush Presidential Library.

26 Photo taken by an unknown United States military photographer at Pearl Harbor on December 7, 1941. Image courtesy of the National Archives and Records Administration.

28 (top) Map originally appeared in the *Detroit Sunday Times Pictorial View* on January 4, 1942. Historical image provided by Geographicus Rare Antique Maps.

28 (bottom right) Photo taken by an unnamed U.S. Army photographer circa December 31, 1943.

36 Postcard published by Tichnor Brothers, Inc., between ca. 1930 and ca. 1945. No artist credited.

66 (upper and lower) Postcard published by Tichnor Brothers, Inc., between ca. 1930 and ca. 1945. No artist credited.

75 Painting by Louise Altson, June 1953. The original artwork is in the Presidential Museum's collection.

76 (top) Oil tanks outside Midland, photographed by Dorothea Lange in May 1937 for the U.S. Farm Security Administration. Image courtesy of the United States Library of Congress.

77 (top) Mid-Continent Supply Co., Odessa, Texas, in 1942. Photographer unknown. Image courtesy of Davick Services.

163 (bottom) *Fred Basset* comic strip was a gift from artist and writer Alex Graham to George and Barbara Bush (and C. Fred).

196 AP Images/Ron Edmonds

197 (bottom) AP Images

200 Published by *Playgirl* magazine in September 1983. Image courtesy of the Audiovisual Archives at the George Bush Presidential Library.

202 (top) ©Wally McNamee/Getty Images

202 (bottom) AP Images/Barry Thumma

210 David Hume Kennerly/Getty Images

INDEX

Page numbers of photographs appear in italics.

ABOUT THE AUTHOR

JON MEACHAM is a Pulitzer Prize–winning biographer. The Rogers Chair in the American Presidency at Vanderbilt University, he is the author of the *New York Times* bestsellers *And There Was Light: Abraham Lincoln and the American Struggle; His Truth Is Marching On: John Lewis and the Power of Hope; The Soul of America: The Battle for Our Better Angels; The Hope of Glory: Reflections on the Last Words of Jesus from the Cross; Destiny and Power: The American Odyssey of George Herbert Walker Bush; Thomas Jefferson: The Art of Power; American Lion: Andrew Jackson in the White House; American Gospel: God, the Founding Fathers, and the Making of a Nation;* and *Franklin and Winston: An Intimate Portrait of an Epic Friendship.*